ACRYLIC PAINTING TECHNIQUES

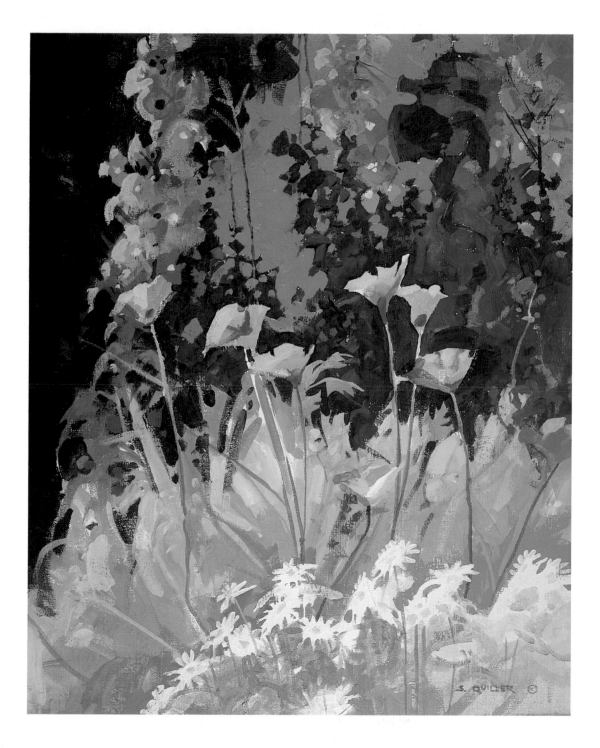

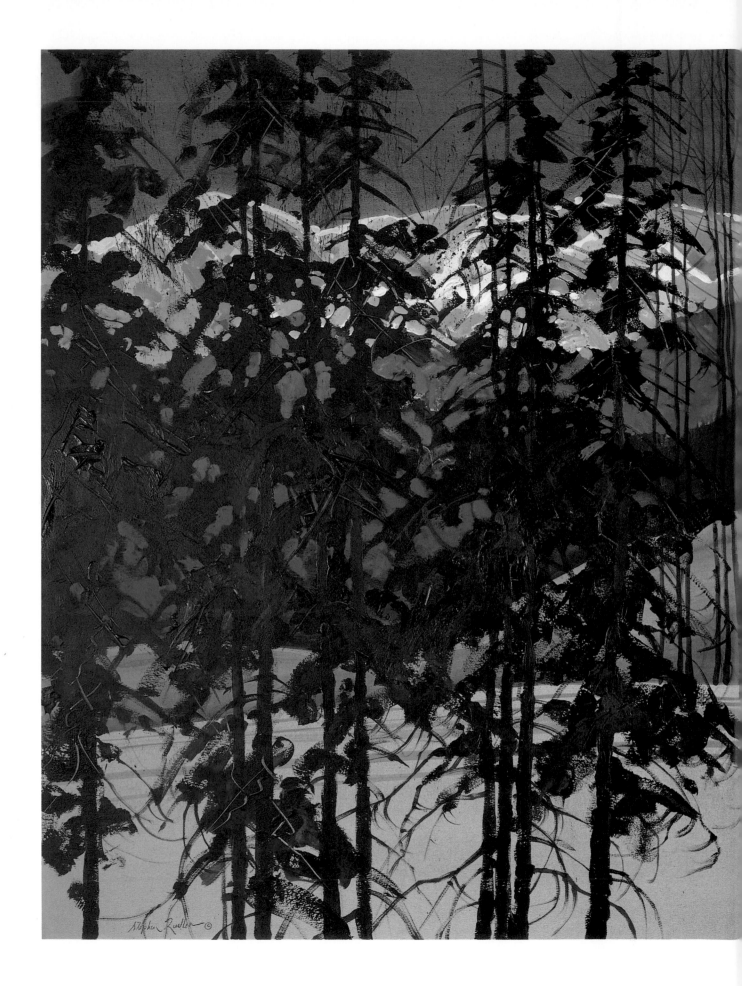

ACRYLIC
PAINTING
TECHNIQUES

STEPHEN QUILLER

For my friend & fellow painter
Rose — Best Wishes,

Stephen Quiller
May 1999

For Rose, Yosemite – 11-'01
Stephen Quiller

WATSON-GUPTILL PUBLICATIONS/NEW YORK

I would like to thank Candace Raney, Senior Editor at Watson-Guptill Publications, for her assistance and her editorial direction; Dale Ramsey for his fine editing; Areta Buk for her skillful layout and design; and Hector Campbell for superbly carrying out the production of the book. I also owe many thanks to Marta Quiller for editing and proofing my manuscript and giving her suggestions, general help, and encouragement; Grant Heilman for the photographs in Chapter 1; Pierre Yann Guidetti and Stacy King of Savoir Faire, importers of Lascaux acrylic paint, for their information and assistance; Mark Golden and Jim Hays of Golden for their information and assistance; the people at Liquitex who provided information; Jack Richeson of Jack Richeson & Co. for palette, brushes, and materials; Rena Rosequist of the Mission Gallery, Taos, New Mexico; James Schaaf for the use of photography equipment; Elizabeth Welch for the use of art equipment and supplies; and Debbie Whitmore for her computer work and printing.

Art on half-title page: **POPPIES, DAISIES, AND DELPHINIUMS.**
Acrylic and white gesso on linen, 18 × 14" (45.7 × 35.6 cm).
Collection of Janice and David Leistikow.

Art on title page: **SUNSET ON THE LAGARITAS, JANUARY 17.**
Acrylic on Crescent watercolor board #5112, 28¹/₂ × 33" (72.5 × 83.2 cm).
Courtesy of the Quiller Gallery.

First published in 1994 in the United States
by Watson-Guptill Publications,
a division of BPI Communications, Inc.
1515 Broadway, New York, New York 10036

Library of Congress Cataloging-in-Publication Data

Quiller, Stephen
 Acrylic painting techniques : how to master the medium of our age
/ Stephen Quiller.
 p. cm.
 Includes index.
 ISBN 0-8230-0105-9 : $29.95
 1. Acrylic painting—Technique. I. Title.
ND 1535.Q55 1994
751.4'26—dc20 94-17459
 CIP

Manufactured in Hong Kong

1 2 3 4 5 / 98 97 96 95 94

IN MEMORY OF BARBARA WHIPPLE, MASON JOHN, AND EARL DEACON,
WHO ENRICHED MY LIFE AS WELL AS MANY OTHERS' IN MANY WAYS.

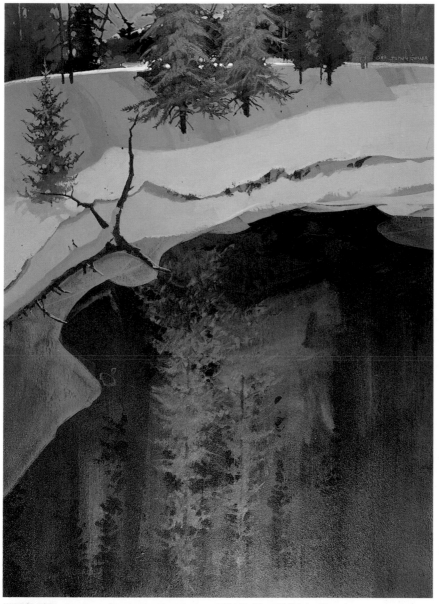

WINTER POOL. Acrylic on Crescent watercolor board #5112, 36 × 26" (91.4 × 66 cm).
Courtesy of Quiller Gallery, Creede, Colorado.

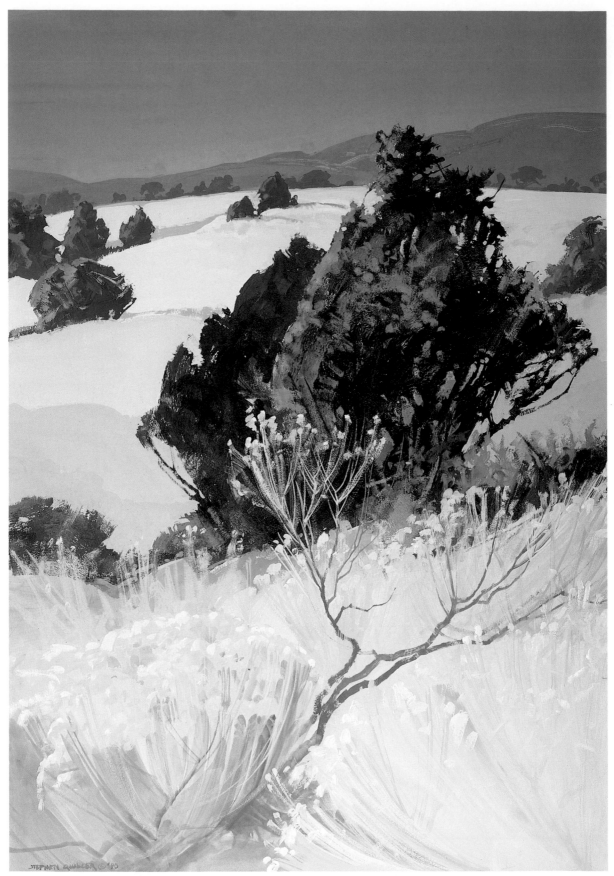

JUNIPER AND CHAMISA, SEPTEMBER. Acrylic and casein on Crescent watercolor board #5112, 34 × 26" (86.4 × 66 cm).
Courtesy of Mission Gallery, Taos, New Mexico.

CONTENTS

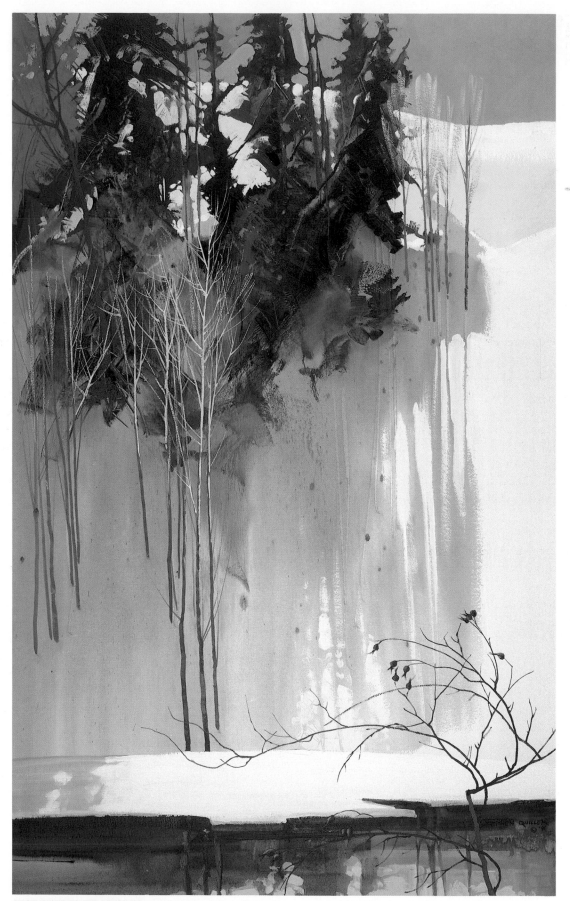

SNOW SHADOWS AND ROSE HIPS. Acrylic and casein on Crescent watercolor board #5112, 34 × 24" (86.4 × 61 cm).
Collection of Bob and Marcia Bailey.

INTRODUCTION

Acrylic paint is the artistic medium of our age. Based in a synthetic polymer resin, acrylics were developed for painting in the late 1940s. In a relatively short evolution, artists have explored many different approaches to acrylic painting and have found it by far the most versatile and permanent medium available.

Acrylics can be worked transparently or opaquely. They can be used with collage or mixed-media. They can be painted on virtually any nongreasy support, including paper, Masonite, canvas, metal, and glass. And they remain flexible and nonyellowing even with age.

Today, acrylic paint is used by more artists than any other painting medium. It is constantly developing, and there are more and more technical advances and experimental products developed each year.

I have used acrylic for watermedia and oil-style easel painting since the late 1960s. As with any painting medium, it is important to thoroughly understand acrylic and the unique advantages that it offers the artist. I do not advocate utilizing a set formula for painting. There are many ways to paint and each expression should take its unique path. That is why acrylic is so rewarding—if you understand the medium's potential. Standard-body acrylic and its myriad polymer resin-based products can be used for almost any painting approach.

It is exciting when the craft of painting in acrylic is well understood, but this comes only with prolific painting. After much time is spent before the easel, you come to understand what acrylics can do and how they react to the various painting surfaces. You know what type of brush will work best for any particular approach. You have a feeling for the amount of drying time needed. You have a feeling for the intensity, luminosity, and richness of color that this medium offers, what the color will look like when wet and how much darker or lighter it will be when dry. You know when the gloss and matte media, gels, modeling pastes, fluid acrylics, metallics, or interference acrylics are

needed for your work. And finally, the more knowledge and mastery of the medium you have, the more it will free you to express yourself in virtually any direction you choose.

I have designed this book to be a workbook. The first chapter is a reference chapter involving all the materials related to acrylics. Chapter 2 focuses on the area of color in acrylic painting. In this chapter, I have designed an acrylic color wheel with over seventy specifically located acrylic tube colors. The chapter demonstrates how to work with complementary, analogous, and triadic color schemes. At the end of this and all the subsequent chapters, there is a painting exercise unit. This section will help you more fully understand the information and develop the techniques presented in the chapter. Chapter 3 explores the many ways acrylics can be used with the watermedia approach—not just transparent but translucent and opaque methods also. What I call "easel painting" with acrylics is emphasized in Chapter 4, which deals with the various supports, grounds, and varnishes that are needed with this form of painting. Chapter 5 delves into innovative and experimental techniques and emphasizes glazing, matte and gloss mediums, gels and modeling paste, metallics and interference colors, and acrylic gouache. Various other media that can be combined with acrylic are the subject of Chapter 6. Acrylic paint is coupled with watercolor, gouache, casein, and the various drawing media.

Since I started working on this book, I have had the opportunity to explore the many exciting aspects of the acrylic medium more deeply. I have had the opportunity to stretch myself and try some things I would not have normally done. It has opened some new possibilities for my work. It is my hope that this book will give you a foundation for acrylic painting. I hope that you experiment with the many ideas that are in the book and learn the painter's craft. It is my wish that you then take that most important step and use this craft to develop your unique form of creative expression.

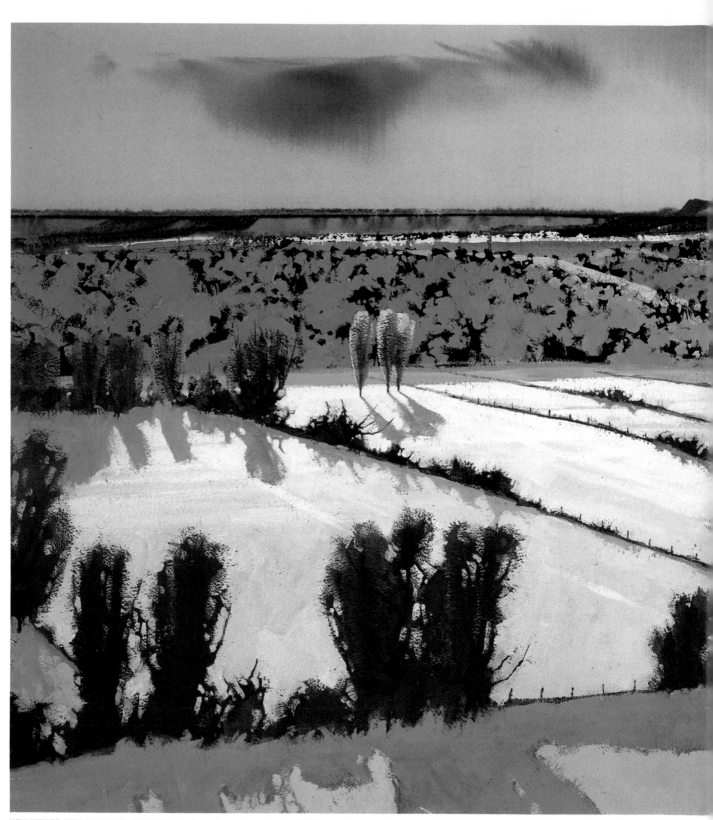

NEW MEXICO FIELD PATTERNS, JANUARY. Acrylic and casein on Arches 555-lb. rough watercolor paper, 26 × 36" (66 × 91.4 cm). Artist's collection.

1
ACRYLIC MATERIALS

I have been working with acrylic products and exploring the various possibilities of the acrylic medium since the late 1960s. During the intervening years, it has been exciting to watch the medium's growth, both in easel painting and watermedia, as more and more artists have experimented with it. Acrylic manufacturers have continued to develop new products to extend the potential of the medium. It is now by far the most permanent, durable, flexible, and versatile medium we have available. Acrylic can be explored for its full potential as transparent, translucent, and opaque watermedia. It is excellent as an "easel painting" medium, both in the studio and on location, on practically any support. Acrylic can be combined with collage approaches or with any form of mixed-media painting. Muralists use it extensively, both indoors and outdoors. In addition to the paint itself, there are gloss and matte mediums, gels, modeling pastes, metallics, pearlescent and interference colors, liquid and impasto acrylics, gessos, varnishes, and retarders. Increasingly, these are being developed to add to the visual qualities and handling characteristics of the medium.

Acrylics and Their Applications

In this reference chapter I cover all aspects of acrylic materials, from the various types of acrylic paint, mediums and gels, to the paper, canvas, and hardboard supports, as well as the types of brushes and palettes. I will explain how each material can be used and what limitations should be considered. This knowledge is the basis of your craft.

In the succeeding chapters, I will discuss many of the applications that acrylic and the various mediums and additives have. Each study and finished painting will give information regarding the type of acrylic paint used, any mediums or additives, and its support. You will be able to return to this chapter to find any additional information you need pertaining to materials.

STANDARD-BODY ACRYLIC PAINT

Standard-body acrylics (or heavy-body acrylics, as they are called by some manufacturers) are simply the regular acrylic paint that artists have come to know. Brands will vary somewhat as to the fluid consistency and concentration of pigment of standard-body paint. For instance, Lascaux's paint has a buttery consistency and a high concentration of pigment, while Liquitex's product is more fluid, with less density of pigment.

A relatively new product, the acrylic medium was developed to combine the advantages of oil painting methods with the flexibility and fluidity of watermedia applications. In the best brands of acrylic, the paint consists of the highest quality, full-strength, pure pigment combined with a synthetic polymer resin emulsion. There are no fillers, extenders, or pacifiers and no toners or dyes. This emulsion, composed of minute particles of polymer resin suspended in water, has a light, translucent, milky appearance. It dries, however, to a clear, hard, but flexible film. Because of the emulsion's appearance while wet, opaque color will dry a bit darker. The paint when dry is insoluble and nonyellowing. If the paint that is selected has a top lightfastness rating, it is absolutely permanent. Acrylic is nonoxidizing, will not crack even in the thickest layers, and will not age.

Acrylic paint can be used straight from the tube for easel painting applications with brush or palette knife, or it can be thinned with water for watermedia methods. Brushes should be moistened with water before being dipped into the paint. They should also be cleaned with soap and warm water immediately after use.

The normal visual quality of acrylic is one of a rich intensity and a somewhat glossy appearance. Many of the brands are not highly opaque, and it may take two to three overlays of opaque color over a dark passage to achieve a brilliant light tone. This can be used to advantage, for the layering of translucent, lighter veils of color over dark can give a beautiful pentimento effect. On the other hand, some acrylic paint, such as Lascaux, has a high concentration of pigment in its emulsion and has a juicy, buttery quality. With this superior paint, high-intensity opaques applied in strokes over dark passages have a strong hiding power. The result has a matte appearance when dry, much like casein. I like this visual quality, but if another quality is desired, a thin application of matte, satin gloss, or gloss medium will serve to alter it.

Acrylic is insoluble to water once dry. A thin application can dry in a few minutes. Thus, so long as each layer is allowed to dry completely, thin transparent glazes can be applied, one over another, indefinitely. This approach not only ensures that the underlayer will not lift, but also achieves a pleasing richness of color and depth of transparency. The quickness of drying time is a definite advantage for many of today's artists. For painters desiring a slower drying time and more time to manipulate the paint, retarding mediums can be used. When these are added to each paint color, the drying time is slowed. It should be mentioned that once the paint dries completely on the palette, it cannot be used again.

Impasto layers can be built up without the danger of cracking, provided that each application is allowed to dry completely. Depending on the thickness of the layer, the drying time can take as long as a few hours. Thick, juicy, textural paint that cannot be achieved in any other painting medium is possible.

Acrylic has outstanding adhesive qualities, so it binds well on almost any nongreasy surface. One should clean any support with soap and warm water to remove any dirt, grease, and grime.

Another characteristic of acrylic is the unique feel that it has, as a synthetic, when you stir the brush in the paint. It has a plastic feel. I know many watercolor painters who have tried acrylic for watermedia painting only to be disappointed with the way it handles. However, its texture is merely different from that of watercolor, and one can easily adapt to it in time. Furthermore, and especially if a painter has worked mainly in watercolor, transparent acrylic painting is a natural transition to working in other ways with acrylic. It certainly handles in its own distinct way, but the techniques are the same, and it offers many more ways to put down paint. The painter will have a greater range of ways to express him- or herself. I refer to this as "increasing the artist's vocabulary."

Colors come in tubes or jars, depending on the brand of paint. Many companies offer a paint of standard body manufactured in a tube and a paint with a thinner, more fluid body packaged in a jar or a plastic squeeze dispenser. (Some companies, such as Golden, do make their thicker paints available in jars.) It is important to research the brand of paint as well as the type of acrylic consistency that you need before you buy.

Other important factors, when it comes to the purchase of acrylic paint, are its lightfastness and toxicity ratings. Ratings are set according to the standards of the American Society for Testing and Materials (ASTM) and certification is given by the Art and Craft Materials Institute (ACMI). Many acrylic paint manufacturers will have ratings such as those shown below printed on their containers of paint.

Lightfastness Ratings
- *Rating I*
 Recommended for all applications, including outside mural painting.
- *Rating II*
 Recommended for all applications, except those exposed to heavy ultraviolet rays.
- *Rating III*
 Fugitive color.

Toxicity Ratings
- *CP Nontoxic Seal*
 Products with a Certified Product (CP) seal are nontoxic, even if ingested, and meet or exceed specific quality standards.
- *AP Nontoxic Seal*
 Products with an AP (Approved Product) seal are nontoxic, even if ingested.
- *HL Seal*
 Products with an HL (Health Label) seal may not be safe to ingest. However, they are certified to be accurately labeled, with the proper warnings, in accordance with an evaluation of their toxicity by medical experts.

FLUID ACRYLICS
Fluid acrylics are relatively thin in body, and are made available most often in plastic squeeze dispensers. Their consistency is similar to that of heavy cream. The thin base of a brand such as Golden Fluid Acrylic is a pure polymer resin emulsion with a pure concentration of lightfast pigments. It can be used in much the same way as the fluid dyes that are on the market; it resembles them in appearance also. However, the acrylics have a far greater adhesive quality, and they are permanent.

One might ask why it would not be just as good to thin the standard-body acrylics with water and use those instead.

While this can be done, thinning the standard acrylic paint with a lot of water causes two things to happen. First, the emulsion is greatly diluted, weakening its adhesive quality. Second, the intensity of the color is not as strong. The fluid acrylics are designed to be used thin but to keep the advantages of the strong adhesive quality and high intensity of color.

Fluid acrylics can be applied to canvas or paper in a variety of ways. They can be poured, brushed and washed on, applied as a stain, or sprayed. They can be mixed with the standard acrylics, including the iridescent, metallic, and interference colors, for a variety of visual qualities.

The Swiss manufacturer Lascaux has come up with a product called Aquacryl, which is an acrylic watercolor specifically. A concentrated and viscous liquid, it is made with finely dispersed, lightfast pigments suspended in an age-resistant acrylic copolymer resin. Diluted with water, this paint will make the most delicate washes and glazes. Overlays of this paint can be applied without lifting an underpainted color. However, with some effort, you can soften edges and lift layers of paint by massaging an area with a clean, damp brush. It is worthwhile to explore this facet of the acrylic medium.

PASTE ACRYLICS
The paste acrylic has a thick, plaster-like texture and is intended to be used for heavy impasto, relief and sculptural painting, and mold applications. Once dry, it can be painted over, or even carved and sculpted. It is very durable and permanent, made from lightfast pigments. It has a semigloss finished appearance. Paste acrylic can be used by itself or in combination with other acrylic materials for a variety of visual qualities and working properties. I find this medium especially effective for the buildup of surface texture while working with acrylic collage. With some imagination, the possibilities are endless.

Golden and Lascaux fluid acrylics.

IRIDESCENT ACRYLICS

Iridescent colors can be used by themselves or mixed with other acrylic paints for a variety of iridescent and metallic effects. Most companies manufacture an iridescent white and iridescent metallic colors like silver, bronze, copper, and gold. However, Lascaux also produces twelve pure hue colors under the trade name of Perlacryl. These colors have great intensity, brilliance, and radiance and are made with the same care and quality that goes into their other acrylic paints. They have great color strength and hiding power and can be mixed with other standard colors for a variety of effects.

Interference Acrylics

Interference colors are a variety of shimmering colors that can create unusual effects when used alone on light or dark surfaces or when mixed with other acrylics or mediums. The unique character of this kind of paint is that, depending on the angle of the light, it will refract a sheen of the complementary color. Thus, an interference blue can have an orange or blue sheen, depending on the angle of the light and position of the viewer.

This phenomenon occurs because there is a high concentration of mica flakes thinly coated with titanium mixed in with the paint. As light hits the mica flakes, it either reveals the direct color or passes through to another layer, reflecting the complementary color, an action that is characteristic of mica crystals. Used on a light surface, the pigment will give a subtle sheen of the color or its complement. Used on a dark surface, this sheen has a startling intensity. Mixed with other colors, it will impart its iridescence to that particular color. Interference colors may also be mixed with gloss mediums and acrylic gels for a variety of effects.

Metallic Acrylics

The metallic acrylic colors add yet another dimension, and come in a variety of colors, some of which are silver, aluminum, copper, pale gold, deep gold, green-gold, bronze, and steel.

The colors are made from metallic powders, are stabilized, and are bright, lightfast, and nonoxidizing. However, to prevent tarnishing, it is highly recommended that metallic coats be sealed with acrylic varnish.

Metallics can be used in a variety of ways, as solid fields of metallic color or mixed with other acrylic paints. When mixing with the latter, I think in terms of analogous warms and cools. For instance, copper metallics mix with the similar family of red-oranges and oranges, gold metallics with yellow-oranges, pale golds with yellows, green-golds with warm greens, and silver with the cool greens and blues. For further reference, check the color wheel in the next chapter.

MATTE ACRYLICS AND ACRYLIC GOUACHE

Matte acrylics have been developed for the serious painter who wishes to work with acrylics but dislikes the standard satin finish. These have the same composition as standard acrylics, but with the addition, in many cases, of a matteing agent. The resulting visual quality is like that of casein, oil distemper, or gouache. The matte acrylics have a buttery consistency, hold a better edge on the brush than the standard acrylics, and seem to be more highly opaque, giving better hiding power. The handling characteristics are the same as the standard acrylic paints, and they are insoluble once dry. These acrylics can be mixed with mediums, gels, and other paint for a variety of effects.

Holbein's Acryla Gouache is a matte finishing acrylic that is similar in its visual and handling characteristics to regular gouache. It is different from other matte acrylics in that it is partly soluble once dry. It has good coverage power, and overlays of color can be applied without disturbing the undercolor.

An acrylic gouache that I particularly like is one made by Lascaux. It handles just like regular gouache but with richer color, excellent lightfastness, and great binding and coverage power. The acrylic additive makes the pigment bond to the support much better than regular gouache.

Lascaux iridescent Perlacryl paints.

Holbein Acryla (tubes) and Lascaux acrylic gouaches (bottles).

Acrylic Mediums

An acrylic medium is fundamentally a polymer resin emulsion suspended in water. Depending on the medium you use, the visual quality obtained will be one of gloss, semi-gloss, or matte. (To make a matte version of this emulsion, a matteing agent is added.) The mediums have a cloudy, milky appearance when wet, but they dry to a hard, clear, and flexible film that will not yellow.

The mediums can be mixed with the acrylic paint to increase the brush quality and extend the paint, as well as to add to its luminosity and transparency and increase its binding quality. Like all acrylic, it can be thinned with water, and it dries quickly.

A painterly effect can be achieved by thinning acrylic paint with the medium and applying it to a smooth support such as cold- or hot-press watercolor board or gessoed Masonite. Both thin and thick transparent and translucent brush applications show easily, and brush marks and textures will remain.

Gloss medium can be used in place of varnish as a final coating for an acrylic painting. Matte medium is not recommended for this, because the dry coat is still somewhat cloudy and will affect the look of the painting.

Gloss and satin gloss mediums may also be used quite well for glazing. Add small amounts of acrylic color to the medium and apply it evenly over the section that needs to be glazed. This will give you a rich, luminous depth and a unified appearance to the painting.

I additionally use gloss and satin gloss mediums in collage work (see below), as if they were glue. They glaze and adhere rice paper, tissue paper, and other materials to a firm support. Once dry, the glossed papers will not be disturbed when painted over.

Acrylic mediums perform the function of a glue in the construction of a collage, such as this one in which I used a favorite material, rice paper.

AUTUMN TEXTURES. Acrylic collage using standard-body, fluid, and metallic acrylics, on rice paper, 34 × 25" (86.4 × 63.5 cm). Courtesy of the Quiller Gallery.

The satin gloss and matte mediums also work well as a clear sizing for canvas. This sizing works like rabbit-skin glue, in that it will show the natural beauty of the raw canvas. Some acrylic color can be added to this sizing if the canvas needs a transparent tone.

GELS

Acrylic gel medium is a thick, clear paste made from polymer resin emulsion. Added to acrylic paint, the gel causes the paint to dry more slowly. It can be mixed into the paint with a palette knife to extend the paint without losing the color consistency.

Gel can be applied heavily to the painting surface (usually the surface has been primed with a gesso first) with a brush or palette knife either as a thick, noncracking "paint film" or built up by itself as an underlayer. Once it is dry, subsequent layers of acrylic color can be applied over this textural underlayer.

If you want to increase the luminosity of an acrylic painting and give it the appearance of a juicy brush application, the clear gel may also be used with heavy, textured brush marks over the painting once it has dried.

In addition, heavy, clear acrylic gels are used with collage. The thick paste will easily hold most collage materials that are placed on a rigid support.

Liquitex has come out with some textural gels, such as ceramic stucco, natural sand, resin sand, and blend fibers. Golden has come out with a pumice gel. These gels can be mixed with any acrylic color to create infinite possibilities for effects and techniques.

MODELING PASTES

Modeling paste is a putty-like medium used for building heavy textures and three-dimensional relief forms in painting. The consistency of the paste can be altered by letting some of its moisture evaporate before or during use.

Very thick applications should dry slowly, so that the paste will not crack. To ensure this, cover these areas loosely with plastic. Modeling paste will take two to three weeks to dry to maximum strength and hardness. At this time it can be sanded or carved. Modeling paste adheres best when used on a rigid support such as a primed Masonite or watercolor board. If it is mixed half-and-half with gel medium, it will have sufficient adhesive quality to be used on canvas.

Acrylic colors can be mixed with the paste to tint it. Normally, however, the paste is painted over with acrylic color when it dries. Modeling paste is ideal for the buildup of relief, for sculptural painting, and for collage. Fabric, stones, and wood can be embedded in the medium.

Most modeling pastes are white and consist of finely ground particles. Lascaux makes a coarser modeling paste, Modeling Paste B. It has the same properties as the regular

Winsor & Newton, Liquitex, and Lascaux matte mediums.

paste but is one-third silica sand with a heavier grain. This can be used like the other paste, but, of course, it has a much more noticeable texture.

RETARDERS

One of the advantages of using acrylics, in the view of many of today's painters, is that it dries rapidly. This allows for great areas of coverage in a short amount of time and for a more rapid buildup of paint layers if desired. However, some artists require a longer time to manipulate, model, and blend paint. Adding acrylic retarder to the paint provides the extra drying time. The amount of time prolonged before drying depends on the amount of retarder used but also the climatic conditions while painting. Generally, retarder can double the normal drying time. Furthermore, the addition of retarder improves the workability of wet-on-wet passages and glazes.

The retarder can be mixed with each color directly, either with a palette knife on a glass palette or directly with a brush. It should be quite thoroughly mixed with the paint. Some manufacturers will recommend that only 15 percent of the mix should be retarder, while others will suggest that as much as 50 percent of the mixture should be retarder. Check the directions of the particular brand of choice.

FLOW ENHANCERS

Acrylic flow enhancer performs in a manner similar to that of the ox-gall medium used with watercolor. It reduces the surface tension of the water in the acrylic emulsion and thus increases the flow of the paint. This can aid the artist in a variety of ways.

The watermedia painter can add one part flow enhancer to twenty parts water (in other words, just under 5 percent of the mix is enhancer) to enhance the coverage power and flowing characteristics of the acrylic. Wet-on-wet areas will have the appearance of deeper, saturated color.

This aid can be used by artists wishing to pour transparent acrylic paint on raw canvas. It increases the flow of the paint and gives some beautiful effects. The acrylic paint is permanent and will not damage the support as oil paints will over an extended period.

Large areas of flat, smooth opaque color can be easily covered by thinning the acrylic paint slightly with flow enhancer and water. The paint goes on in a unified, even manner and with only slightly noticeable brushstrokes.

GESSOS

Acrylic gesso is the *primer,* or pretreated ground, separating and protecting the support, such as canvas, Masonite, or paper, from the paint. It thus isolates the paint from the support and provides an ideal ground to bond with the paint. The support surface must be free of grease and oil and be completely dry before the gesso is applied. The primer will then adhere well to the support.

Thin or thick layers of this medium can be applied, depending on the painting surface that is desired. Make sure that the gesso is well mixed before use. If you are working with a heavily woven, textured linen canvas, thin coats of gesso will best maintain the texture yet keep the surface flexible without cracking. If a very smooth coat is desired over untempered Masonite, use very fine sandpaper to develop the surface between coats (see page 21).

Acrylic gesso may also be utilized to prime a surface for oil painting, in which case three separate coats should be applied to prevent oil penetration.

In many cases, artists use a white gesso. However, there are a variety of gesso colors, including the primary and secondary colors, plus gray, black, and a canvas color. Colored gesso can be used to advantage when some of the ground is left unpainted or allowed to show through translucent passages. The tone of the gesso, if keyed with the color scheme of the painting, can unify the composition as it shows through in various ways throughout the painting.

Holbein has created a series of colored, matte-finish acrylic gessos trademarked Acryla Gesso. Red, yellow, blue, and green—as well as earth-colored terre verte, yellow, and red ochre—are offered. Gold, in addition to the standard white, black, and gray, is also a part of the series.

VARNISHES

Acrylic varnish is a clear, protective polymer coating made specifically for acrylic paintings. This medium allows a painting to be exhibited without glass. Many varnishes make a surface dust-resistant. Nonyellowing and easy to clean, varnishes may be purchased with a gloss, satin, or matte finish. The application of any varnish will tend to deepen and intensify the colors. A variety of varnishes are available, depending on your needs.

There are varnishes that have filtering agents that protect your work from the effects of ultraviolet light. Ultraviolet rays can damage, fade, or darken pigments. By choosing lightfast paint and by also using the ultraviolet protective varnish, the painter can be reasonably secure that the art work, with proper care, will last.

Certain varnishes can be removed from the painting surface with solvents such as ammonia or mineral spirits. This is obviously important for restoration purposes.

A mineral-spirit acrylic varnish forms a tougher coat and is less permeable than most other acrylic varnishes. This is a durable varnish, suitable for outdoor mural painting.

To clean a painting that has an acrylic varnish coating, simply use a soft cotton ball soaked in a solution of warm water and mild liquid soap. Gently massage the cotton on the surface of the painting, changing the cotton as needed.

Daniel Smith gray gesso, Holbein colored gesso, and Golden white gesso.

Brushes

It is very important for the artist to know the craft of painting. He or she must know the workability and handling characteristics of all the materials used in the painting process—the palette, the paint, the painting support, and the brushes. These are the tools that make expression possible. It is important to use the best quality materials available (and this does *not* always mean buying the most expensive materials). In using the best, the artist is not forced to fight the materials while trying to be creative.

The type of brush used is critical to the success of the painting. It is helpful to do a series of studies with various brushes in order to learn the ways they can best be used to put down paint. In time, the knowledge gained from exploring the handling of each brush will make it possible to select a brush that will be most effective in a given passage of a painting. The brush can eventually become an extension of the mind, eye, body, and hand.

There are two general categories of brushes: watermedia brushes, which are used for fluid approaches to acrylic, usually executed on a paper support; and oil-painting brushes—I prefer to call them easel painting brushes—which are used for the heavier acrylic applications that resemble painting in oils, usually on a canvas or Masonite support. I want to look at both categories in some detail, but before doing so, I should mention one other tool—a supplement to the brush: a paper towel or a rag, normally held in the hand opposite the brush.

I usually use a heavy, double-folded paper towel and may go through a whole roll while completing a single painting. Many artists are more comfortable using painting rags instead. Regardless of the type of material used, by dragging or dabbing the paint-filled brush on the towel, you can regulate the amount of paint and water to be used for each application. With practice, the painter will always have the right amount of paint and water for the type of application needed.

When purchasing a brush for painting in acrylics, there are several things to consider. First, examine the spring or the snap of the brush. When the brush is wet, draw a finger across the fibers. The bristles should snap back to their original shape. Also check the amount of water the belly of the brush will hold. The more it holds, the better the brush. Further, see if the brush will come to a sharp, flat edge or a point. There should be a continuous edge without any divisions on the tip of a flat brush. Make sure the ferrule is tight and the handle feels good in your hand.

Natural vs. Synthetic Brushes

Contrary to popular belief, any kind of brush can be used for acrylic painting, including sable or natural hair brushes. However, most natural bristle brushes are expensive and thus should be used with the utmost care. With prolonged use, the wetting agent of acrylic paint will tend to extract the natural oils from the hair. After use, the brush should be carefully washed with lukewarm soapy water. Occasionally, the brush can be greased with Vaseline. This will help keep the natural oils in the hair. Before reusing it, simply clean the brush with warm, soapy water.

Today there are many inexpensive but excellent synthetic brushes on the market. The synthetic material is commonly a nylon filament. Some of these brands are so good that it is almost impossible to tell the difference between them and the natural fiber brushes. In fact, I use the synthetic bristle not only for acrylic, but for all watermedia, including casein, gouache, and transparent watercolor. I have found the Richeson 7000 round series and the 7010 flat series to be ideal. These brushes are economical, hold a lot of paint, keep a great point or edge, and have a nice snap.

The natural hair or synthetic fiber brush should *always remain wet* while in use. Paint should not be allowed to dry on the heel of the brush (where the bristle meets the ferrule) or on the fibers. If acrylic does dry on the brush, it will be insoluble in water. The paint will, however, dissolve in alcohol. While this will remove the paint, it is not good for the life of the brush.

Finally, choose the size, shape, and kind of brush that feels right for you. The way you paint is different from the way any other artist paints. The more you experiment with a variety of brushes, the easier it will be for you to decide which brushes are right for you.

WATERMEDIA BRUSHES

The two basic kinds of watermedia brushes are the *flats* and the *rounds*. I use both. The type of brush used depends on the artist's personal preference; the way the paint is applied and the artist's "marks," a matter of style, are taken into consideration.

Flat brushes come in a variety of sizes: $1/8$", $1/4$", $3/8$", $1/2$", $3/4$", 1", $1^1/2$", 2", 3", and so on. They are great for angular edges, thin lines, dry-brush and splayed-brush textures, flat and control washes, and wet-on-wet techniques. I use most of these sizes in my painting.

Round watermedia brushes also come in a variety of sizes. The #000 is a very tiny, fine brush used for detail. As the number increases, the brush gets larger. I will typically use a #3, #6, #8, #12, and a #24. Smaller brushes work fine for intricacies and thin, flowing lines. Midsize brushes, like the #8 and #12, give a fine line and also make a variety of marks depending on the amount of paint and water in the brush. They can be used for dry-brush and scumbling as well as control and wet-on-wet applications. A #24 can be used in a similar way but is ideal for large wet-on-wet passages.

OIL, OR "EASEL PAINTING," BRUSHES

Like watermedia brushes, both natural and synthetic easel painting brushes, such as you'd use with oils, can be used for acrylic with the same precautions.

Easel painting brushes, generally speaking, have much stiffer bristles than watermedia brushes. There are a variety of natural-bristle brushes, including hog bristle, sable, squirrel hair, ox hair, and camel hair.

There are numerous shapes and sizes of easel painting brushes. Each size and shape is particularly designed to hold a certain amount of paint and give a certain type of application or mark. Some common shapes are as follows.

- *Bright:* a short, square brush head with a flat ferrule
- *Flat:* a long, regular brush head with a flat ferrule
- *Filbert:* an oval brush head with a flat ferrule
- *Round pointed:* a pointed brush head with a round ferrule
- *Round domed:* a domed brush head with a round ferrule

Care should be taken in cleaning a brush. Again, never let the acrylic paint or medium dry in the brush. Always clean the bristles and heel of the brush (where the bristle meets the ferrule) with warm soap and water. While it is wet, reshape the brush to its proper state and place it in a container in a manner in which the bristles will not be disturbed.

Watermedia brushes: Richeson 7000 and 7010 round and flat series synthetics.

Acrylic "easel painting" brushes.

Acrylic Painting Supports

The painting support—the surface on which the acrylic is painted—may be paper, canvas, or Masonite. Of course, prior to painting you must consider a number of factors in selecting the support. If you are taking a watermedia approach, the surface is usually paper. Does it need to be a heavy- or a lightweight paper? Does it need to have a rough, medium, or smooth surface texture? It should be a good-quality, natural-fiber paper, such as linen or cotton rag, that is acid free and pH neutral. This ensures that the paper support will be more or less permanent.

If you are using acrylics with an oil-painting approach, you will probably work on canvas or Masonite. Canvas is flexible and even moves as the artist applies paint. Among canvases, the most permanent weave is linen, and then cotton. There are tighter and looser weaves, smoother or coarser textures, and gessoed or ungessoed canvases from which to select. Masonite is a more solid support.

WATERMEDIA PAPERS

There are many quality papers available to today's artist. Some of the best known brands include Arches, Crescent, Fabriano, Lanaquarelle, Murillo, and Strathmore. The only way to know which is the best paper for you is to experiment with as many of them as possible. Often, paper companies or art supply stores will give you free paper samples. You will try some that suit you better than others. For instance, a short while back I experimented with Lanaquarelle 300-lb. rough paper. I found it to be much whiter than most, and this enhanced the vibrancy of transparent acrylic. The rough texture and the softness of the paper are ideal for my use. It takes scarring, scraping, lifting, collage, and mixed-media applications well. Here is some information that may help you when selecting a paper.

Textures

Papers are made in various surface textures. The following are three common textures of watermedia papers.
- *Hot-pressed:* This is a very smooth, almost slick surface produced by pressing paper through hot rollers after the sheet is made. Rich, intense color shows well because of the flatness of this surface. Surface texture can be created easily with a brush or a knife, by spattering, and with a variety of other tools. Extremely fine detail can be applied with a brush.
- *Rough:* This is a heavily textured paper produced with minimal pressing after the sheet is made. Each company's product has its own degree of roughness, but whatever the brand, your brush marks will have rough, irregular edges.

Also, sparkling and spontaneous texture can be achieved by dragging a semi-dry brush quickly across the paper. Because of the ridges and pockets of the rough paper surface, sedimentary color and glazing applications also work well. It can also be used for wet-on-wet painting.
- *Cold-pressed:* This paper has a mildly textured surface somewhere between hot-pressed and rough. The surface is produced by pressing the paper through unheated rollers. It is a general, all-purpose paper, good for most uses, including dry-brush, control wash, and wet-on-wet.

Sizing

All watermedia papers have a sizing added to the paper. It may be gelatin, starch, resin, glue, or modified cellulose. It can be added at the pulp stage or to the surface of the paper when dry. The amount of sizing used will determine the absorbency (or resistance) of the paper to the liquid. Each manufacturer has its own formula, so it is wise to experiment to find how best to use each brand of paper.

Paper Weight or Thickness

A paper's weight is stated either in pounds or grams. The formula for pounds is the weight in pounds per 500 sheets (a ream). Thus a 90-lb. sheet of paper equals a ream of the same paper that weighs 90 pounds. The standard size for each sheet weighed is $22 \times 30"$. The weight in grams is measured by the grams of weight per one square-meter space. It is shown as gm/m^2. The following are some standard watermedia paper weights.

90-lb. paper = 185 gm/m^2
140-lb. paper = 300 gm/m^2
260-lb. paper = 555 gm/m^2
300-lb. paper = 640 gm/m^2
400-lb. paper = 850 gm/m^2

WATERMEDIA BOARDS

Watermedia paper can also be purchased mounted on a board. It gives a much more rigid support and alleviates the problem of the paper buckling. It is good for all forms of painting approaches, including collage and mixed-media uses. It is important to check the type of board to which the paper is mounted. If it is a regular high acid-content chip board, it can affect the permanency of the paper. An acid-free board is best. I have been using a relatively new cold-press Crescent watercolor board, Series #5112, and have been very happy with it.

RICE PAPERS

Rice paper is a common misnomer applied to lightweight Oriental papers. These come in a variety of textures and weights. They generally have less sizing and more absorbency than Western papers. The papers can be painted on directly with good results. I like to laminate a variety of torn and cut rice papers to watercolor board using acrylic matte medium. Arranging different tones and textures of the paper to the support gives an exciting surface for acrylic collage.

EASEL PAINTING SUPPORTS

As stated earlier, acrylics are often used much like traditional oil paint, as an easel painting medium, for they offer certain advantages over oils: Not only do they mix and thin with water—eliminating messy cleanup chores and the need for toxic solvents—they are also faster-drying, nonyellowing, flexible, and noncracking. They can be used in combination with other media and adhere strongly to the support. Although acrylic will adhere to almost any surface as long as it has been cleaned of any grime or oil, the usual oil painting supports are most often used.

Stretched Canvas

Canvas has been used for centuries as a support for painting. The natural fibers of linen and cotton are used for the most durable canvas. This support is prepared by stretching the canvas over stretcher bars and then sizing or gessoing the canvas.

The stretched canvas has some "give" to it when the brush comes in contact with it. Many painters find the springy interaction between the canvas and each brushstroke to be very desirable. Occasionally, artists prefer to staple the canvas to a board temporarily while painting. This allows the painter to crop and stretch the canvas to conform to his or her final conception of the work.

Belgian linen is often considered the longest lasting and most beautiful canvas to work with. This natural linen comes in a variety of textures and weaves and also in earth tones ranging from warm umbers and siennas to green grays. I like to use a gloss medium to size this canvas, to preserve the natural linen tone, and then, keeping the surface unprimed (not gessoed), I can utilize the linen tone in my painting.

Watermedia papers (top to bottom layers): Lanaquarelle, Crescent watercolor board, De Wint handmade toned watercolor paper, Arches, and two rice papers.

The fact is, acrylic painting supports do not need to be either sized *or* primed before painting, for another advantage of acrylic is that it will not age the canvas the way oil does.

If canvas is to be primed, it should have two or more coats of gesso. As I mentioned earlier, gesso comes in white, gray, black, canvas color, gold, terre verte, and a variety of pure hues. The color tone of the gesso can be utilized as part of the finished painting.

Canvas can also be purchased pregessoed. This can save the painter time, but it is harder to stretch a fairly tight canvas when using the pregessoed variety. Canvas pliers, which give you a good grip when pulling the fabric, are recommended to help with this process. Nowadays even prestretched gessoed canvases are available. They come in standard sizes, such as 9 × 12", 11 × 14", and 16 × 20". This is a most convenient item for the artist wishing to save time.

Masonite

Masonite is a type of board made by pressing wood fiber into an even thickness, such as $1/8$", which is ideal for weight and rigidity. (Thicker Masonite is made, of course.) When purchasing this board, ask for untempered Masonite. This simply means there is no oil or glue added as a binding agent; untempered Masonite is formed only by placing wood fiber pulp under extreme pressure and heat. The fibers interlock and form a hard, smooth board. Masonite is thus a rigid support that can be primed with gesso in various ways to give a very smooth or a rough and painterly texture.

To achieve a very smooth surface, first sand the Masonite with a fine sandpaper. Clean and coat the Masonite with gesso using a soft fiber brush. When it is dry, use a fine-grit sandpaper to smooth the surface. Clean it and apply a second coat of gesso. After the gesso is dry, again sand it and apply a final coat. Sanding on the final coat should be with an extremely fine-grit paper.

To obtain a textured surface, clean the Masonite with soap and water and apply a liberal coat of gesso. When it is dry, you can put on a second coat using a stiff bristle brush. Let the brush texture show and splatter the gesso as well, if you wish. An alternative is to apply a silica-sand gesso, modeling paste, or liberally brushed gel using brushes or other tools for the second coat. Let this layer dry completely before applying the paint.

A variant of the Masonite support is the clay board (Claybord) panel. This wonderful surface is available with a very smooth texture and with a fine tooth on which the paint can bind. This board has a warm white color and a velvety surface that acrylics bind to beautifully. Because this board is already coated, you can start painting right away. Clay board panels are discussed in depth in Chapter 4.

Gray and white gessoed canvases (left), gessoed Masonite (middle), and raw cotton canvas (right).

Palettes

There are various kinds of palettes available for the artist using acrylics. The simplest is a piece of glass mounted on a white surface, such as mat board. Because of its nonporous surface, glass is the best for acrylic. When acrylic paint dries on the palette, you can spray water on it with an atomizer and, using a single-edge razor blade, scrape the paint. It will slide off very easily.

If you need to leave for a period of time and want to keep the paint usable, simply mist the color, place an open container of water in the center of the palette, and wrap plastic around the palette to seal it (just don't tip the palette!). Color will remain fresh overnight, and even for days.

This is how I set up my studio palette with a color wheel incorporated into it: First I cut a sheet of double-strength glass to 21 × 24". Then I cut a sheet of white mat board the same size. Find the center of the mat board and, with a protractor, scribe a circle 19" in diameter. Lightly mark twelve equal sections around the circle to locate the primary, secondary, and intermediate colors. Mark the primaries with a large wedge shape (starting with yellow at the top), the secondaries with a large diamond, and the intermediates with a square. After all the symbols are penciled in, outline the circle and the symbols with a black marking pen. Then clean the underside of the glass and place it on the wheel. With 2" duct tape, wrap a 1/2" border around the glass and fold the rest of the tape under the mat. This will seal the fragile sides, protect your fingers from the sharp edge, and keep paint from leaking onto the edges of the mat board. This palette helps me to organize my thoughts about color and color mixing as I paint. After working with this kind of palette for a while, you will find that mixing color becomes second nature. If you are unsure where to place each color, refer to the color wheel in the next chapter.

JONES PALETTE BOX

The Jones Palette Box, model 1418, is designed to hold a 12 × 16" disposable palette insert. A deep channel around the inside of the lid secures this disposable palette, even if the unit is held upside down. To keep your acrylics moist, spray the palette with water.

A glass palette.

THE QUILLER PALETTE

I designed the palette shown below (top), manufactured by the Jack Richeson Company. It can be used for all watermedia, including watercolor, gouache, and casein, and acrylic. It comes with an instruction guide showing how to organize the palette and set up the colors for each of the watermedia. When I travel on painting trips or to do workshops, this is the palette I use. The cover seals tightly, and with a damp paper towel or sponge inside, acrylic color will stay fresh for days. If paint does dry out, it can be removed by spraying with water and scraping. Any paint that is hard to remove can be dissolved with alcohol.

This palette is specifically designed for color mixing and watermedia. You will find that it is a great tool.

ROWNEY STAY WET PALETTE

This is a very workable palette that is specifically intended for acrylic. Designed to keep acrylic color moist for a day or more, the palette has a vacuum-formed plastic foundation with a two-part disposable paper system for retaining moisture. The bottom sheet acts as a water reservoir. When wet, it will provide moisture for the paper on which you paint. With the clear plastic lid on, color will remain moist for days.

The Quiller Palette.

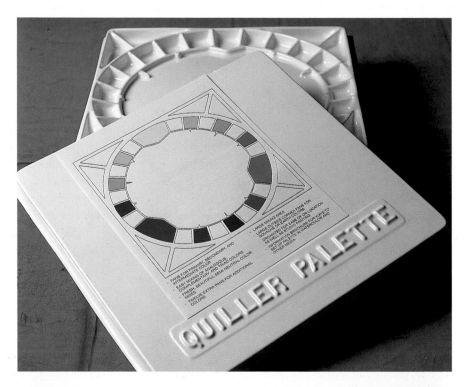

The Rowney Stay Wet Palette.

24

Acrylic Questions and Answers

The following is a series of questions I am commonly asked pertaining to the acrylic media. Many of these answers come from literature and research developed by Golden Artist Colors, Inc., in New York, and by Lascaux, in Switzerland. Golden puts out a flyer titled "Just Paint" that discusses the history of acrylic as well as technical information on the many related media and varnishes.

Question: Are different brands of acrylic paints compatible if used together?
Answer: There has not been a lot of testing done using different brands together, and the acrylic painting medium is very young. One would have to observe paintings for hundreds of years to know the answer for certain. However, after discussing this issue with chemists from acrylic paint manufacturers, the consensus is that, yes, the brands can be mixed. Basically, paint formulas are much the same from brand to brand. The polymer emulsion and the pigments are the same, although the additives may differ. In addition to these ingredients, the paints have surfactants that disperse pigments in water, defoaming agents, wetting agents for pigment flow, and even preservatives to prevent bacteria.

Question: Are acrylics a permanent painting medium?
Answer: Again, for this relatively new painting medium, complete testing over time has not been done. But the thinking among most chemists and conservators is that acrylic is by far the most permanent medium available. The acrylic binder remains flexible and clear with age, unlike the linseed oil used with oils. Our society is concerned about our plastics not decomposing in our landfills; it makes sense to assume that the plastic media will hold up.

Recently, acrylic paint received some bad press in articles stating that some museum-owned acrylic paintings were not holding up. It is true that a few early acrylic paintings were painted on top of faulty gessos with too much pigment and not enough binder, and the paint did not properly adhere. (On further review, it proved that one of the artists in question, the color-field painter Mark Rothko, was actually using oil and not acrylic.) With proper care and the right materials, varnishes, and supports, acrylic should hold up very well over time.

Question: I have been an oil painter and have had trouble working with acrylic. It just does not work like oil. There are many qualities of acrylic that I like, but I am struggling. What can I do?

Answer: It can be misleading to compare acrylic to oil. Each has its own properties and characteristics. Acrylic is unique and versatile. Consider these points: In oils, molecules of linseed oil are very small and will carry a heavy concentration of pigment. Acrylic molecules are much larger, are suspended in water, and thus carry much less pigment. For this reason, oil is more highly opaque than acrylic.

Oil paint dries much more slowly than acrylic and thus the workability of the paint is quite different. Acrylic may not be for everyone but it is used by more artists than any other painting medium today. I can only advise that you persist with acrylics until you can fully discover and take advantage of its special properties.

Question: Do acrylics dry darker than when first applied?
Answer: Acrylics will appear to dry darker than when first brushed on the support. However, the pigment does not darken at all. What accounts for the change is the polymer emulsion binder. While the paint is wet, this binder is milky and translucent. The pigment is suspended in this substance and thus looks lighter. When the paint dries, the emulsion turns clear, allowing the pigment to be seen with a deeper richness and clarity.

Question: How can I control the drying time of acrylic? It dries too quickly for me.
Answer: Drying time is related to the evaporation rate of water, which is affected by temperature, humidity, and the rate of the air current on the surface. Acrylic retarder medium may be added to the paint to slow the drying time somewhat. Atomizers may be used in wet-on-wet areas to keep the paint moist. If you are working in a thin, wet-on-wet watercolor approach, work in stages. Wet and work the surface until the paper is close to dry. Stop and let it dry completely, and then rewet. Because the undercolor will not lift once dry, limitless wet, transparent overpainting can be done without having a scrubbed, muddy look.

Question: When I am on-location getting informational sketches and color notes, is acrylic a good medium to use?
Answer: I do a lot of on-location paintings with acrylic, and most of these are finished paintings. I work on paper in a watermedia approach or on canvas or panel in an easel painting manner. For the latter I usually use standard-body acrylics.

When I am out doing information sketches and color notes, I use a 6B water-soluble pencil and some transparent watercolors. I work first on a value sketch and then I wash

some color notes over it. Many times, besides the sketch, I make notes that are particularly important to the inspiration of the subject. Notes may concern the features of light, composition, or color relationships and mood. I can carry a small palette, sketchbook, and pencils in a day pack and go almost anywhere.

Question: Is it safe to use my regular watercolor brushes when using acrylic?
Answer: When working in any watermedia, I use the same set of brushes—watercolor, acrylic, gouache, casein. However, I use *synthetic* brushes that are much less expensive than

sable, and I clean them with liquid soap and warm water after use. I feel that these brushes perform just as well as the expensive sables and will last for many years. I would advise against using an expensive sable brush with acrylic simply because the brush, if not cleaned after use, will be ruined.

Question: What are the restrictions to be aware of when working with acrylics?
Answer: The two most restrictive elements to be aware of are, first, that the acrylic medium will not lift once dry— except in the case of the so-called acrylic gouache products.

EARLY SPRING REFLECTIONS.
Acrylic on clay board,
14 × 11" (35.6 × 27.9 cm).
Collection of Willis Piper.

EARLY OCTOBER, SOUTH FORK. Acrylic on Crescent watercolor board #5112, 15 × 29" (38.1 × 73.7 cm). Private collection, courtesy of the Mission Gallery, Taos, New Mexico.

This can be thought of as an advantage in many instances, but if you want to lift, push, and pull the paint around, you will be limited to doing so while it is still wet. Second, as explained above, acrylic dries rapidly, and this further limits the working and reworking of the paint. If you want some leeway to manipulate the paint for a while, then oil should be the medium of choice. Retarder medium can slow the drying time of acrylics, but it will not give the paint the same physical characteristics as oil.

Question: For an art competition, in what category should an acrylic be entered?
Answer: It depends on the way the paint has been used and the type of support that it is painted on. In most national watercolor shows, what may be accepted is simply watermedia on paper. Acrylic, of course, is water-based and can be applied in the same way as watercolor, so if it is on paper and framed as a watermedia work, it probably qualifies.

If the work is done on an "easel painting" support, it will probably be accepted in the oil category. This is becoming universal. Of course, some paintings overlap categories; usually their placement will depend on the support they are painted on and how they are framed.

Question: How do you recommend framing an acrylic painting?
Answer: There are many different ways to frame paintings, but there are two basic approaches.

The first is that of watermedia, where the paint is applied thinly, though it may be opaque. Paper—watercolor paper, rice paper, watercolor board—is usually the support, and I recommend framing in this case with a mat and glass. The mat should simply allow the viewer to see the image; it should not interfere with it. Thus, I use both warm and cool whites, creams, or a light gray, depending on the dominant colors of the work. Many times I will double-mat using the same mat color, adding a subtle accent without interference. I like to see a fairly wide mat around small works. I also add a 1/2" to the bottom width of the mat to "weight" it. An average-size painting works well with a 3" to 4" mat; large works that are 30 × 40" or larger require narrower mats. With this type of artwork, glass, or plexiglas, is important. It should never touch the art, but always be between the frame and the mat.

The second approach is that of paint applied to canvas or a hard panel such as Masonite. I have seen large canvases on which the paint extended around onto the unframed sides. This can work as a finished presentation. Another nontraditional method is to have simple strips of wood on the sides of the canvas.

Representational works, however, usually benefit from traditional framing. I often use a linen and wood liner of an off-white color; one that does not show a seam in the linen at the corners looks especially nice. Again, I like to use wide liners on small works and narrow liners on large works. I select a molding (the framing material, usually wood) that is as deep or deeper than the depth of the liner.

In every instance, the frame should never overpower the image but should simply work well with it.

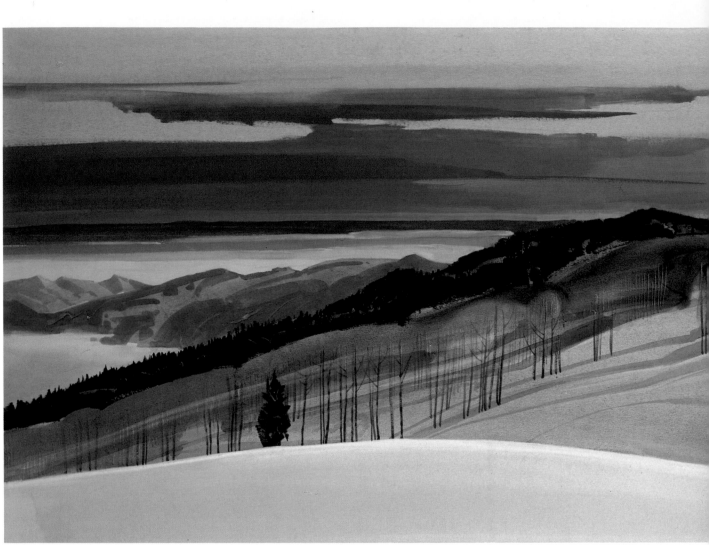

VIEW FROM BACHELOR TOWN SITE, JANUARY 17. Standard-body acrylic and acrylic gouache on Crescent watercolor board #5112, 17 × 38" (43.2 × 96.5 cm). Courtesy of the Quiller Gallery.

2

ACRYLIC COLOR

One of the most exciting qualities of acrylic is its rich, luscious color. Thus, it seems important to me to focus on this element—at least by way of a synopsis, for an entire book would be required to do a thorough study of color. Color mixing, color relationships, and color harmony are the same regardless of the media used. However, there are colors that are manufactured only in acrylic. To find true complements and triadic mixes in acrylic, I have designed a color wheel. I will show you how to use this wheel for some basic color schemes and relationships. Whether you work in a watermedia or easel painting approach, the theory is the same. I focus on three well-known color schemes: the complementary, the analogous, and the triadic. These three schemes will work not only as finished color schemes, but also in mixing any semi-neutral color. Of course, color is a major element in painting. The artist should take the time to understand it. Study the color wheel, a very useful aid, and your color relationships will become harmonious and vibrant.

The Acrylic Quiller Wheel

The color wheel displayed on the opposite page is designed specifically for acrylic painters. It will not make a difference whether the color is a heavy-body, fluid, or paste acrylic. The color slot on the wheel is the same for all acrylic media. The colors used on this chart are manufactured by major acrylic paint companies. Many, but not all, acrylic colors are represented. If the color you are using is not represented on the color wheel, just match the color closest to it on the wheel and proceed from there. In addition to the regular acrylic colors placed on the wheel, there are some colors of light value located farther outside the color wheel. These colors are the same hue as their adjacent colors on the wheel. However, the lighter colors have a tint base added to ensure a rich, though lighter value color. They can be used in the same way as the standard colors on the wheel, mixing with analogous, triadic, or complementary families.

This color wheel is set to give the most accurate color relationships and color mixing. There are many reds and many greens manufactured which are not complementary each one to the other. Some reds are orange-reds or warm reds while others are bluish reds or cool reds; some greens tend to the yellow side, others to the blue side. For the painter, it is most important to know which red and green colors are true complementaries and will "gray out."

The right choice of two colors will combine to produce beautiful semi-neutral colors and will not be muddy. Understanding this color theory and mixing system allows the artist to achieve fresh, clean color. And most important, it liberates the painter to use color in any direction of choice.

1. Lemon yellow
2. Cadmium yellow lemon
 Cadmium yellow primrose
 Hansa yellow light
3. Cadmium yellow light
4. Hansa yellow medium
 Cadmium yellow medium
5. Diarylide yellow
6. Yellow-orange azo
7. Naples yellow hue
8. Yellow oxide
 Yellow ochre
9. Raw sienna
10. Raw umber
11. Cadmium orange
 Cadmium orange light
12. Orange oxide
13. Vivid red-orange
14. Indo orange-red
 Cadmium orange medium
 Cadmium scarlet
15. Quinacridone gold
16. Brown oxide light
17. Burnt umber
18. Burnt sienna
19. Vat orange
20. Cadmium orange deep

21. Quinacridone burnt orange
22. Cadmium red light
23. Red oxide
24. Cadmium red medium
25. Light magenta
26. Cadmium red deep
27. Cadmium red Bordeaux
28. Naphthol crimson
 Quinacridone red
29. Alizarin crimson hue
 Quinacridone crimson
30. Permanent rose
31. Permanent rose light
32. Quinacridone violet
33. Mars violet
 Violet oxide
34. Deep magenta
35. Medium magenta
36. Prism violet
37. Permanent violet deep
38. Dioxazine purple
39. Brilliant purple
40. Ultramarine violet
41. Ultramarine blue
42. Light blue-violet
43. Cobalt blue
44. Phthalocyanine blue

45. Prussian blue hue
46. Payne's gray
47. Cerulean blue
48. Manganese blue
 Turquoise blue
49. Permanent blue light
 Brilliant blue
50. Turquoise deep
51. Phthalocyanine green
52. Cobalt green
53. Aqua green
 Phthalocyanine green light
54. Permanent green deep
55. Viridian green hue
56. Cadmium green deep
57. Emerald green
58. Permanent green light
 Cadmium green medium
59. Chromium oxide green
60. Hooker's green
 Jenkins green
61. Olive green
62. Cadmium green light
63. Sap green
64. Cadmium green-yellow
65. Brilliant yellow-green
66. Neutral

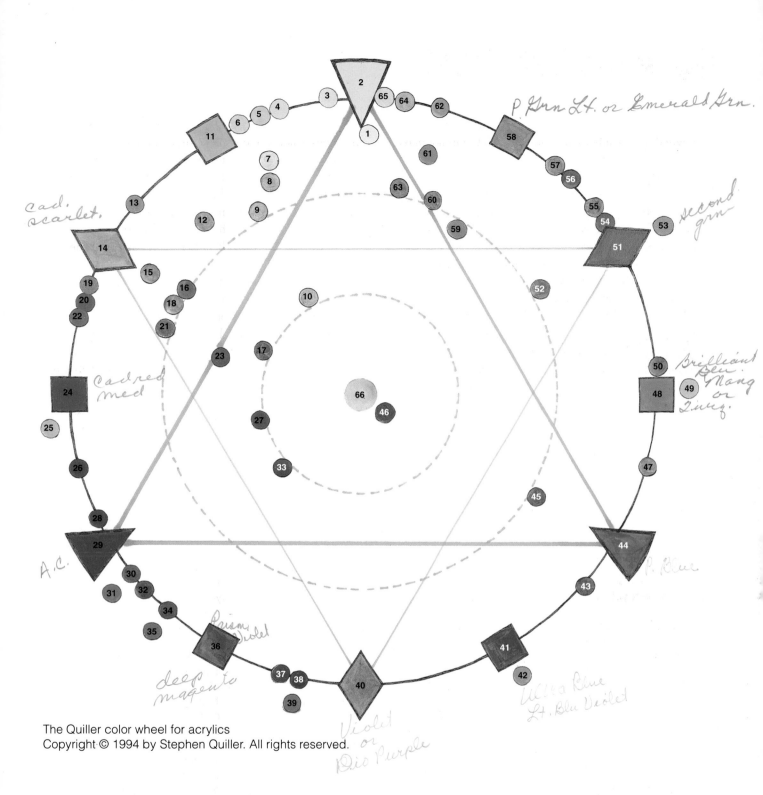

The Quiller color wheel for acrylics

P. Grn Lt. or Emerald Grn.

second grn

cad. scarlet.

Brilliant Blu. Mang or Turq.

Cad red med

A.C.

P. Blue

Prism Violet

deep magenta

Ultra Blue Lt. Blu Violet

Violet or Dio Purple

31

Value-Intensity Relationship

The relationship between value and intensity is the most important factor when it comes to color. If you understand and can put into practice these factors, the craft of painting will come much more easily.

Value is the relative lightness or darkness of a color. Intensity is the relative brightness or dullness of a color. You can develop the abstract structure of a painting and move the viewer's eye through the composition by your handling of the relationship of value and intensity. These two concepts must be considered with every stroke of paint you put down.

The following are some studies showing value, then intensity, and then showing ways that the two can be put together. In each of these studies, I use the complementary colors, located directly across from each other on the color wheel, yellow-orange and blue-violet.

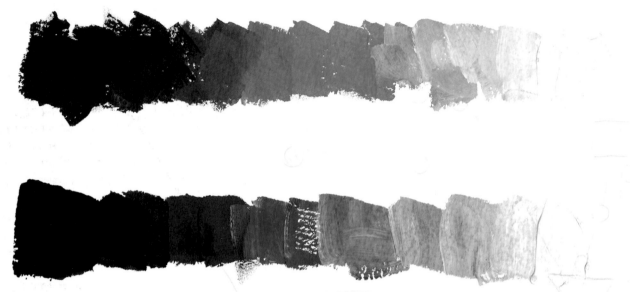

Here I painted with complementary colors—yellow-orange, or cadmium orange light, and blue-violet, or ultramarine blue. White has been added to lighten the pure hue until it is completely white at the right end of each study, and black has been added to darken the pure color until it is completely black at the left. The way the value pattern of the colors is developed throughout the composition is what gives the form and abstract structure to the painting.

Squinting, turning the painting upside-down, or looking at the reverse image in a mirror are ways that will help you see the abstract value pattern and structure. Notice that the pure yellow-orange is located more closely to the white end of the value study, while the blue-violet is located more closely to the black. This means that yellow-orange, in its pure state, is a light value color, while blue-violet is a dark value color.

In this study, neither white nor black have been added. Only the pure hue complements yellow-orange and blue-violet are used. Refer to the color wheel on page 31. Notice that these two colors are located directly opposite each other on the circle. I have progressively added more of the opposite color to the pure hue until a gray, lifeless color develops in the center. If two contrasting colors will mix a true gray, they are complementaries.

A semi-neutral color is located between the pure hue and neutral in the center. It is important to learn to mix fresh semi-neutrals, for 90 percent or more of the color in most paintings is in the semi-neutral range. As color becomes less intense, it becomes easier to look at. Large, quiet passages of paintings, then, can be developed by simply mixing complementary colors.

In addition, by learning to mix the semi-neutral, rather than using it straight from the tube, you have the option of manipulating the color to make it somewhat brighter or duller. In other words, the artist has the choice of creating some variation within the color itself.

Large passages of pure hue will overwhelm the eye. Thus, bright notes of color are normally best used in small areas to add life to a passage and to help lead the eye through the composition.

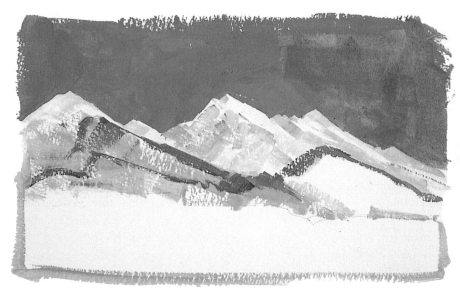

In this study, I worked with concepts of value and intensity together. Squint your eyes and notice that all the values are to the light side of the value study and that no black has been added. Using value in this way will give the study a subtle, soft feeling. Also notice that the yellow-orange and blue-violet color have not been mixed to create semi-neutral color. However, white has been added to the pure hue in varying concentrations to give a pastel quality.

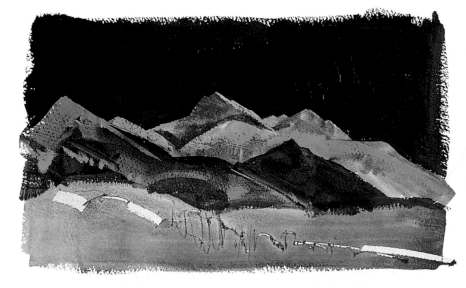

This study is just the opposite of the previous one. All the complementary colors have been dulled, or *neutralized,* to various semi-neutral states. There is no pure hue. Furthermore, black has been added to some of the color to keep the value relationships to the darker end of the value scale.

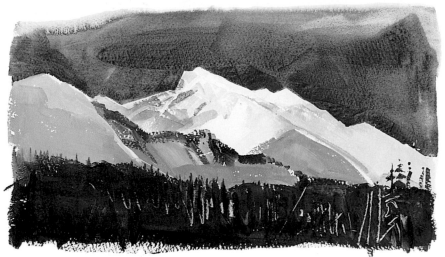

Here I painted with a full range of intensity and value. Observe that there are pure, full-intensity notes of both the yellow-orange and blue-violet, as well as varying degrees of duller semi-neutral colors. Also there are strong contrasting values between the almost-white mountain peak and the low, dark sky. As the eye moves away from the mountains, the value becomes less contrasting, or more *analogous,* and the color becomes duller. Notice that in the foreground ridge and tree passage, there are some warm yellow-orange semi-neutrals playing against the predominant semi-neutral blue-violet area.

33

Complementary Color Relationships

Complementary colors are contrasting colors which, when used together, can be visually very pleasing. Since the 1830s, when Eugène Chevreul first experimented with and wrote about complementary colors, artists (colorists) have been using these pairings in their works. Applications of complementary color include optical balancing, accenting of colors, creating beautiful semi-neutral color mixes, or even providing a strong vibration between colors.

The concept of complementary color is central to color theory and is universally used by painters. Charles Burchfield, a visionary American painter, wrote in his journal on August 15, 1914: "The charm of the season—and the day in particular—is to be found, I think, in the union of the two complementaries blue and orange. An artist finds his happiest combination in a play of complementary colors. They are direct contrasts yet do not jar; they awaken the beholder, but do not disturb him."[1]

As demonstrated in an earlier study, true complementary colors are located opposite each other on the color wheel. To find a color's complement, first locate the color on the color wheel and then follow a straight, imaginary line from this color through the small central gray circle to the opposite side of the circle. The color positioned there is the complement. For instance, on the acrylic color wheel on page 31, cadmium orange light and ultramarine blue; vivid orange-red and cobalt blue, vat orange and phthalocyanine blue; permanent green light and prism violet; and cerulean blue and cadmium red light are some of the many true complementary groups.

What follows is a circular diagram and two studies using the complements blue (cobalt blue) and orange (vivid orange-red). Both studies work with warm and cool color, contrasting and analogous value, and brightness and dullness (high and low intensity).

This diagram illustrates the two complementary colors painted in the following studies, vivid orange-red and cobalt blue. Notice that the resulting mixture of the two complements in the center of the circle is a true gray.

VIVID RED-ORANGE

NEUTRAL

COBALT BLUE

1. *Charles Burchfield's Journals: The Poetry of Place.* Edited by J. Benjamin Townsend (Albany: State University of New York Press, 1992).

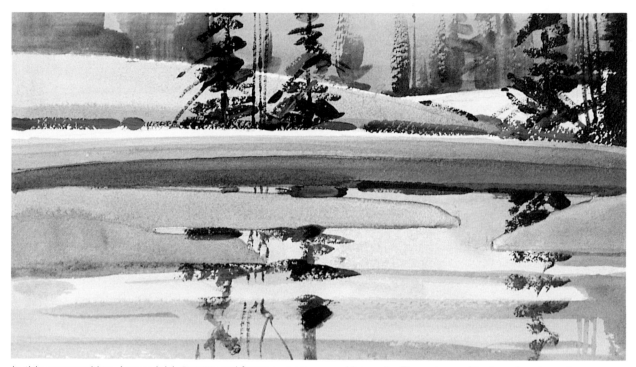

In this composition, I use vivid orange-red for my warm color and cobalt blue for its cool complement. Orange, the dominant hue, is predominantly used as a semi-neutral, with some pure color notes along the tree bank and in the water. Some light, pure blue in the snowbanks is adjacent to the orange water to bring out the glow and intensity. The values of both colors have been organized to create quieter passages in the outlying areas, with more contrasting values along the tree line and upper pocket of water, the focal point. Notice that the overall feeling of this work is one of warmth and quiet serenity.

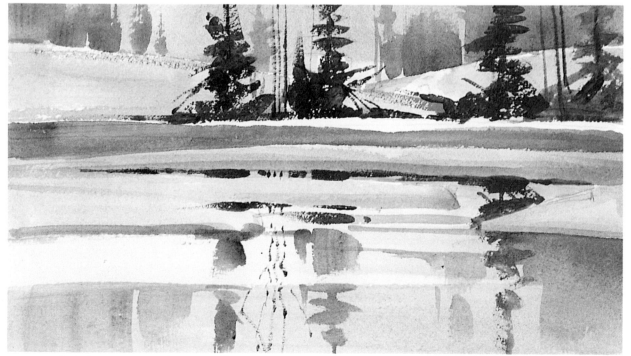

Here cobalt blue is the cool, dominant color, while vivid orange-red is the warm, subordinate complement. Much of the blue was applied as a light semi-neutral, with a few notes of intensity along the central snowbank and among the central trees. I put pure notes of the orange in the upper-left snowbank and central-right pocket of water, while most of the orange is in light semi-neutrals. The value of both colors is used in an analogous, quiet way in the outlying passages and in a more contrasting manner in the central tree line, upper water, reflections, and central snowbanks. This painting gives a cool, quiet, serene feeling.

Analogous Color Relationships

Analogous colors are adjacent to each other on the color wheel, so they are similar and closely related. Analogous color relationships are developed by using three to four primary, secondary, and intermediate colors that are in the same color "family." For instance, refer to the color wheel on page 31 and locate cadmium green-yellow, permanent green light, phthalocyanine green, and turquoise blue. These colors are all located within the adjacent primary, secondary, and intermediate colors of yellow, yellow-green, green, and blue-green. All have some yellow and some blue in them. Thus they are closely connected, harmonious, and in the same family of colors.

The colors on both the outside (light-valued) and the inside (semi-neutral) of the color wheel are analogous to the colors on the wheel. A semi-neutral can be mixed by adding a bit of a complementary to a color (or you can simply use the semi-neutral color straight from the tube.) For instance, an analogous palette could include sap green, Hooker's green, Jenkins green, and chromium oxide green. Look at the diagram showing a different analogous palette from the same family.

Another diagram of analogous colors is followed by two studies that use the same colors. Note that I have intentionally altered the value and intensity in each of the studies to convey different moods. A series of many studies could have been done, each entirely different. The two studies are taken from a sketch I did of a house and marshland along the South Carolina coast.

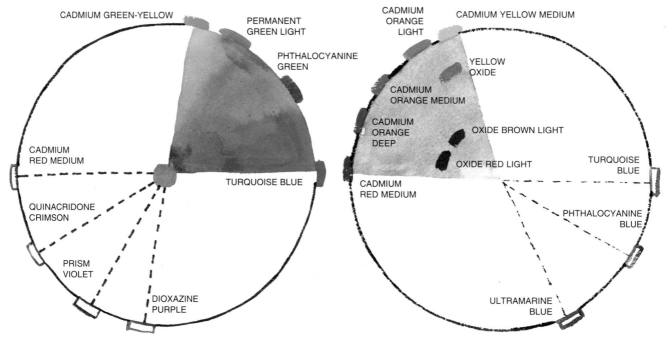

This diagram displays the analogous color relationships of the colors cadmium green-yellow, permanent green light, phthalocyanine green, and turquoise. All are from the same color family because they have both yellow and blue in their makeup. The complements of these colors have been used to mix the semi-neutrals. In a true analogous passage in a painting, the complement can be used to mix the duller hue, but that opposite color will not be in evidence.

This diagram illustrates the analogous colors I used while painting the following studies: cadmium yellow medium, cadmium orange light, cadmium orange medium, cadmium orange deep, cadmium red medium, yellow oxide, oxide brown light, and oxide red light. The complementary colors which neutralize these hues are turquoise blue, phthalocyanine blue, and ultramarine blue.

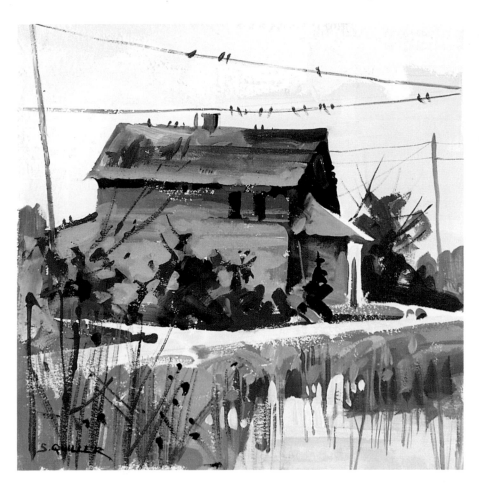

In this study, I used a full range of values. I painted pure colors of yellow and orange, with some white for the sky and part of the porch roof. I painted with analogous, semi-neutral colors for the house and foreground marsh grass. This strategy gives a feeling of a rich, clear glow to the sky and an earthy, natural quality to the structure and land forms.

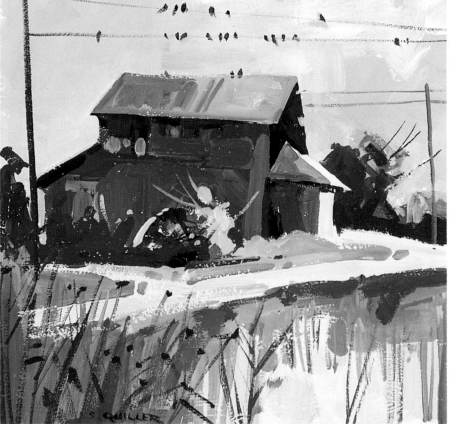

Here the sky is almost a true gray—a neutral mixed from orange and blue. The foreground marsh grass is painted with semi-neutral warm tones and the house in strong, pure hues. Here there is a complete range of values. The sky in this painting has a soft, atmospheric feeling that sets off the bold, dominant, exaggerated color of the house.

Triadic Color Relationships

Triadic color relationships, as the name implies, are color schemes based on three colors and mixtures of them. Any three colors located equidistant from each other on the color wheel will work, and as long you mix semi-neutrals from only two of the three, the results will be fresh and alive.

The most common triadic colors are red, yellow, and blue, but more exciting triadic mixes can be achieved by using the secondary colors green, orange, and violet; the intermediate colors red-violet, yellow-orange, and blue-green; or the colors blue-violet, yellow-green, and red-orange.

Besides these triadic schemes, there are many others that can be used effectively. The key is that all three colors are equidistant from each other on the color wheel. The interesting thing is that every triad will give a different mood and feeling. And by altering the value and intensity within one set of three colors, you can attain many different color qualities. Look at the diagram of the intermediate triad of red-violet, yellow-orange, and blue-green. Following the diagram are two studies using the same three colors and composition but with very different results.

This is an example of an intermediate color triad. The three colors are cadmium orange light (yellow-orange), turquoise (blue-green), and prism violet (red-violet). In each mix, I use only two of the three colors. In this way, the resulting color will be fresh, and you will avoid "mud."

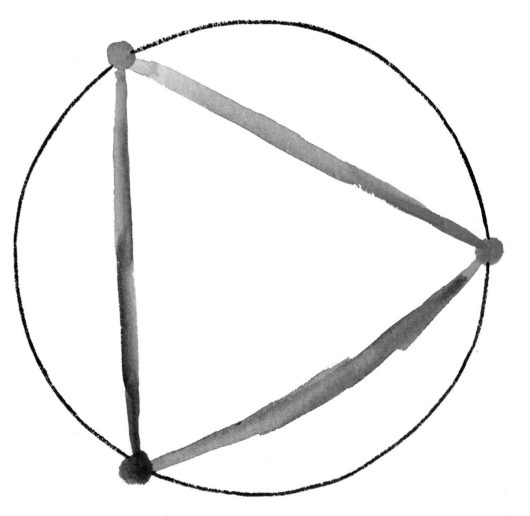

I painted this composition with the same three colors that are in the diagram. There is no pure hue in the painting except for the yellow-orange in the flowers. I used strong contrasting values to set off the daisies and irises and analogous values in the secondary leaf patterns.

I used the same three colors in this study, but with an entirely different result. The irises and two daisies are a light, neutral gray. To get this mix, I added a bit of each of the three colors and a lot of water. The background shapes are developed with a lot of pure hue and, in some cases, with the addition of white. The neutralized red-orange in the foliage patterns is a mix of the yellow-orange and red-violet.

Color Enhancers

As noted in Chapter 1, there are many new and exciting acrylic painting products. Two of these are the iridescent metallic paints and the interference paints. Both may be used separately or in combination with the standard acrylic colors. After focusing on how to work with value, intensity, and analogous, complementary, and triadic palettes, you will benefit from experimenting with these paints. I examine some possibilities for their use below and provide a color wheel showing where the metallic and interference colors are located.

METALLIC COLORS

Metallic acrylic colors can be mixed with other acrylic colors and used in complementary, analogous, or triadic color relationships. When a metallic color is combined with another color, the result will take on its iridescence. When the metallic is mixed with a complement or a triad, the color will neutralize but also still have the metallic shimmer.

All the colors can be used with pure hues or semi-neutral acrylic colors. The bronze and steel are very neutralized to start with and will work very well with a neutralized palette of warm colors (burnt sienna, burnt umber, raw sienna, quinacridone burnt orange, and so on).

Although there are claims that the metallic colors will not oxidize with age, to be safe I put a clear-plastic sealing spray or varnish on paintings that have involved metallics. These paints, like any other visual enhancer, have their place. They are not meant to be used in every painting. Always consider whether the materials you use are an appropriate and an integral part of the painting process—whether they will enhance your expression.

I have found the metallics to be particularly effective on many of my acrylic collages. Experiment with various applications and mixtures of the metallic paints and acrylic colors. (For more information on using metallics, see Chapter 5.)

A printed book cannot duplicate the iridescent metallic pigments without the use of special inks. Nevertheless, in this diagram these pigments have been placed as to their appropriate location on the color wheel. For instance, aluminum can be combined with the violets, blue-violet, blue, blue-green, or green to add to the cool hues. It can also be mixed with a complementary warm color to help neutralize it. Painted full-strength, placed next to its complement, and used in analogous and triadic relationships, a metallic will give you a variety of effects.

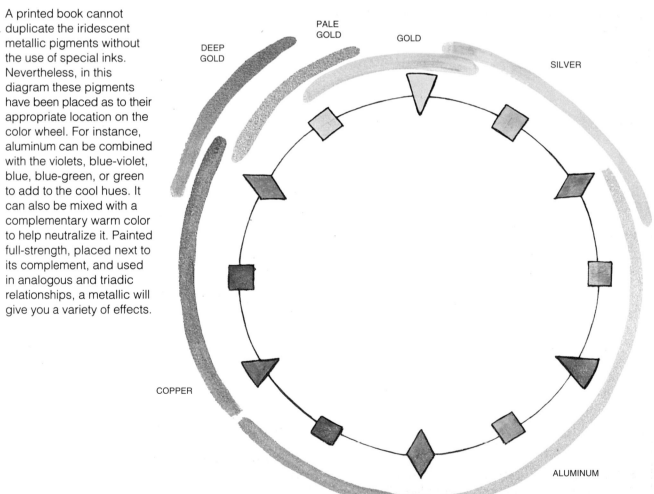

INTERFERENCE COLORS

Interference acrylic paint is simply titanium-coated mica particles combined with the polymer resin base. By itself, the paint has a iridescent, translucent, milky quality that reflects a sheen of the color or its complement, depending on the angle of light on the surface. The color can be combined with acrylic paint, although the iridescent quality is greatly reduced. If the paint is glazed over white paper or clear acrylic gel, the sheen comes to life. Interference colors can also be glazed over colored acrylic passages The undercolor appears lighter and somewhat cloudy. The reflective quality of the mica, however, is full-strength and adds visual excitement to the passage. Shown here is a diagram of six interference colors and where they are located on the color wheel. (For more information on how to use interference paints, see Chapter 5.)

Color knowledge is an extremely important foundation for any painter's technique. While all the studies in this chapter have focused on accurate uses of the complementary, analogous, and triadic relationships, this color foundation can be used much more liberally. You can combine many color mixtures within one painting, and as you glance through this book, you will see many of my paintings that do use color more freely. Yet close study will reveal that every passage within the painting uses the same foundation for color relationships and for semi-neutral painting mixes. For a much more complete development of how to work with color, you can refer to my book *Color Choices*, published by Watson-Guptill in 1989. This book has been widely used as a college text and for reference by color-theory instructors.

This is a diagram of six interference colors and their appropriate location on the color wheel. At times the sheen of the color registers as its complement.

EXERCISES

EXERCISE 1: Select any two complementary colors and a simple composition. This can be abstract or figurative, a still life, a landscape, and so on, but keep the shapes very simple. Do a series of six studies using the same motif. On three of the exercises, have one color dominant and the second color subordinate. Then on the final three studies, exchange the dominant and subordinate. On each painting, vary the value and intensity of the colors. For instance, the first one may show a full range of value and intensity of both colors. The second may show analogous darker values and semi-neutral intensities of all colors. The third may show a full range of values of all colors, with the intensity of all color in the semi-neutral range. Keep focusing on analogous and contrasting values and intensities of the dominant and subordinate colors.

EXERCISE 2: Select a simple study and try to evoke a mood through the use of analogous color relationships. Choose three adjacent colors on the color wheel, plus their complements and white. The complements will be used only to neutralize the color and will not be apparent in the painting. Use water or white to lighten the color, depending on whether you are working transparently or opaquely, and focus on the value and intensity of each color to develop the desired mood.

EXERCISE 3: Choose any three equidistant colors on the color wheel and place each on a large glass palette at points on an imaginary triangle. Choose a simple subject and paint it twice. On the first one, use all three colors at nearly pure hue with very little mixing. There can be some semi-neutral color and a full range of values. On the second study, work totally in the semi-neutrals with no pure hue. Remember to mix only two colors to get each semi-neutral. Work with a full range of values. Notice how completely different each exercise is, even though the colors used are the same.

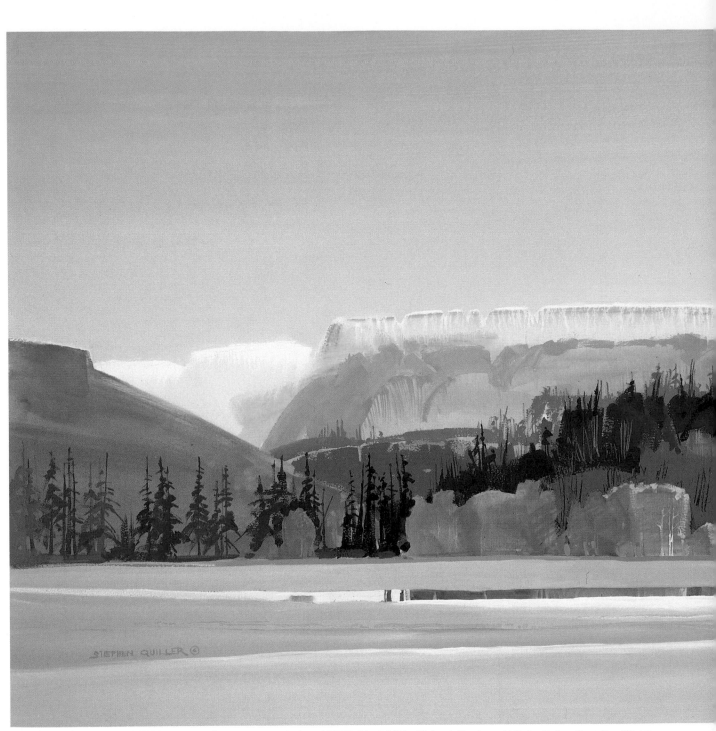

RIO GRANDE RIVER BASIN PATTERNS. Acrylic on Crescent watercolor board #5112, 24 × 34" (61 × 86.4 cm). Courtesy of Mission Gallery, Taos, New Mexico.

3
—
WATERMEDIA TECHNIQUES

"Watermedia" is a fairly recent term. In the history of watercolor painting until around 1970, there was a general expectation of what a watercolor should be. Viewing a major watercolor show at that time, one could expect to see transparently painted works that were mostly representational. Then, in the late 1960s, a number of artists like myself began to experiment with various combinations of water-mixed paints—watercolor, gouache, casein, and acrylic. We discovered new applications for what is now called watermedia. There has since been a creative explosion. Today, in most national watercolor exhibits, the definition of what may be accepted for show is simply "watermedia on paper," and one can expect to see all kinds of painting directions, from representational to abstract and totally transparent to totally opaque. Artists may choose the technical approach and medium or combination of media that will serve their conception best. The exciting thing about acrylic is that it can do almost everything the other watermedia can do.

Creating Texture in Acrylic

Before describing the many exciting ways to use watermedia techniques with acrylics, I shall demonstrate twelve textural applications of acrylic. There are many possibilities for texture, and each painting will call for a certain textural approach. It could need a soft, delicate spatter or a harsh scarring and scraping. If the painter has a good sense for the feeling that is to be conveyed in the painting, it will be easy to select the right texture to work with it. Within each of the following studies, there are many options on how to work with and utilize the texture shown. With experimentation, you will discover some of the initiatives you can take in using acrylics.

I apply wet blue-green and violet, and while the paper is very wet, I freely use the tip of a knife to incise and scar the paper surface. The wet paint seeps into the cut area to create the dark, linear effect, seen here in the right-center area. When there is a dull sheen on the paint surface, I lay a pocket knife on it as if I were buttering bread and then pull it across the surface, lifting the paint and exposing a clean, light mark.

I mist the surface with an atomizer bottle and draw a single-edge razor blade loaded with paint across the paper. Much of the paint stays on the incised cut, but some paint floats on the wet surface to give a soft, blurry edge. On the lower area, I apply paint to a white, dry surface to give a crisp, sharp look.

I brush orange and violet pigment on fairly heavily while the paper is wet. As most of the paint settles, some of it erodes and floats on the wet surface. I apply blue-green paint transparently and, when it is halfway dry, I add a heavy body of paint to the heel of the brush and press it to the surface. This gives a soft impression of the heel.

The surface is dry, and I spatter transparent yellow-green paint with a single stroke of a flat brush on the upper diagonal half. I wet the lower diagonal with transparent blue-green and immediately spatter it with heavier paint. The paint bleeds into the wet paper, leaving a blurred impression. I do both applications by facing the brush down and striking it sharply on an index finger of the opposite hand. This causes the paint to land at an angle and slide a bit on the surface.

I cover the entire paper with dark, transparent blue-green and let it dry. I put in dark, opaque red-violet spatters. Then I add middle-value red-orange, lighter-value red-orange, and light-value pink opaque spatters, allowing each step to dry completely.

I wash the paper with transparent green and blue-green tones, covering it and then letting it get semi-dry. I spatter clear water on it with a toothbrush. While it is still damp, I charge a flat watermedia brush with clear water into the paint to form the branch shapes. The clear water from both applications gently pushes away the semi-dry color, leaving a feathery textural quality.

I cover the entire surface with a dark, transparent red-violet and blue-violet wash. When the paint is almost but not quite dry, I splash clear water on the surface. This keeps the paint wet only where the fresh water has landed. When the rest of the surface is dry, I use clear water to wash the surface, leaving the pattern of the splashed water.

I cover the surface with a warm, transparent yellow tone and, while it's still wet, I hold a torn-paper shape close to the upper right corner and spatter fairly heavy orange and violet acrylic paint with a toothbrush, which produces a soft, blurry quality. When the surface is completely dry, I use the same shape at the lower corner and splatter the same colors, giving a sharp, crisp quality.

I wash transparent orange, burnt orange, and violet on the upper part of the paper. While it is semi-damp, I crinkle and roll plastic wrap over the paint, picking up some and leaving this texture. I then roll the plastic wrap in the paint on the palette, and apply it to the white dry paper below, leaving the positive paint texture.

I spatter and brush a high-quality latex resist on a smooth, dry sheet of watercolor paper. When the maskoid is completely dry, I apply transparent color over the entire surface. After the color is dry, I rub off the latex, leaving the white paper. Acrylic is the perfect medium for this approach because it will not lift or smear when it has dried.

I wash transparent color over the paper surface in orange, red-orange, and violet. While it is still partially wet, I touch a brush dipped in rubbing alcohol to the painted surface. Each drop of alcohol pushes away the color in a circular pattern, giving an unusual visual quality.

I cover the paper with blue-violet, blue-green, and green transparent washes and immediately sprinkle the surface with table salt. As the color dries, some of the water and stained color is absorbed by the salt. When it is completely dry, I wipe off the salt, leaving this interesting textural quality.

Transparent Techniques

Acrylic is a beautiful medium when used transparently. The paint can be used in a manner so closely resembling watercolor that it is visually impossible to tell which of the two media has been used.

Certainly, if transparent acrylic is your choice, it should be used to the best advantage. What, then, are the advantages, the visual qualities, and the handling characteristics of transparent acrylic?

Transparent paint applications are done in a way that the paint is applied thinly. A veil of paint is applied to white paper. The paper can always be seen through the paint and so it affects how we see the paint. Light penetrates through the thin layer of paint to the paper and reflects back to the eye. Because of the way the light is seen bouncing off the stained paper, the color has a special radiance. Whites are achieved by "saving" the white of the paper; white paint is not used.

Acrylic transparent washes can be applied over dry ones without concern for disturbing the underlayer. Glaze over glaze can be applied, creating a splendid depth of transparency. As long as each layer is allowed to dry, the color will not lift (I use a hair dryer to speed the drying process between each glaze), and it will retain a fresh, lively quality. An overwash can also be applied to unify a composition through the repetition of a common color.

Acrylic also offers the most intense color of any of the watermedia. It is an extremely vivid paint. Thus it makes sense to use acrylic for compositions which require strong color, such as richly patterned florals, still lifes, and abstracts. When acrylic color is applied transparently, the passage will dry with close to the same intensity and value it had when wet.

The watercolorist should have a fairly easy transition to transparent acrylic, because the wet-on-wet, control wash, and dry-brush applications in acrylic are handled as they are in watercolor. However, he or she is advised to expect some differences. Acrylic has a plastic feel on the brush, and the paint should be completely mixed to avoid streaking. It does take some time to get used to this particular sensation in the mixing of color.

In the studio, I like to use a glass palette, as illustrated on page 24. Fresh color is arranged according to its position on the color wheel. A spray bottle is used to mist the colors occasionally. I constantly clean my central mixing area with the atomizer spray bottle, a single-edge razor blade, and paper towels. This keeps dried plastic particles from getting into a fresh wash. At the end of the painting session, I wet the palette and scrape the unused paint from the glass. Once the paint dries, it cannot be used again.

Shown here is a five-step study demonstrating some of the potential of transparent acrylic. Following this is another example and two of my completed paintings showing different approaches to this transparent medium.

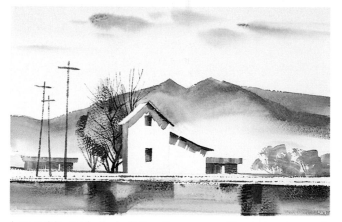

I start this study by building the composition in transparent value with blue, blue-violet, violet, and some neutralized cool colors. I apply paint with a razor blade, creating the sharp, linear horizontals in the foreground. I then use a flat brush to soften the forms in the bottom passage. I save the whites of the paper, just as in a watercolor. When the paper is dry, I rewet the upper passage and add the wispy clouds.

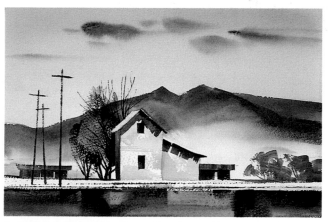

I apply washes of Naples yellow hue with a touch of Indo orange-red over most passages of the value study, leaving some areas of sparkling white paper. The yellow-orange wash tends to neutralize the blue-violet underlayer, making the cool tones not quite so intense.

I apply stronger Indo orange-red washes over the Naples yellow and the cool undercolor. I then use the orange pure hue in the strip along the foreground, and I apply touches of cadmium red on the roof form. Again, this wash does not disturb or lift the insoluble cool undertones.

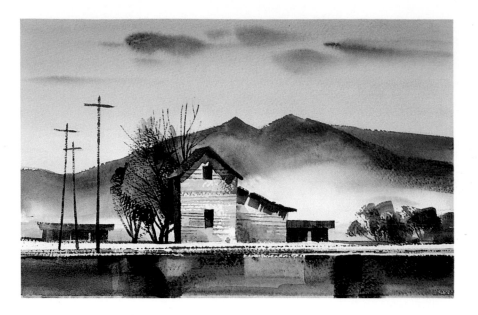

I charge quinacridone violet glazes into the hills and some of the foreground and add a touch of this color to the sky. I put in the telephone lines and birds to help break the sky shape in a more interesting way.

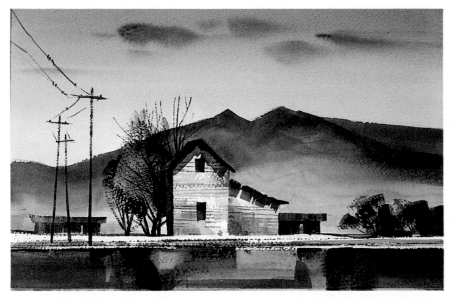

A neutralized blue glaze softens the red-violet tone in the mountain area. This wash creates a more blue-violet tone, complementing the yellow-orange of the sky and building. I develop the finished piece by constructing the composition first in cool colors and dark and light values, and then adding the series of colored washes.

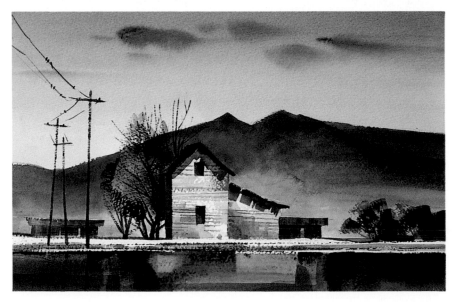

These four stages of a study, along with the finished paintings on pages 50–51, demonstrate the beauty in transparent acrylic color.

Each stage below gradually develops the value, intensity, and rhythm of the image. The colors used are cadmium yellow lemon, yellow-orange azo, Naples yellow hue, Indo orange-red, cadmium red medium, quinacridone violet, dioxazine purple, ultramarine blue, phthalocyanine blue, and brilliant blue. Note the consistent use of glazing here to "build" the image and to use the white of the paper—primary techniques of the watercolorist.

I create abstract rock forms and water patterns in a loose, expressionistic way using intense color. I apply the paint, allowing the white paper to reflect the brilliant hues. At this stage, I leave much of the white paper untouched.

Continuing to glaze and overlay warm and cool colors, I sometimes create rock shapes by painting negatively around them. I use strong color and more contrasting value as I develop the abstract pattern. The composition now focuses on the rhythm of large and small curvilinear rock forms.

I now mix phthalocyanine blue with a touch of ultramarine blue and begin to glaze in, over, and around the various shapes. This blue tone represents water and is applied over some of the rocks to give the appearance that they are below the surface. This gives a feeling of abstract water patterns mingling against the rocks.

I add another glaze of phthalo blue and ultramarine blue to deepen the value, letting the first glaze show in some areas. This develops more value contrast with some of the rock forms and sets off the color. A very dark blue-violet glaze, applied to the upper horizontal band and around the bush form and the rock that appears in shadow, echoes the rock form below.

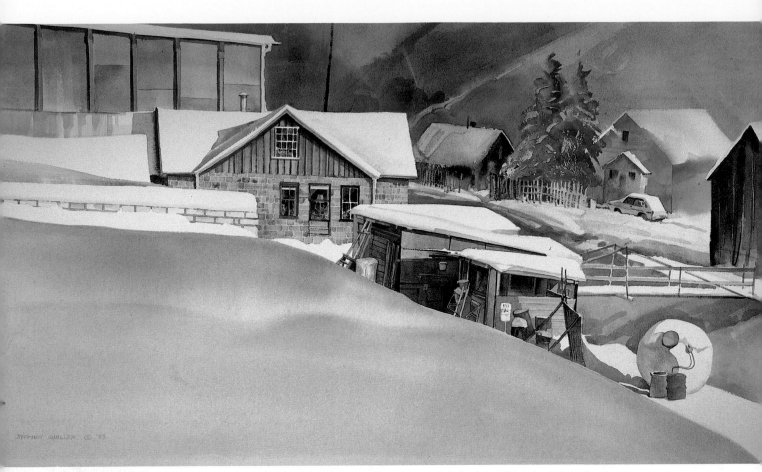

VIEW FROM MY STUDIO. Acrylic on Lanaquarelle 300-lb. rough, 19³/₄ × 36" (50.2 × 91.4 cm). Collection of Richard and Cathy Ormsby.

In this view from my studio window, the patterns of white—the fresh snow and light—impressed me deeply, and I observed closely the rhythm of white shapes in the arrangement. From right to left there are two paths of white. One starts with the alley and propane tank, while the other starts at the shed on the far right and moves over the bridge. The shapes then move to the snow patterns on the roof of the lower, central sheds, up to the snow on the roof of the house, and out at the left of the rectangular roof shapes.

Because of these whites, the subject needed to be done transparently. I built glazes slowly in the upper background, gradually developing the value and neutralizing the color. The large blue snow field in the foreground has at least three washes that have gradually deepened in value. By letting each layer dry completely, I kept the color clean

and fresh. The painting itself uses more neutralized color than many of my works, and almost anyone examining the actual painting would be surprised to find that it was painted in acrylic rather than watercolor.

I thought a long while before finally deciding to put in the yellow car. I noticed that the yellow was repeated in a plastic tarp covering a table saw, the cream-colored bricks at the left, and the dull lamplight seen within the house. The color moves throughout the composition. As I developed this work, one of the most important things, even to the addition of the pole at the top of the painting, was the abstract arrangement of the space. Although the formal elements of design and the choice of medium were critical to the success of the painting, the most important thing to me is that the expression came very close to what I wanted to say.

MOUNTAINS BY BUFFALO CREEK. Acrylic on Lanaquarelle 300-lb. rough, 13⅛ × 15¼" (34 × 38.7 cm). Collection of Robert and Dixie Slater.

To many people, the winter means frigid temperatures and isolation. However, there are many times during the winter that a late afternoon light on the mountains gives me a feeling of warmth.

This painting was first conceived looking at the Collegiate Range, in the central Colorado Rockies. The late afternoon backlighted the mountains with a hazy glow under a golden sky. While the majority of the rocky forms were in blue-violet shadows, touches of gold hit edges of the mountains. The foreground and lower hills, dotted with pinyon trees, had a raking light, and pockets of orange light danced among the trees in a rhythmic pattern.

Transparent acrylic gave me the richness of color to capture the golden glow and the deep blue-violet tones and values. It also gave me the opportunity to glaze and build the mountains, gradually breaking down and building up the series of diagonal, triangular forms, while leaving the most distant mountains in the softest blue, conveying a feeling of depth. The color remained fresh and crisp, which was most important in getting to the essence of the statement.

Transparent, Translucent, and Opaque Qualities

The versatility of acrylic is evident when one explores all its visual qualities in one painting. When working this way, the possibilities for paint applications are limitless. Learning such versatile approaches increases the artist's vocabulary and adds another dimension of expression. And that is what painting is ultimately about: to discover the best way in paint to most closely express what you want to say.

Of course, opaque is the opposite of transparent The paint is applied more densely, in a manner that does not let light penetrate to the support. Light is reflected directly off the paint to the eye. This gives a solid quality to the color. Depending on the paint used, the visual effect can look glossy or matte. White paint is used to lighten color and the white of the paper is hidden.

Translucency falls somewhere between transparency and opacity. The paint is applied a bit more heavily than a watery, transparent veil and, most of the time, has some white paint added to it. Although the paper or undercolor can be seen through the paint film, it has a cloudy, milky quality. When you work with all these visual qualities in one composition, translucent paint applications are a good way to create transitions between the transparent and opaque.

There are many ways to use the three applications in one painting. The following are some general principles I have observed over the years, which, of course, have exceptions. First, the applications should be visualized ahead of time as an integral part of the painting process. More times than I can count, I have seen paintings where opaques have been used to change areas that developed unsuccessfully as a result of poor planning. The resulting image usually has a blotchy appearance. Second, try not to use the opaque paint like a postage stamp, stuck on in an isolated area. Create transitions and repetitions to make opaque areas effective. Third, it is easier to make a painting work if the majority of the painting leans toward the translucent and opaque, using these applications to set off the transparent. The translucent and opaque applications add substance to a painting, giving a full range of visual qualities.

I have found that these visual qualities can help capture the atmosphere, light, and substance found in landscapes. For instance, sky and water have a transparent look. Land is solid, and thus opaque. Fog and various atmospheric effects appear translucent. Hazy light on distant hills can be achieved by glazing translucent veils over opaque passages. These are just a few ideas to try.

The following is a demonstration of the interaction and distinct differences among the three visual qualities. The color in each passage is keyed in some way to the color in the next step. Notice the difference in visual qualities, and how they can be woven together. Then examine my finished titled paintings demonstrating the various uses of these visual qualities.

Notice the vibrancy of the color, which I apply to a Lanaquarelle watercolor paper, whose brilliant white surface will show the color to its advantage. I paint with yellow-orange, orange, and red-orange analogous colors for this first step, applying the color spontaneously and saving some of the white paper.

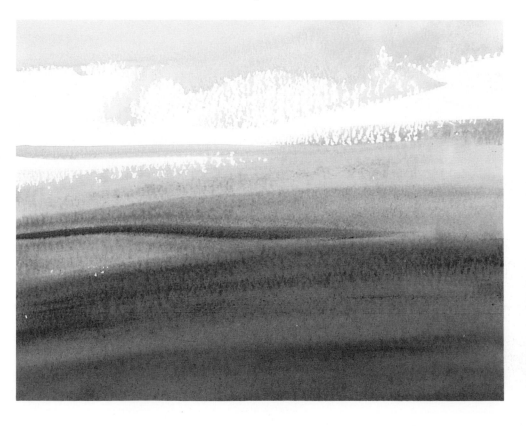

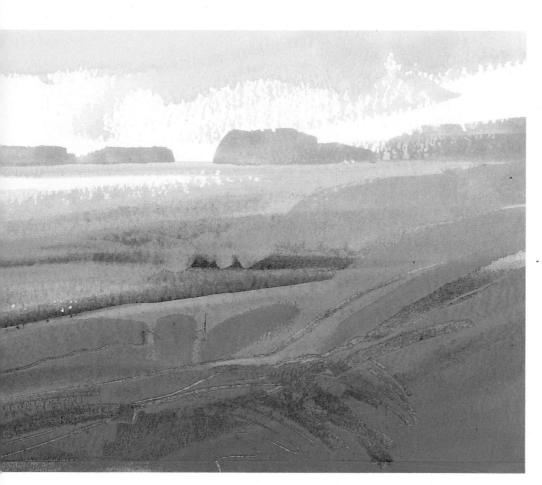

In the yellow-orange passage I add its complement, blue-violet mixed with white, to give a milky, translucent look. This paint application lets the eye see a very diffused underlayer of color. I paint over and around much of the yellow-orange color, and as I move further down the composition I add more white and change the color to blue-green, complementing the red-orange undercolor. When the lower passage is half dry, I scrape with a pocket knife to expose the transparent red-orange.

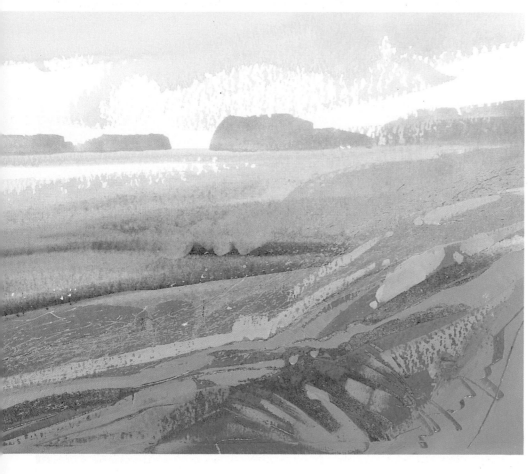

Beginning with the center band to the foreground, I begin putting in some opaques. First, I spatter with yellow-greens and then build with the opaques, which completely cover the undertones. In some instances, I paint around the scrapes that expose the transparent color to give the contrast of visual quality. I use three analogous colors, yellow-green, green, and blue-green, to contrast with and complement the red-orange.

It was most important to select acrylic for the painting medium because the vivid color conveys the excitement of early spring. Ninety percent this composition is done transparently. The whites of the island and the snow of the upper landforms are the untouched watercolor paper. The water and reflections and many of the trees are painted transparently.

In the upper area, after putting in the transparent yellow-oranges, greens, and violets of the mountains, I have come back with translucents and opaques and painted negatively around the shapes to set off the transparent color and create strong abstract tree-like forms. This is a good example of combining transparent and opaque visual qualities to set off color.

I built transparent acrylic glazes from lighter to darker color in the water reflection and lower passages. I also applied the paint to suggest rock forms visible in the water.

It was important to develop the idea in this format to emphasize the feeling of patterns, rhythm, and movement of the mountain forms, island, and water. The vertical shape is very much present in the Colorado high country.

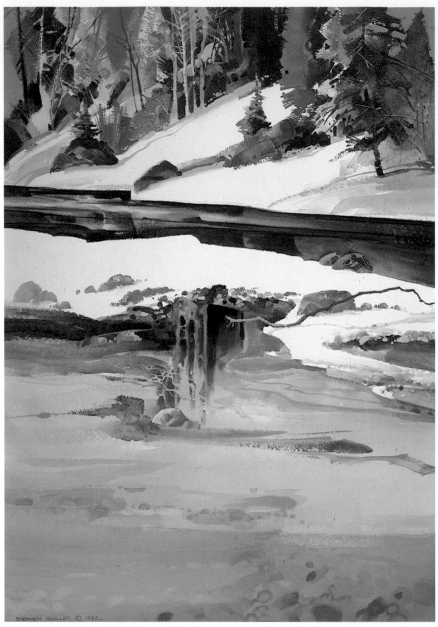

RIO GRANDE PATTERNS, MID-APRIL. Acrylic on Lanaquarelle 300-lb. rough, 36 × 24" (91.4 × 61 cm). Collection of Jeff and Mary Hervey.

In this detail of the upper-right corner of *Rio Grande Patterns, Mid-April*, note how transparent color can be set off by translucent and opaque acrylic. I applied the paint in an expressionistic manner, sometimes scraping and scarring the paper, to form the tree patterns. Also notice the intense, striking color.

54

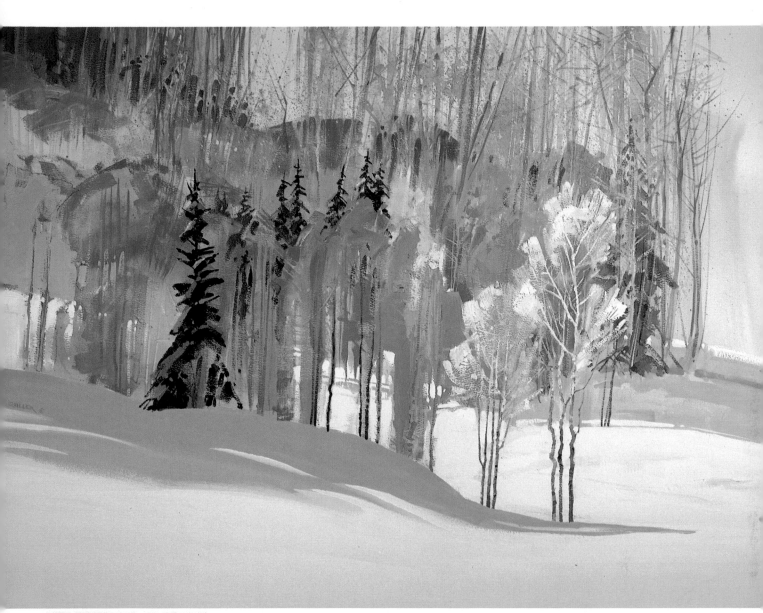

ASPEN PATTERNS IN YELLOW AND VIOLET. Acrylic on Crescent watercolor board #5112 rough, 24 × 36" (61 × 91.4 cm). Collection of San Juan College, Farmington, New Mexico.

The inspiration for this painting came while on a cross-country ski tour. I was on a trail that wrapped around the edge of a mountain. The strong directional light of late afternoon gave a dramatic effect as the strips of brilliant yellow-white snow and shadows wove with the vertical tree patterns. It created beautiful rhythms amid the aspen patterns moving down the hillside. I paused and did a few pencil sketches and jotted some notes concerning color and how I visualized a painting.

The work was done in the studio, and I decided to use a fairly limited palette, mainly yellows and violets, with some blue-violets, oranges, and touches of green. I wanted to capture the light of this time of year. I started by washing the whole surface with transparent yellow and some neutralized violet tones. This can still be seen in the upper sky area and in some of the trees. Once it was dry, I started spattering and brushing on trunk and branch textures, transparently and in a spontaneous way, on the upper part of

the painting. I then began to build some of the background mountain forms, as seen through the trees, using translucent and opaque darker violets and greens. I worked with the board upright and let the color melt and slide on the surface.

Eventually, I started to build the tree forms, working first with translucent and opaque darker passages and building to the lighter ones. I worked fairly abstractly with the large, general shapes. I painted the central area of violet and orange and then the pockets of yellow-white snow; the latter I did negatively, to let the darker passage suggest tree forms. I concentrated on rhythm and pattern in this section. Moving to the right, I put in the positive, most intense yellow and the yellow-orange aspen trees. Finally, I put in the foreground light, the snow shadows, and some suggestion of spruce arranged around the picture plane.

This is a good example of working with acrylic paint transparently, translucently, and opaquely in one composition with strong color and a fairly limited palette.

This painting is an example of how flexible and versatile acrylic can be and why it is such a good medium for manipulating a painting. The initial sketch had been done in early June while I was traveling on a high valley road by the Sangre de Cristo Mountains. The yellow-green foliage of the aspen was just emerging.

I did not attempt the composition that summer, but in late fall I drove by the same area after a fresh snow and in almost horizontal light. I made a mental note of the lighting effect and color. At a painting workshop later on, I pulled out the old sketch and did a demonstration painting using the late-autumn tones. I enjoyed painting the rhythmic tree forms and the passages in the lower part of the painting.

Back in my studio, I pulled out the demonstration. I referred to it as I started to work on a large painting. As this piece developed, especially in the sky and distant, dramatic mountains, it seemed to me that the elements in the composition were competing. The mountain forms distracted from my main focus, the lower horizontal banding of mesas, trees, stream, and snow.

I made a decision to eliminate the mountains. With titanium white acrylic, I covered the mountains until there was just a solid-white painterly sky shape. When the paint dried, I simply glazed, starting at the top, with a transparent orange-yellow moving into a cooler, lighter, lemon yellow. This glazing approach, with the white brushwork underneath, actually gave a much more brilliant glow than if the wash had been placed on white paper. I let the yellow glaze move down through the distant mesa to neutralize the violet and add depth.

Looking at this finished painting, it is easy to see how much the work has evolved from the original study and how the acrylic medium helped me to get there.

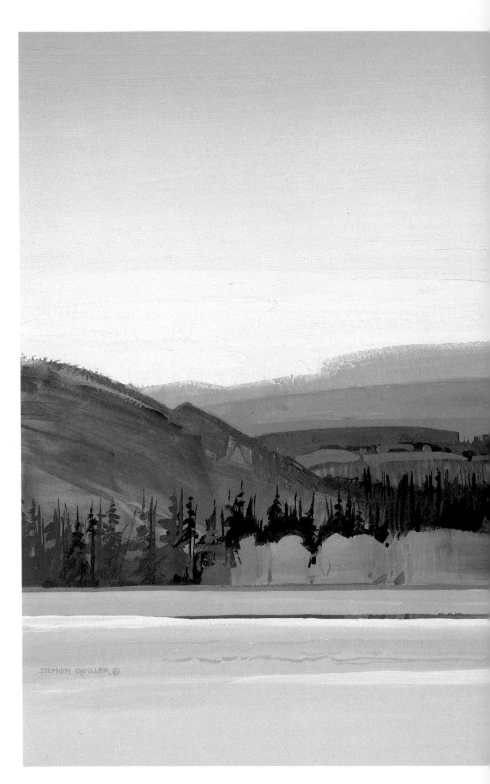

56

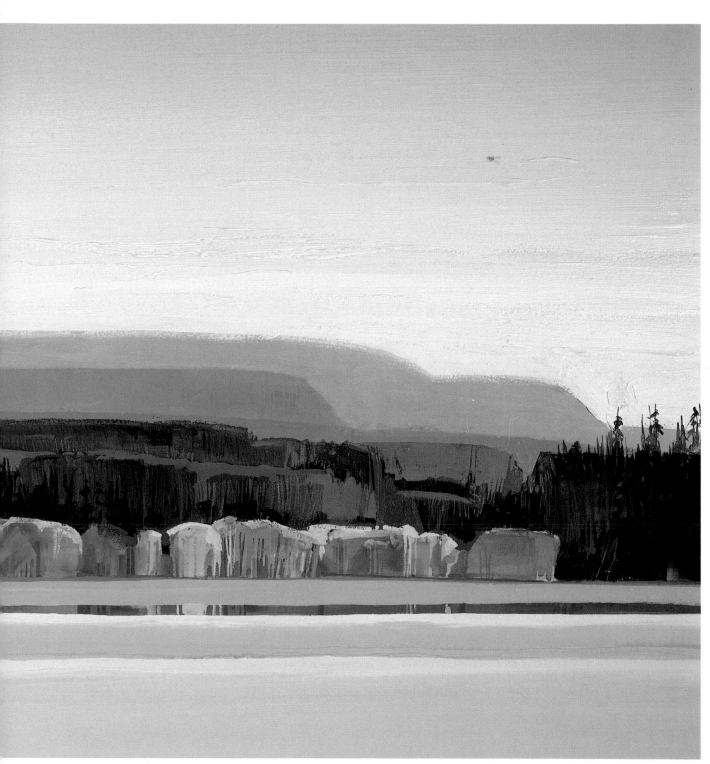

WINTER PATTERNS, RIO GRANDE RIVER BASIN. Acrylic on Crescent watercolor board #5112, 20 × 34" (50.8 × 86.4 cm). Collection of Sam and Coila Maphis.

Establishing a Transparent Underlayer

Another possibility when working with acrylic as watermedia is to select a color or related colors and wash them over the paper transparently before starting the finished painting process. Starting a painting in this way does two things.

First, it can set a mood for the painting. In order for this to happen, it is important that this color be left untouched in some areas and allowed to radiate through in other parts of the finished composition. Again, a common color can help unify a painting.

Second, by first putting on this color tone, you darken the paper in value. Thus, the painter must become more aware of value. The darks can be developed to build form, as is usual in transparent watercolor, but the whites and lighter values must be built with translucents and opaques.

This method is similar to the way many English painters have worked for the last three hundred years. They used a toned paper to establish the mood, and watercolor and body color (gouache), to build both the darker and lighter values.

With transparent acrylic, the undercolor can be easily used with intense or with neutralized color. Since the paint will not lift once it is dry, virtually any color tone can be put down without a fear of disturbing it. A question that I often hear is whether the acrylic wash will seal the paper because of the polymer resin base. The answer is that so long as the medium is used transparently, it does not noticeably affect the paper. Subsequent transparent washes can be applied and the paper will react the same way.

I demonstrate this in the following study and painting.

Although this will eventually be a snow scene, I want to capture the feeling of warm light on a winter afternoon in the high country. I begin by covering the surface with transparent yellows, yellow-oranges, and some orange where I want some emphasis in the composition.

I develop the background ridge by using transparent and, sometimes, translucent cool colors. I apply this color in a way that lets some of the warm undercolor show through. This is done by painting around the undertone, or by scarring, scraping, and lifting the overcolor. I use a rough paper to help me focus on the texture that speaks of mountain forms.

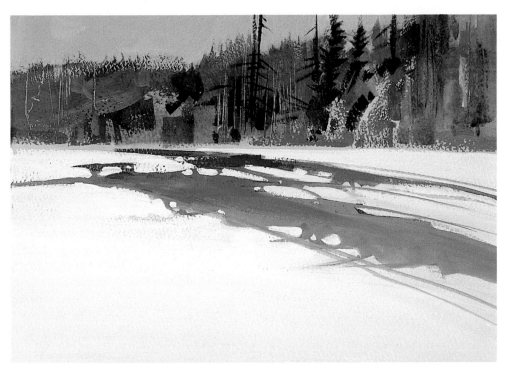

I now start using values lighter than the tone which was first applied, developing the sky and snow patterns. In the sky I paint negatively around the existing mountain forms, using a translucent pale blue that allows the warm undercolor to radiate through. In the foreground passage, I first put in the tree shadow forms in transparent blue-greens to blue-reds, darkening and lightening the value. I then paint around these shapes with the soft translucent and opaque whites to capture the feeling of sunlight.

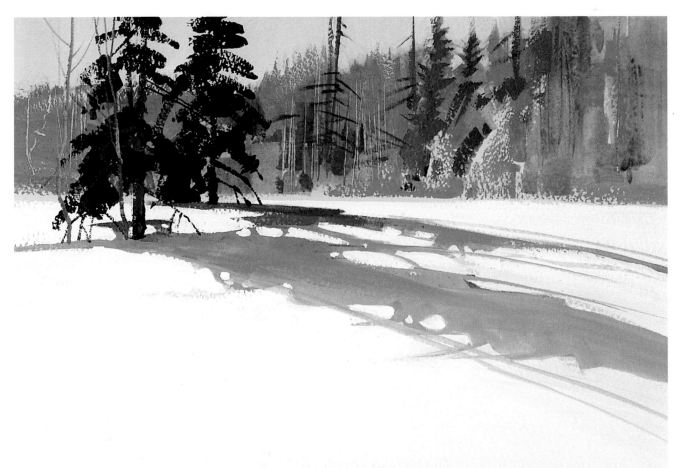

I now establish the spruce and aspen forms by coming in with opaque, strong, dark color. This provides strong contrast to the area of emphasis. As I put in these forms, I am aware of the yellow-oranges and oranges in the background and allow some of this color to peek through.

Palm fronds and the bay at Acapulco, Mexico. This photograph exhibits the color, texture, and patterns that excited me. It took five days of looking before I felt that I could tackle the subject. I had never painted anything remotely similar to this before. However, it proved great fun to see the painting develop and to make choices that would alter the composition.

This painting was done during a workshop at a villa overlooking the bay in Acapulco, Mexico. There, I studied the palm tree and its abstract qualities. I began by painting very wet, making pools of the light-to-middle values and the general color tones of the fronds, mistletoe, and trunk. While the paper was wet, I developed the general shapes of the leaf and trunk, varying the violets and greens. When the painting dried, I negatively painted the opaque blue-violet shapes around what appears to be the palm frond. Next, the two adjacent opaque bands of darker blue-green and burnt orange were applied in the same way. Then the very light opaque violet and Naples yellow shapes were added around the leaf patterns and lower trunk area. Once the general shapes were completed, I painted the central branch, root, leaf, and berries of the mistletoe opaquely. The painting was refined by adding the little pockets of cream tones to give some visual surprise to the composition. The opaque red-orange berries were the final notes necessary to complete the painting.

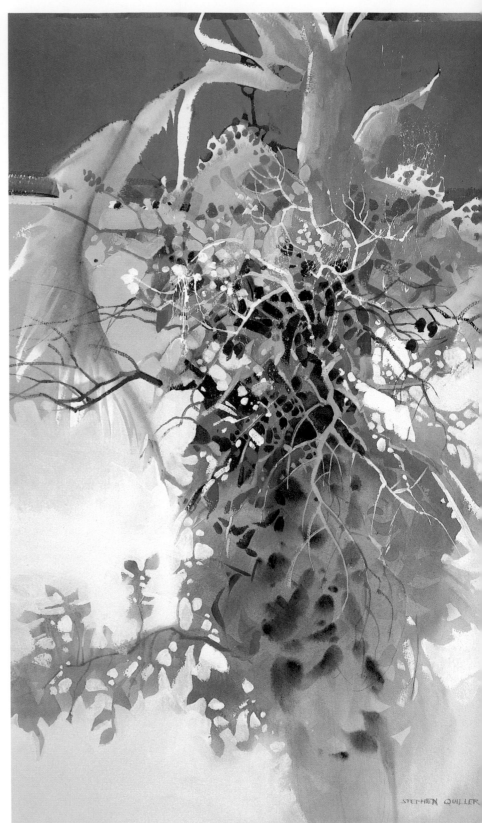

PALM FRONDS AND MISTLETOE. Acrylic on Lanaquarelle 300-lb. rough, 28 × 18" (71.1 × 45.7 cm). Collection of the artist.

The Batik Approach

This method, using acrylic color instead of dye and maskoid as a "stop-out" instead of wax, is otherwise like that of traditional batik. Of course, for a painting support, watercolor paper, not fabric, is preferable.

Maskoid (also called *frisket*) is not something that I use in my traditional watercolors. The look of areas saved with maskoid seems foreign to watercolor handling; white areas stick out especially. I feel that it is much better to learn to use the brush to paint around the whites. It may seem clumsy at first, but eventually the work will have more of the artist's mark and personality. This batik method, however, yields results that could not be attained any other way. When using this method, stopping-out areas I want to save, I combine it with other painting approaches—

transparent, translucent, and opaque—weaving them together to give a unified appearance.

I have seen transparent watercolor attempted with this method, and the removal of the maskoid is difficult, for some of the paint may rub off or smear. The masking agent may lift some of the undercolor, too, when it is removed. This will not happen with acrylic. The masking agent that I have found most suitable is White Mask, a high-grade latex. It dries fairly clear, leaves a tough film without pinholes, dries quickly, and is easily removed.

My demonstration is an example of how to use the batik method abstractly. Subjects such as florals, landscapes, and seascapes work well using this method. The study is followed, for example, by a finished landscape.

Using a cold-press watercolor board, I save some of the white paper as I apply bright, transparent acrylic color. I spatter it and flow on a few washes, working abstractly. The paint is left to dry completely. Then the masking agent is put on. I spatter it on with a brush also, and then paint in a few bubble shapes in the upper horizon area. When dry, the maskoid is clear; thus you cannot see it in this illustration.

I glaze over the entire surface, starting in the upper area with a red-orange and grading it to a blue toward the bottom. I keep in mind that the stop-out isolates the undercolor where it has been applied. When the overlay of transparent acrylic is dry, I develop more patterning with the masking agent. I apply it by spattering and brushing on curvilinear forms in the upper bubble forms, then use it to save the lower part of the painting.

I wash more blue over the surface and then some light blue-green to vary it. Each time I apply a wash, the color darkens in value. Once the color is dry, I add more latex to repeat some of the rhythmic forms and to isolate some of the color and areas that I want to save. I now wash a deep blue-green tone over the whole surface. The value of this wash is very dark to help bring out the shapes in the composition. When the glaze is dry, the maskoid is completely rubbed off, exposing the dazzling acrylic color and crisp shapes. The look is very batik-like, hard-edged, spontaneous and fresh.

Now I build and develop the painting, using transparent and translucent glazes and opaque applications, to let it evolve to its finished state. I use these methods to glaze down the color, soften some of the edges and diffuse some of the passages. In some instances, I do paint over unwanted forms.

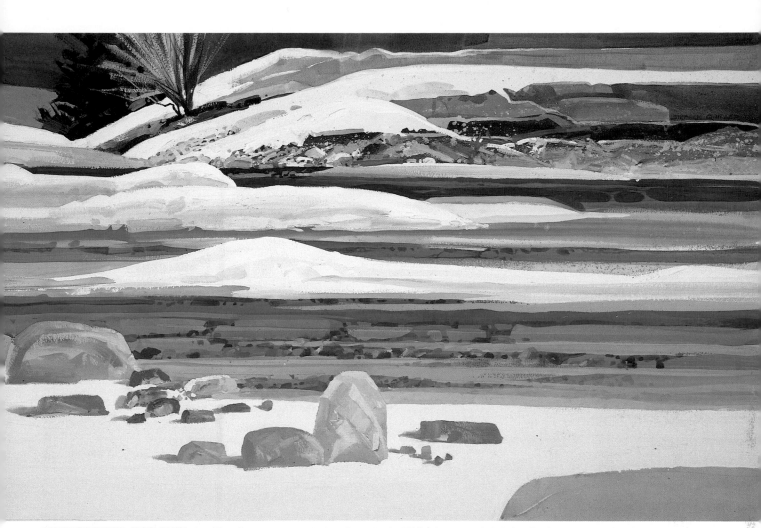

RIO GRANDE LAYERS, EARLY SPRING. Acrylic on Crescent watercolor board #5112, 19 × 29" (48.3 × 73.7 cm). Artist's collection.

This painting is representative of the batik approach. Along the Rio Grande River in Colorado's San Juan Range, I came across this particular subject. What struck me was the seemingly isolated layers, horizontal bands in the foreground snow and rocks; the central ice, snow, and water; and the background bank of rocks, earth, and snow, with one willow against a spruce way over to the left.

The ice patterns and water patterns seemed most easily stated in the batik method, so I decided to use that approach throughout, using it in the rock and earth of the background and to isolate the rocks in the foreground. After doing a sketch on-location, I returned to the studio and started by glazing transparent color, stopping-out areas, and glazing more color in the land forms and water passages. I continued through four stages of the process

and then removed all of the masking agent. I then started to develop the painting in transparent, translucent, and opaque acrylic. Sometimes the opaque paint was fairly juicy and buttery-thick. This can be seen in many of the sunlit snow passages. I enjoyed using it in contrast to the adjacent thin, transparent areas. In the foreground, I wanted to keep the rocks and shadows very simple against the snow. I intentionally isolated many of the rocks and let their shadows carry to the next rock shape.

The finished painting demonstrates a weaving between the various paint applications. The batik applications are sometimes glazed with transparent color and in some instances overlaid with a translucent tone, creating a transition to a juicy opaque. Playing with the paint in this way is a great joy, creating some exciting visual qualities.

Working Dark to Light

This approach is one that has been used successfully by many contemporary watermedia painters. It is essentially the reverse of what we consider transparent watercolor, in which one saves the white of the paper and gradually builds from lighter colors and values to the richer and darker colors. Taking this different direction, start out with the dark colors and values, building around the darks with middle tones, then apply the lighter translucent and opaque colors.

Once this is achieved, work freely back and forth, light to dark and dark to light. This makes full use of the various ways in which acrylic can be used. The following is an example of this direction, and a similar approach is used in the next painting.

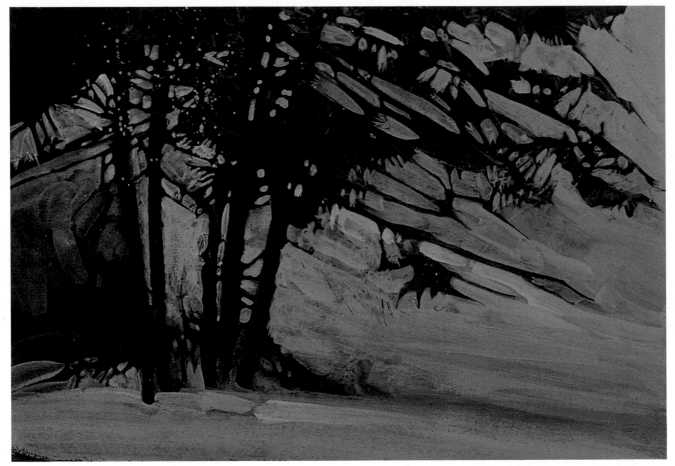

I wet the surface of a cold-press watercolor board and add dark tones of blue, blue-greens and violets, covering the surface. When it is dry, I negatively paint lighter, translucent green and blue tones around the foliage and tree forms. I focus on developing interesting negative patterns and relationships between the foliage, branches, and trunk forms. The colors are kept in the cool range, mainly translucent with some opaque.

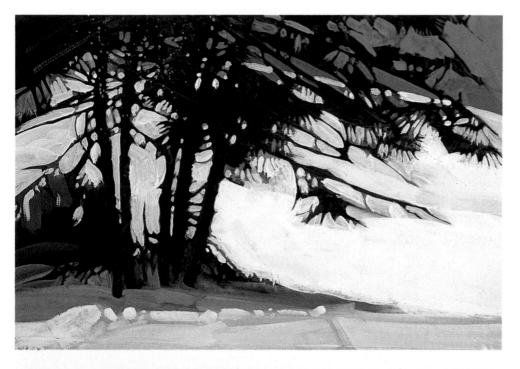

I continue to paint the negative forms, starting with the upper diagonal band of translucent blue-violet and washing into the blue-green upper horizon area. Adjacent to this I place an opaque band of whitish red-orange to complement the blue-green. I apply this whitish tone translucently and opaquely all the way down, following the negative patterns of the composition. I add a few positive notes of stronger red-orange to create branch forms—some warms in a cool composition.

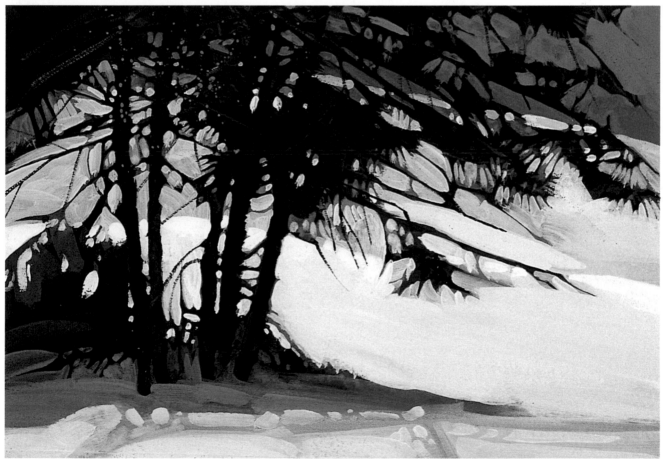

I add opaque whitish red-orange negatively to the central and foreground passages. I add dark branches and then some red ones for some positive shapes to help break up the composition, giving it more three-dimensionality.

I do not have the opportunity to spend much time painting in New England, and it takes a while to get to know the landscape, its forms and light, to know how to express it in one's painting methods. The light is very different in this area as compared to the west. This painting, done one late afternoon during a workshop, was painted starting dark and working light. The hillside absorbed the sunlight like a sponge, and occasional fluorescent-like light bounced off the foliage. I went through a lot of paint to get the essence of the deep darks against the brilliant color.

I began transparently washing dark blue-violets and violets down the paper's surface. Some scarring and textural spatter were applied while the paint was wet. Middle-to-dark-valued opaque greens and oranges were put in rather loosely, representing tree patterns on the mountain. The mid-value opaque sky was added, painting negatively around the tree patterns on the mountaintop. The rich opaque yellows, oranges, red-oranges, and yellow-greens were used to create sunlight on the central maple tree in front of the dark violet bank. Finally, I painted the opaque lime green meadow and added the cows.

The painting was done very spontaneously and quickly. I needed to capture my impressions before the light changed too drastically. Twenty minutes after I completed the painting, the central maple and part of the foreground meadow were in shadow.

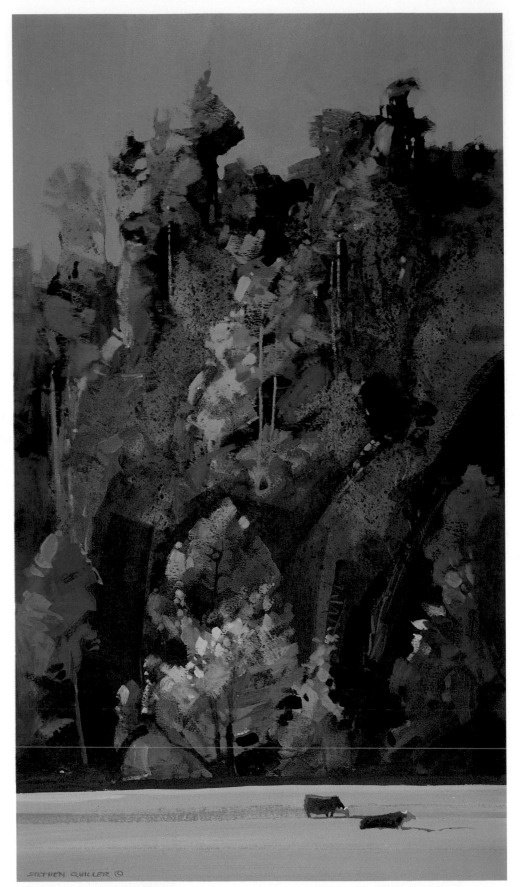

NEW ENGLAND PATTERNS, OCTOBER. Acrylic on Crescent watercolor board #5112, 12 × 22" (30.5 × 55.9 cm). Collection of Marta Quiller.

EXERCISES

EXERCISE 1: Select an appropriate subject for a series of transparent washes, such as a rocky river bed, a floral still-life, or an abstract. Begin with the warmest and lightest wash and save the whites of the paper wherever needed. When the paper is completely dry, begin the next wash. Cover every part of the paper except those you are saving—whites or areas of the color of the first wash. Continue similarly with a series of washes. Notice the richness of transparency, without obtaining mud!

EXERCISE 2: Do some small studies focusing on transitions between transparent and opaque passages. Begin with a transparent strip of color. While the paint is wet, charge the lower edge with a translucent tone. This is done by adding a small amount of white paint to the color tone of the previous wash. Develop the graded wash from transparent to translucent. Continue to add a bit more white to the color until the lower edge of the wash is opaque. After mastering this application, do it again, but change colors at each stage; for example, paint from transparent yellow to translucent orange to opaque light violet.

EXERCISE 3: This exercise focuses on a rich, transparent undertone with complementary translucent and opaque overpainting. Select a landscape, and get a feeling for the dominant color of the painting. Is it warm oranges or cool greens? Choose the complementary undercolor and wash it over the entire paper. When it is dry, develop the overpainting, but let color peek through. In some areas, paint around the undertone and in others lift the overpainting or scrape through some opaques to reveal the bottom layer.

EXERCISE 4: Practice the batik approach using standard-body acrylic and working loosely and freely. Be totally abstract, thinking about color, shapes, and texture. On a smooth watercolor board, either hot- or cold-press, start with bright, warm transparent colors and splash them on, leaving a bit of white showing. Use a hair dryer to dry the paint. Now spatter and block any of the areas that may seem interesting with maskoid (liquid latex frisket). Also mask larger and smaller abstract shapes that seem appropriate for the composition. When it is dry, charge the painting with richer, deeper-value transparent colors. Then repeat the process, further saving interesting shapes with the latex. Keep repeating the routine each time, using deeper colors but keeping them transparent. When you are finished, let the exercise dry completely and then remove the latex. At this point you can leave things as they are or do some direct painting to soften or even to paint out some areas.

EXERCISE 5: Tape a small watercolor board to a plywood support. Flood the surface with analogous, dark acrylic colors—ultramarine blue, phthalocyanine blue, cobalt turquoise, and phthalocyanine green. Flow the paint on. Now work with these same colors plus their complements—cadmium orange, Indo orange-red, cadmium red medium, and alizarin crimson hue. Add a bit of titanium white to each color and slowly build some abstract shapes in lighter translucent tones. Continue to build lighter and brighter shapes, while occasionally scraping through to the undercolor. Play with the scraping technique and also do some directional spattering to create some visual texture.

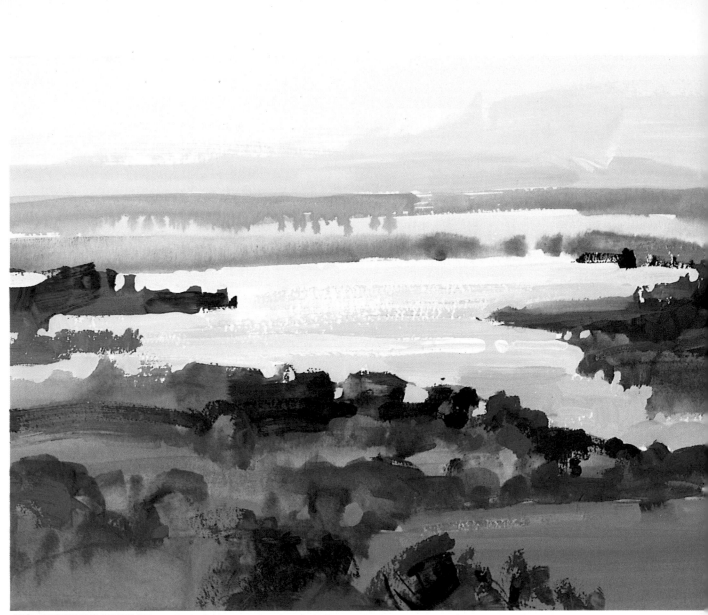

VIEW OF THE HUDSON FROM OLANA. Acrylic on Crescent watercolor board #5112, 8 × 16" (20.3 × 40.6 cm). Courtesy of the Quiller Gallery.

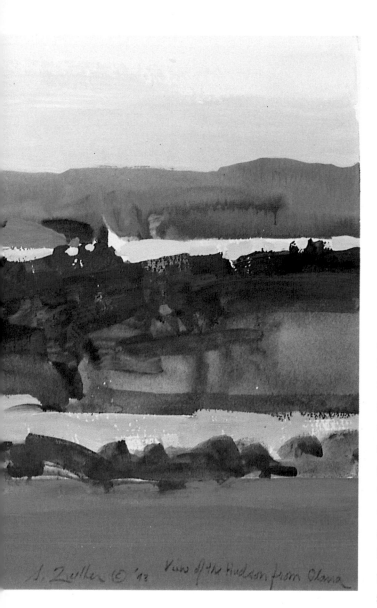

S. Zuller © '18 View of the Hudson from Olana

4
"EASEL PAINTING" TECHNIQUES

Acrylic is usually considered an "easel painting" medium, like oil painting. Generally, the support is placed upright on an easel, and the paint applications are thick and opaque. The support can be gessoed Masonite, rigid watercolor board, stretched and primed canvas—just about any clean surface. The finished painting is usually varnished and does not require glass. Acrylic is a versatile medium for this approach, for the paint dries quickly, allowing for overpainting and glazing in a short time. With the addition of retarder medium, the painter gains more time to develop a passage. Today there are abstract painters who build up the painting surface one inch or more in thickness with acrylic paint on a canvas support, while photorealists airbrush acrylic very thinly onto Masonite panels. The polymer resin medium is flexible once dry, so there is no fear of the paint eventually chipping or cracking.

Rigid Easel Painting Supports

One of the most important factors in the easel painting process is the choice of support or surface on which the paint will be applied. In this chapter I will demonstrate different paint-application techniques for acrylic easel painting, discussing the variety of supports and how they will influence the paint when prepared with different grounds.

While stretched canvas has a flexible, springy response to the brush and paint, rigid supports such as Masonite panels, clay boards, canvas boards, and watercolor boards have little or no flexibility. Consequently, the painter's brushstroke acts very differently with each one.

Though canvas board supports are indeed rigid, I will discuss them briefly later, under "Canvas Easel Painting Supports." Starting with the other rigid supports, I discuss painting techniques such as creating texture on the support with modeling paste or gel medium, undertoning with the complement, and building surface texture with overlays of paint. I then explore the many exciting aspects of painting on canvas.

Lastly, after providing some exercises, I consider mural painting, a form of expression that I treat as a special, separate story about how I created a large, four-panel commissioned work near my home.

GESSOED MASONITE

This panel can be prepared by the artist. A $1/8$" untempered sheet of Masonite is cut to size, and the edges are slightly filed. A damp cloth cleans the surface, and acrylic gesso is brushed on evenly and allowed to dry. A fine-grit sandpaper is used to smooth the surface, and is cleaned again with a damp cloth. This process is repeated three to four times, using a very fine sandpaper after the last gesso application.

One may use white, gray, black, or colored gesso. The gesso gives a hard, enamel-like surface that paint can slip and slide on. It also holds paint well. Overall, if the surface is used to advantage, it will display the personality and the unique mark of the artist.

You can texture the gessoed panel by spattering gesso or applying sweeping brush texture with gesso and a stiff bristle brush. Texture can also be added with gel mediums or modeling paste.

Shown here is a study I did on the back balcony of my studio, which looks out on a corner of a mountain village. It has been photographed in stages to show various ways that the panel, covered with three coats of very white gesso, accepts acrylic paint.

I use a small, gessoed Masonite panel and work with some of the shapes that are seen from my studio. With a charcoal pencil, I roughly sketch some of the buildings and trees. I work with a large brush and lay the acrylic paint directly on the white surface. Establishing some of the large general shapes, I work very loosely and concentrate primarily on the tree forms and background mountain. I also begin to put in some of the roof shapes. The paint is applied in a thick, juicy, opaque manner, and the hard surface allows the paint to slide and be pushed around in a spontaneous way. The tip of the handle of the brush is used to scrape back to the gesso layer and indicate some tree branches.

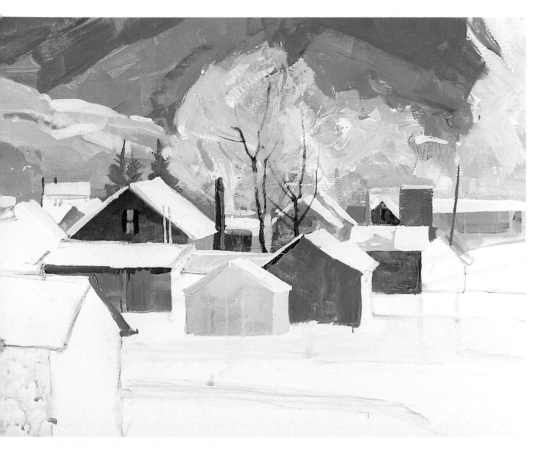

I put in more of the roof and house forms and leave some of the white panel exposed. The paint is still applied thickly. I focus on the rectangular shapes of the structures and plan a repetition and rhythm through the composition. I eliminate some of the buildings on the right side.

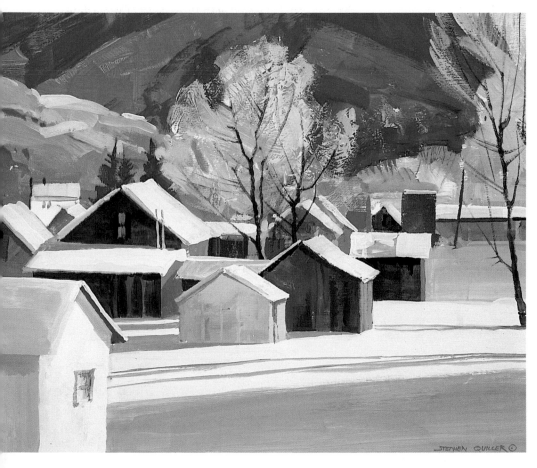

I now develop the snow shadow and sunlight patterns on the land mass that surrounds the buildings. I refine the tree forms and bring in the tree shadows. I continue to build surface texture by scumbling paint on the trees. Adding color to the structures, I indicate the left foreground house by thin neutralized washes in the shadow areas and, mostly, the exposed white panel with a bit of a soft yellow wash on the sunlit side.

CLAY BOARD PANELS

Charles Ewing, a fine artist from Colorado, originally developed this board, a type of Masonite panel. It has two kinds of surfaces, both with a covering of a clay and glue mixture. One is very smooth, while the other has a fine tooth on which the paint can bind. I prefer the second and have found it to be a unique and beautiful surface. It has been developed to be used for drawing and scratchboard applications as well as acrylic easel painting. Clay board is now available from many fine-art supply stores under the trademarked name Claybord. More information is available by writing to Ampersand Art Supply, 8920 Business Park Dr., #120, Austin, Texas 78759-1936.

This board has a pH neutral (nonreactive) surface and is very durable, permanent, and has a warm white color. It has a uniquely receptive, velvety surface. Thin applications of acrylic become a part of the clay body, while heavier applications will adhere well, yet sit on the surface. Thus, transparent and translucent underlayers of color interact in an exciting way with thicker opaque strokes. Acrylic paint adheres well to the surface. An advantage to working with this support is that the board is already coated and ready to go; you can immediately start painting.

The painting here is photographed in three stages, showing how clay board accepts acrylic. This painting was done from a watercolor sketch done on a high mountain valley road. Along with the study, I made notes as to the tapestry of color and the compositional rhythm that I felt. I liked the shift of the pocket of aspen and shadows to the lower left and the soft diagonal rhythm of the hills moving to the right. After reviewing this study, note the two finished paintings done on clay board.

I choose an elongated, horizontal piece of clay board for my format. I first apply some underwashes of blue-violet and red-violet to establish underlying complementary tones. The overpainting of the aspen and hills will be done in yellow-greens, sage greens, and yellow-oranges. Notice that the acrylic paint absorbs readily into and becomes part of the clay facing. In the upper half of the composition I next develop some abstracted patterns that will eventually represent some tree patterns and mountain forms.

In the middle ground I paint neutralized greens, violets, and yellow-greens and apply the paint to go along with the rhythm of the forms. In the background I develop flat patterns in the upper-right corner. Again, notice the beautiful matte look of the painted absorbent clay. Where I want the paint to be a little juicier I apply the paint thicker and, unabsorbed, it gives a nice contrast of surface texture. I lay in the aspen shapes with some negative paint applications to form pockets of light through the trunks and branches.

I constantly refer to my sketch and try to capture what I felt. I focus on the color notations written on the sketch: Naples orange, yellow-orange green, soft blue, sage green, rust orange, gray rust-violet, and maroon. As I work, I think mainly of value, color, rhythm, and surface texture. Finally, I develop the foreground and work a bit more on the middle ground. In the foreground, I use many of the colors that were in the middle and background areas. However, I keep these colors at analogous light values. Thus the foreground passage works as a total shape and as a foil setting off the rest of the painting.

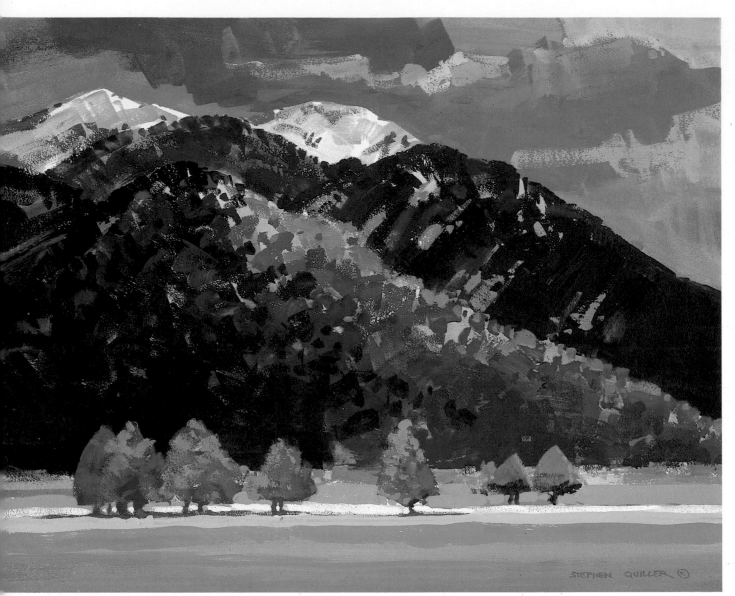

VIEW OF TAOS MOUNTAIN. Acrylic on clay board panel, 11 × 14" (27.9 × 35.6 cm). Courtesy of Mission Gallery, Taos, New Mexico.

I have spent many years painting the light and unique landscape forms of northern New Mexico. Although geographically I am very close, the color, light, shapes, texture, and the culture are entirely different from those of the upper San Juan Mountains of Colorado. This April day, I was at the edge of a village looking east to Taos Mountain. The late afternoon raking light intensified the contrast of lights and darks, color, and texture of the mountains and pinyon trees. I set up my French easel and worked very rapidly on a clay board panel, completing the work in less than two hours.

The clay absorbs the thinner applications of paint—much the way, I imagine, the lime of fresco painting would do. I was using Lascaux paints, which appear more matte and are particularly strong in opaque pigments.

This painting exhibits many different ways to apply acrylic on a clay panel. The white of the mountain peaks is the untouched clay surface. The neutralized light blue of the snow and red-orange (the undercolor) of the mountain are transparent washes. I worked most of the sky, some of the mountain, and the foreground meadow with thin, flat, opaque paint. And I developed some of the evergreen texture and pinyons with juicy opaque marks. This type of panel provides a variety of surface texture unlike any other. Before framing, I coated the painting with a matte ultraviolet-protective acrylic varnish.

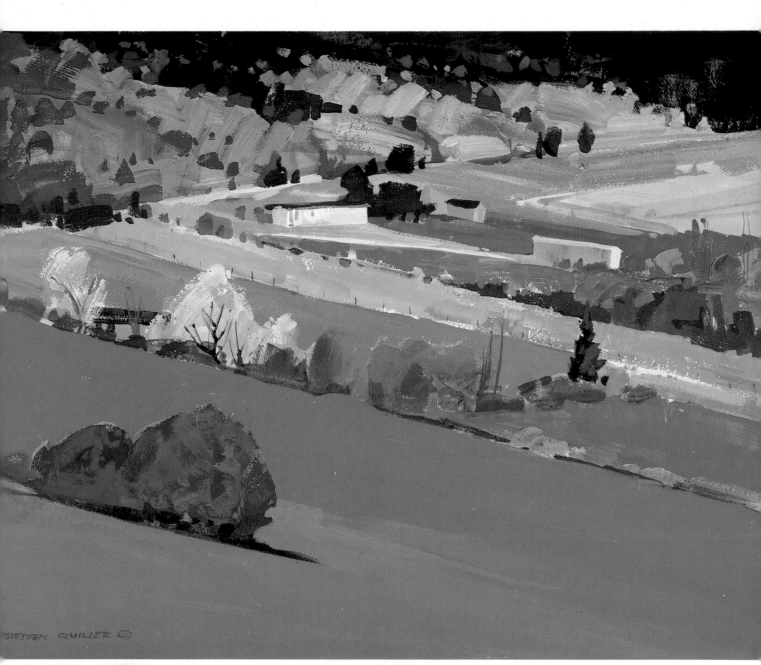

VIEW FROM VALDEZ RIM. Acrylic on clay board panel, 11 × 14" (27.9 × 35.6 cm). Collection of Carolyn and Fred Miller.

On a high mesa rim overlooking some marvelous New Mexico field patterns, I found rhythmic compositions and unusual ways to break up space. In this particular work, the parallel movement of the various diagonal patterns is countered by the opposing diagonal edge of the hillside. Spring was emerging in the valley, so there were hints of budding foliage on the trees, yellows on the willows, some blossoms on fruit trees, and a feast of varying green hues blanketing the fields.

I developed the painting spontaneously, completing it in one morning session. After sketching in the basic composition, I charged thin medium and thick applications of paint onto the surface. I started the hillside with transparent orange and red-orange washes that were overlaid with medium to thick juicy strokes of whitish yellow-orange, blue-violets, and greens. I painted the foreground field patterns with more translucent and opaque paint, with emphasis on the arrangement and repetition of yellow-green to red-violet colors, semi-neutral to pure-hue. The unique look of this clay board is most evident in the foreground. An even, flat, semi-neutral opaque green melts into and becomes a part of the surface. Throughout the painting I used a variety of transparent, translucent, thin opaque, and juicy opaque paint to add visual excitement.

WATERCOLOR BOARD

I include watercolor board in this section because it is one of my favorite supports. It can be used just like clay board and gessoed panels.

I use only the heavy, acid-free boards. My personal favorite is a cold-press Crescent watercolor board #5112. The board also comes in hot-press and rough surfaces. It can be cut to any format and painting can begin immediately.

The rigidity of the board lets the work be finished like other easel painting supports. It may be varnished and framed without glass. The soft paper surface allows paint to flow and adhere well and thus permits watermedia-style underlayers of color. Yet it also can be built up with thicker oil-style paint applications. This technique is discussed following the finished painting shown here, which is typical of my easel painting approach on watercolor board.

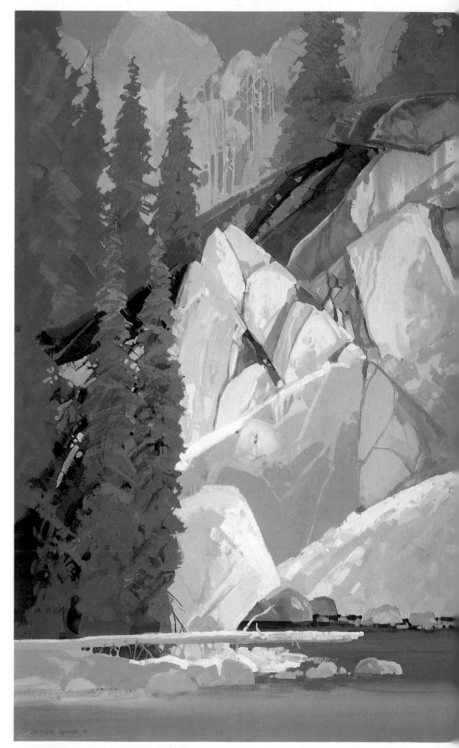

One of the exciting aspects of being a landscape painter is exploring new territory in search of subject matter. Recently, I found a little-known canyon within one hour's drive of my studio. To get to the bottom of the canyon was very difficult, and thus I needed to make sure I had all the right materials for a day's stay. I wore fishing boots and carried only small sheets of watercolor paper, a palette, and other necessary materials and food. When I reached the floor of the ravine, the enchanting light, luminous color of the water, and dramatic shapes of the rocks and trees made the struggle worthwhile. On this trip, I did three finished watercolors and some compositional studies.

I completed this painting in my studio using the information from the studies. I chose a white, acid-free watercolor board because I wanted to build from loose washes to thick opaques. Also, the white surface would enhance the richness of the paint.

I cut the watercolor board to size, stapled it to a plywood board, placed it vertically on an easel, and sketched the general subject with a 2B pencil. I wet the surface and, using 2" and 3" flat watermedia brushes, flowed in transparent acrylic to give the general form. When it was dry, I painted the surface with thin, translucent and opaque acrylic. In some areas I let the underlayer show for an interesting interaction of transparent, translucent, and opaque qualities. (This can be seen best in the upper-right rock area.) Finally, I built the paint in thicker strokes in the foreground rock and tree passages.

As I do often in studio painting, I focused on color relationships throughout the composition. The spruce trees repeat green, violet, and orange triadic relationships, while the foreground rocks and water emphasize the complements orange and blue.

HEADWATERS OF THE RIO GRANDE, AUGUST. Acrylic on Crescent watercolor board #5112, 35 × 23" (88.9 × 58.4 cm). Collection of Sally and Robert Kent.

76

Toning the Surface: Underpainting and Overpainting

Any support can be used with this method of applying a transparent tone to the surface before working in the traditional opaque manner. This technique is commonly referred to as underpainting and overpainting. This is a good approach to setting up an interaction of warm and cool color and other color relationships as well as to

playing with surface texture. As already demonstrated, I like to work with complementary color for the transparent underlay; painting the overlay of paint, I consciously let some of the undercolor radiate and peek through. Here is a study demonstrating surface toning to advantage. After this example are two finished paintings utilizing this approach.

I have selected an acid-free watercolor board for support because of the brilliant white surface it offers as well as the way it accepts the flow of transparent acrylic. After taping down the support to a plywood board, I lightly sketch the composition with a 2B pencil. I loosely put in transparent acrylic, visualizing the color and mood of the finished painting and using the warm complements. Thus, the snow, trees, and water receive an initial underpainting of their complements, yellow-orange, orange, red-orange, red, and red-violet.

Working on an easel, I apply color in thin translucents and opaques. I work very quickly and loosely, dragging and scumbling the paint. I intentionally let some of the warm underpaint show through some of the cool overlay color. This gives color balance through opposites.

I continue to build paint and surface texture. These overlays of paint are now entirely opaque. I develop the background trees using various values and warm and cool greens. The negative shapes behind the trees are a middle-value, neutral-gray mix of red and green. I leave a complementary red, transparent outline—like a cloisonné line—on the tree forms. I complete the small foreground spruce and shadow.

I finish the background forms, adding a few gray neutrals and letting some dulled warm tones show through. I paint the sunlit snow around the shadows, using orange-whites in the distance and moving to a warm yellow-white on the foreground bank. I pull color in the upper area down into the reflection, repeating the vertical and diagonal abstract patterns.

I did this painting on-location, with an easel painting approach, in a peaceful spot with beautiful mountain shapes and patterns. I make these elements a focus of much of my work and emphasize the rhythm and patterns in nature. In this case, I focus on the interlocking movement of the aspen trunks and branches, contrasting with the background mountain patterns and curvilinear hillside forms.

I first washed a transparent violet glaze over the entire support. This was a key undercolor, a base that would complement the yellow-greens, greens, and blue-greens. In the finished piece, this tone can be sensed throughout and helps to unify the composition. I then applied translucent and opaque applications of the green tones to develop the spruce and mountain patterns. As the work progressed, I applied juicier passages of paint. Next, placing the white and light-toned aspen, I was especially aware of the negative space around and between the aspen. By making sure that the negative shapes were lively, I knew that the painting would be more interesting. Finally, I added highlights on the aspen foliage and foreground grasses.

ASPEN RHYTHM, JULY. Acrylic on Crescent watercolor board #5112, 29 × 20" (73.7 × 50.8 cm). Collection of Kaylee Brennand.

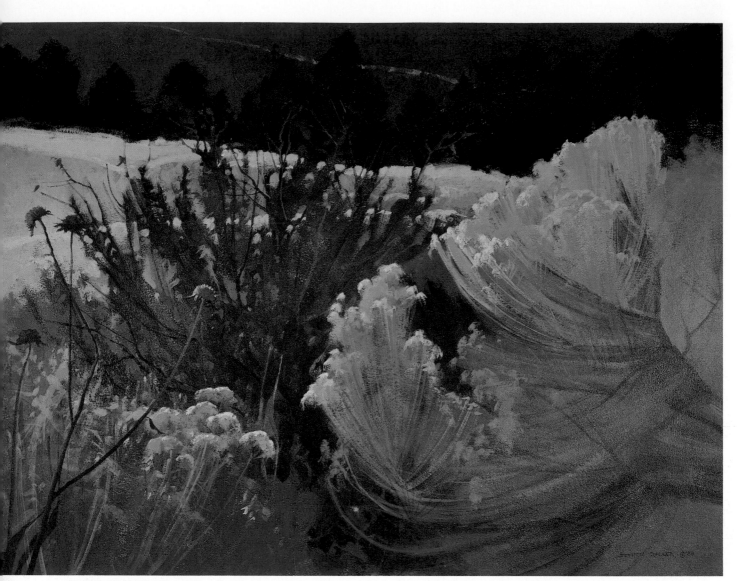

CHAMISA AND SCRUB OAK. Acrylic on watercolor board, 25 × 33" (63.5 × 83.8 cm). Private collection, courtesy of Mission Gallery, Taos, New Mexico.

One of my favorite times to paint is in October, and in northern New Mexico, the hills, arroyos, plains, and mesas are a tapestry of rich, earthy hues. The soft yellow-greens and white-yellow tones of the chamisa, the myriad neutral green colors of the pinyon and cedar, the violet-alizarins and warm, burnt tones of the scrub oak, with the ochre meadows, are fun to weave into a composition. I did this painting on-location in a few days.

The underpainted tone in this work is blue-violet. Many times when I am determining which color to use as an undercolor, I analyze the dominant colors in the painting and use a common color that complements them. Here I used blue-violet because it is the complement of the soft yellow-orange ochres of the meadow, also a key triadic connection for the yellow-green chamisa and the red-orange scrub oak.

As the painting progressed, I allowed the blue-violet underpainted tone to radiate through. When the painting was finished, I applied an ultraviolet-protective acrylic varnish and framed it without glass.

Using a Brayer to Apply Undercolor Texture

Another way to create a textural surface, as well as to create underpainted and overpainted color relationships, is to apply paint with a soft rubber roller called a brayer. To start off, I squeeze generous amounts of paint onto a glass palette. With dabs of paint on the brayer, I roll it back and forth across the glass. When a tacky texture is reached, I run the brayer across the surface of the support.

I usually first paint a transparent tone with a brush on the white support. You may wish to choose the complement of the dominant color of the painting, then apply a closely related color or colors opaquely with a brayer. The tackiness of the paint that results from moving the brayer back and forth across the surface leaves an interesting texture for the overpainting. Pockets of the transparent undercolor interact with the subsequent layers of paint. Here I provide two examples of finished paintings that I did this way.

In using a brayer to apply texture (it can be applied to any support), I suggest that you allow pockets of the underpainting—here, and in the painting below, it is a violet wash—to show through the tacky rolled-on layer.

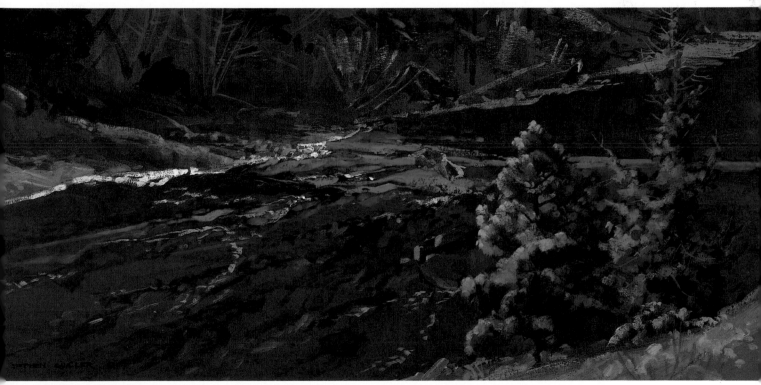

PONDEROSA AND SPRUCE. Acrylic on gessoed panel, 12 × 29" (30.5 × 73.7 cm). Courtesy of Mission Gallery, Taos, New Mexico.

I did this painting in late November, as ice was forming along the Rio Grande. I was struck by how afternoon sunlight caught the brilliance of the ice and cast long shadows from the spruce along the river. In the foreground were sunlit ponderosa and spruce. I responded to the balance of the light on the ice and the foreground trees.

I used the brayer to apply a transparent violet to the gessoed panel. Once it was dry, I rolled on a neutralized blue-violet opaque acrylic. As usual, I let some of the wash show through, and the brayer application produced an interesting texture. Thus my opaque underpainting has its own undercolor to give me a very rich surface to work on. When I started the actual painting, I kept many passages of the blue-violet textured acrylic exposed. These passages indicate the shadows moving across the river and in the rocks and tree forms.

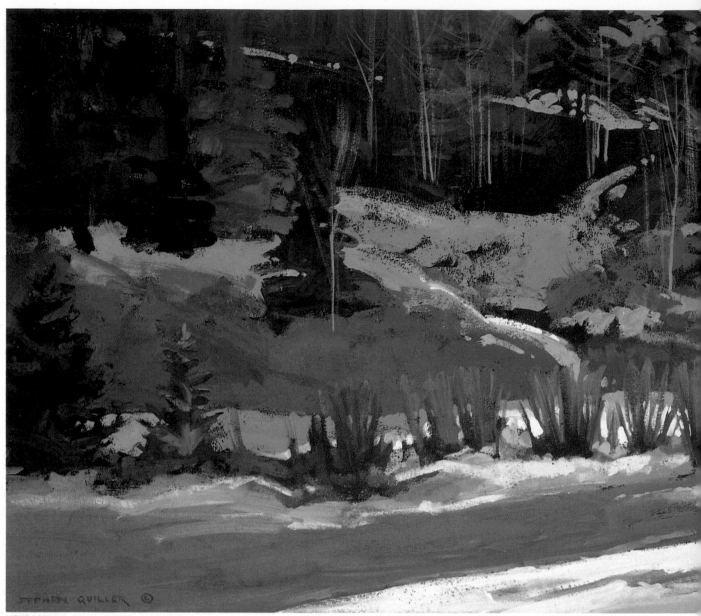

LIGHT POCKETS, DEEP SHADOWS, DECEMBER. Acrylic on gessoed panel, 12 × 33" (30.5 × 83.8 cm). Courtesy of Mission Gallery.

I was working out of my camper, *The Paintmobile,* to keep the paint from freezing on a December day. In a shallow canyon on the way to a high mountain reservoir, there were still open patches of ground amid some snow. The scene suggested an elongated composition with a curvilinear rhythm. Sunlight hit the snow-covered stream bed and the upper mountain forms were all in shadow. Of particular interest was the way the foreground spruce and willows broke up the light pockets of the stream bed.

I developed this painting in much the same way as *Ponderosa and Spruce.* I washed transparent red-violet acrylic (quinacridone violet) over the gessoed panel and let it dry, then rolled neutralized blue-violet opaque acrylic over the surface, creating a tacky tooth and letting some of the red-violet peek through. I wanted the overpainting color to relate to the undercolor and so I painted analogous blues, blue-violets, and violets in the snow-shadow passages. For a triadic relationship of colors, I used dulled red-oranges and yellow-greens to form the willows and spruce. Complementary neutralized yellow-oranges formed the patches of dried grass on the hillside and meadow.

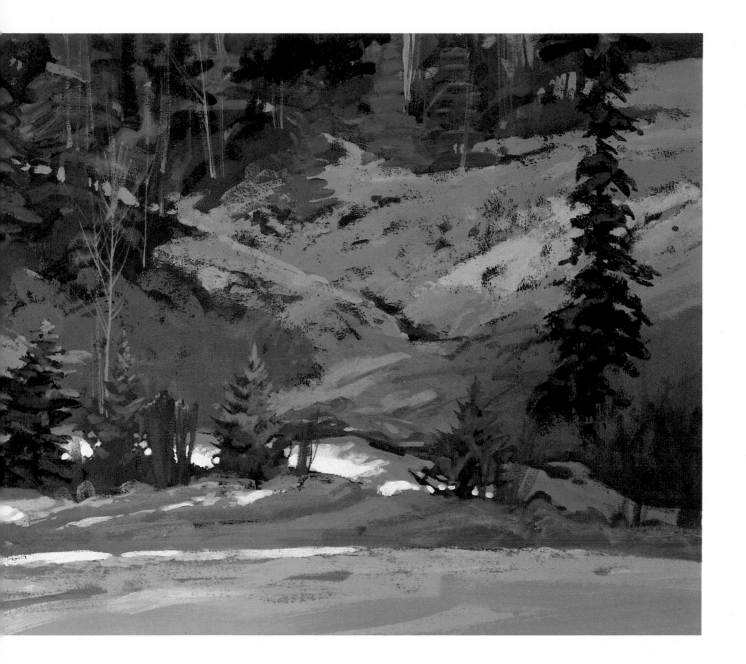

Canvas Easel Painting Supports

Canvas is a general term used for a closely woven fabric of fibers such as cotton, linen, and jute that is used for tents, awnings, and painting supports. In this section I want to examine the various canvas supports, demonstrate how to stretch a canvas for a painting, discuss the various colors of primers and how they will affect the painting, and show many ways to approach acrylic painting on canvas.

I frequently choose canvas to work on; I like the texture of the weave and how it affects the application of paint. I also like the springiness of stretched canvas. It has a nice interaction with the brush and the paint. The cotton and linen fabrics come in tightly woven,, smoothly woven, and coarsely woven textures. Your selection of a weave will be determined by the subject and way the paint is to be applied.

Cotton and linen are generally associated with canvas for painting. Cotton is economical. It has an off-white and cream tone. It does not stretch evenly and does not take primer as well as linen, but linen is very expensive. The more permanent linen is easy to stretch and accepts primer well. It has a beautiful, natural color and comes in a variety of textures and weaves. A good quality linen can have anywhere from 60 to 90 threads per inch.

There are different kinds of canvas supports from which to choose. Your choice will be determined by economic factors, time of preparation, permanency, and how the paint is to go on the surface. The beginner may select a

canvas board. This is a pasteboard that has the canvas fabric glued to it. It should not be used where permanency is important. It is fine for studies and is very economical. There is no preparation involved. However, this is a rigid support and thus there is no springy action with the brush, paint, and canvas.

Prestretched, acrylic-primed canvas is another option which comes in both cotton and linen. These supports come in all the standard sizes. The cotton is economical, the linen more costly. Both need no preparation.

I prefer stretching my own canvas. It does take some time but the advantages are obvious. First, the canvas can be stretched to conform to the exact format of my composition. This may not be a standard size. Second, I can select the type of fabric and weave that will best go with the painting. Third, I can use the color of primer that will best suit the direction of the work.

STRETCHING A CANVAS

Here is how to stretch a canvas over stretcher bars. I usually stretch five or six canvases of various sizes, so that when I am ready to paint, the canvas is also ready. This example uses a white, already primed canvas but the same procedure can be used to stretch a raw cotton or linen canvas. The gesso can be applied after the canvas is stretched. In this sequence, fingers are used to pull the canvas tightly, but canvas pliers can be very useful.

After selecting the size of the stretcher bars, push the corners tightly together. Tapping the corners with a hammer helps to tighten the corners.

Once all the corners are secure, make sure that the rectangle is even. This is done by measuring diagonally, from corner to corner. Both measurements should be the same. In this case the measurement on both diagonals is 25½".

Cut the fabric to measure approximately 2" larger than the distances between opposite stretcher bars. Lay this material evenly over the stretcher and place a staple in the middle of one side.

Now turn the canvas (stretcher and fabric) over. Pull it tightly and staple in the middle. Canvas pliers can also be used to pull the canvas.

On the two corners of the one side, pull the canvas tightly and staple, forming a V.

Turn the canvas over again and pull the corners tightly and staple. There now are six staples on two sides.

Repeat the same procedure on the two other sides. There are now twelve staples, three to a side.

Now pull the edge of the fabric tightly all the way around and place staples every 1½". The fabric is now stretched taut.

Fold and pull each corner at a 45-degree angle and staple.

Neatly trim the excess fabric canvas from the bottom edge of the stretcher bars all the way around.

The canvas is ready for painting. The same procedure can be used with raw canvas, which is then coated with two coats of gesso of choice.

The Gessoed Canvas

When you paint on canvas, a primer is a necessity if you are working with oil paint. Any open spots left unprimed will allow the oils to bleed into the fabric and, over a period of time, the fabric will rot. As we have seen, acrylic painting is entirely different. The paint will not harm the fabric and thus can be painted directly on the bare canvas.

Yet a gesso primer can be used for other reasons. First, it enables the paint to move more freely on the surface; the canvas offers much less resistance. This gives you more control over the painting. Second, depending on the color of the ground, it can enhance of the expression of your concept.

Most canvas is covered with white gesso. The brilliant white surface will enrich the intensity of the acrylic. Acrylic, by its nature, is not a strongly opaque medium. Thus the surface color influences, to some degree, how the paint is seen. If applied opaque but thin, the paint may need two or three coats to give a vivid solid-color tone. This is apparent when one is working over a dark undertone.

The white support can be used to advantage if some paint is intentionally put on transparently or translucently and surrounded by solid opaques. The transparent passages will "pop out" of the composition.

To preserve the natural color of the canvas, matte acrylic medium may be used as a primer. The medium looks milky in the container but will dry clear. Two coats will seal the support and let the paint move freely on the surface.

If painting on a canvas prepared in this manner, leave some of the canvas open and some areas glazed over in order to see the beauty of the fabric.

A gray-primed canvas can take on all kinds of different colors. Because of successive contrast or "afterimage," if an exposed patch of gray ground is surrounded by, say, a neutralized yellow-orange or raw sienna, it will appear to take on the complementary color, blue-violet. A gray canvas also helps the artist to think in terms of value. Whites and light values must be built up from the middle gray. The darker colors must be developed from the gray to develop the form and contrast in the composition.

A colored gesso, such as yellow, should be chosen to go with the dominant mood of the composition or as an undercolor complement. This can add to the strength and unity of the painting if the color is left open in some areas and allowed to radiate through veils of color in others.

There are many choices for the color of the primer of the canvas. When applying it, use two to three coats. The first one can be thinner with a small amount of water added. This will let the gesso penetrate the fibers of the fabric. The second should be thicker and can be used for the final coat.

Shown here are some flower studies utilizing the various colored primers to their advantage. Following these studies are some finished paintings using different colored grounds.

White-gessoed canvas is used to show the brilliance of color. Most acrylic, by nature, is not highly opaque. The white will, to some degree, show through the colors. It is an all-purpose canvas that can be left open or glazed and painted into.

This canvas support has been primed with a clear matte medium. This may be used when the beauty of the raw canvas is to be incorporated into the painting. It may be left open or glazed into, showing the stained canvas, as has been done on the upper area of the background.

The ground here is neutral gray. It has been left untouched in the upper negative areas to show what it looks like. Gray gesso will seem to be the complementary of the color to which it is adjacent. A gray canvas is easier on the eye when painting on-location. It also forces the artist to think about values.

A strong yellow ground has been used as the base here. Some of it appears in the poppy flower and stem, while thin applications of neutralized violet allow the yellow to radiate through in the upper negative areas. A colored ground can help give a strong statement of color.

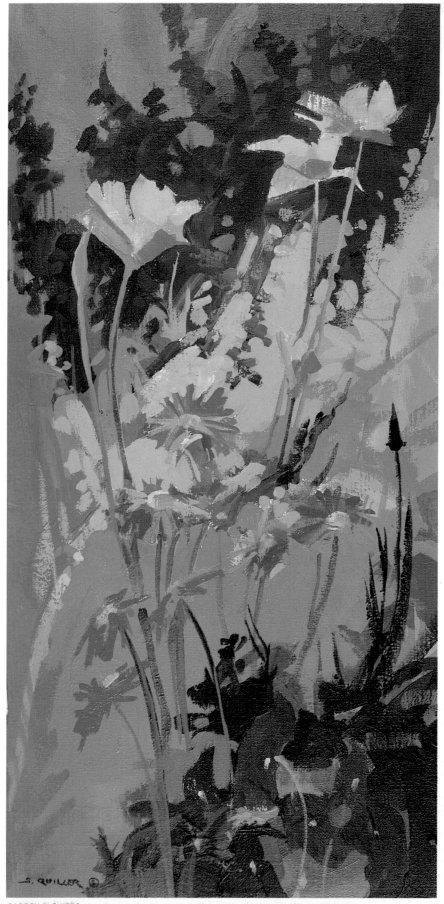

My flower garden was created to be painted. I worked with friends on the placement of the flowers, to coordinate the various colors, sizes, and shapes. The combination that struck me right away was the deep color-mass of the blue-violet veronica against the complementary yellow-orange California poppy. In this painting, the base starts with the low-growing deep violet pansies to the soft violet asters. These shapes are followed by the poppies and then the veronica. I selected an elongated, vertical canvas to help express the upward rhythms.

I chose to work with white-gessoed canvas because I wanted rich, luminous color. When the acrylic is used thin, the canvas will set off the color as the white of watercolor paper would. I selected Lascaux acrylics because they seem to be a more concentrated pigment. Working with the paint very loosely and quickly, I established the primary color relationships. I placed thick swatches of deep blue-violet adjacent to the more thinly painted yellow-orange poppies. At one point, there were two marigolds at the bottom of the composition. They were eventually painted out because their shapes and placement did not work. The values of the pansies, asters, and greenery were kept fairly close to help lead the eye to the strong, contrasting floral shapes in the upper part of the composition.

GARDEN FLOWERS. Acrylic on white-gessoed linen canvas. 10 × 20" (25.4 × 50.8 cm). Collection of Rosemary Kypecz.

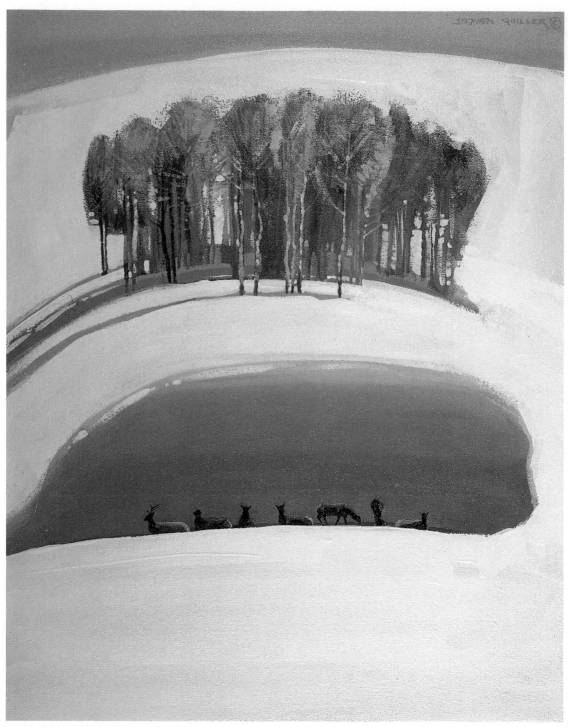

WINTER RHYTHM, ELK. Raw canvas primed with acrylic matte medium, 20 × 16" (50.8 × 38.1 cm). Collection of Sheri and Al Bridge.

Occasionally, while driving, I see a herd of elk feeding and enjoying the late afternoon sun near groves of aspen, which cast rhythmic shadow patterns on a hillside. I decided to combine these two elements and include a deep shadow pocket that would repeat the aspen forms. To get to the final painting, I refined and simplified many sketches. I chose to prime the linen canvas with acrylic matte medium. This would dry clear and show the beauty of the natural linen. The linen color was in keeping with the dominant color of the painting. In the aspen patterns there are many passages where I simply stained the linen and left it exposed. Elsewhere I used thick paint to set off and contrast the thinly painted areas in the trees. I kept the color very simple: yellow and yellow-orange, with their complements violet and blue-violet.

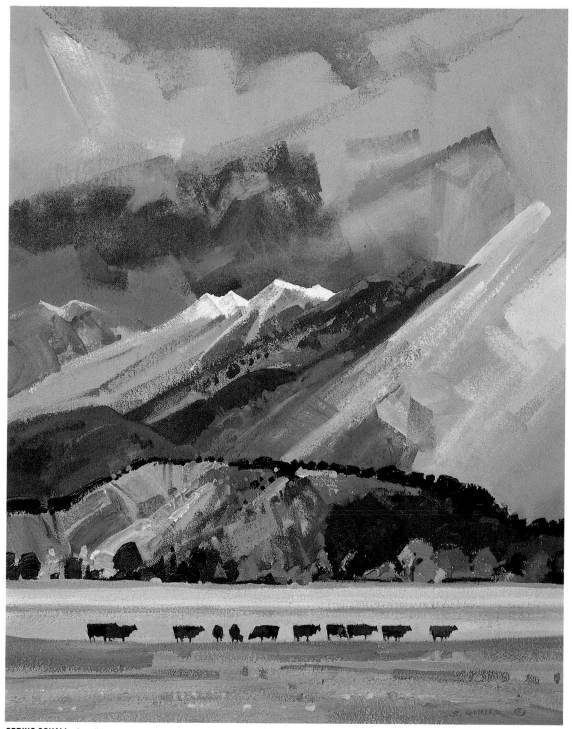

SPRING SQUALL. Acrylic on gray-gessoed cotton canvas. 18 × 14" (45.7 × 35.6). Artist's collection.

Spring is a special time for painting in the Colorado high country. Wind, rain, snow, sunlight—basically all the elements—can come into play. Snow may still be seen in patches, and yet various greens are beginning to sprout. Clouds are moving and shafts of sunlight intensify isolated areas of the landscape. One afternoon a line of cows, moving in to feed, created a nice banding effect in the lower part of the painting. I used a Daniel Smith gray-gessoed canvas to force me to think "grayed" atmosphere and strong value. I left the canvas untouched in some areas of the sky, mountains, and foreground, and the gray appears very different, depending on the color next to it. For instance, in the foreground hill, strong intensities of orange have been applied, so the gray appears blue-gray. In the foreground, neutralized earthy yellow-greens are scumbled across the canvas. In this area, the gray takes on a red-violet quality.

Paint Application

One topic that is extremely important to the success of an easel painting is the physical application of paint to the support. There is more to painting than just having a strong composition, good value, and harmonious color relationships. The paint application should have vitality.

Many times we find ourselves just filling in space with paint instead of making the passage exciting. I suggest that we need to think of sculpting with thick and thin paint. The paint should move with the contour or form of the object or space being painted. As the paint is applied, the artist should be absorbed with the process and make the paint *express* the tree or rock, figure or flower created. Let the paint vary from thick to thin and move the paint in a way that creates contour and texture.

There is a long history of painters who have used paint in this manner. During the Baroque era, Frans Hals, Diego Velàzquez, and Rembrandt were masters of this approach. Some Impressionist and Post-Impressionist painters handled paint in this way, such as Claude Monet, John Singer Sargent, Joaquín Sorolla, and Vincent van Gogh. The early Taos painter Victor Higgins sculpted masterfully with his paint. Contemporary painter Wayne Thiebaud uses juicy paint strokes while painting still lifes and freeway scenes. His paintings of pies and cakes, for example, have been applied in a manner that tempts one, almost, to lick the frosting.

Of course, there are many ways to put paint on the canvas. In the following study, a landscape, I want to suggest other ways to build an exciting paint surface. Landscape painters traditionally start with the sky and move down the surface to the middle ground, and then the foreground. I will start by painting a large, dark mass of trees instead. Then I add lighter and more intense color in and around the trees in order to build their shapes. I then layer paint in the foreground and work it negatively around the trees to form the clouds and sky. Putting paint on to form masses and define shapes can give some unexpected visual qualities and add excitement to the composition.

The canvas is primed with clear acrylic matte medium. I start by forming the masses of pinyon trees with thick, dark, and opaque greens, blues, violets, and reds. I charge the paint in with a fairly large brush. These tree shapes form a horizontal band along the lower quarter of the canvas. I apply a middle-value color field of blue-green to the foreground.

I come in with yellow-greens, greens, orange-greens, and blue-greens and start to build on those tree shapes. With light, bright color in and around the darker paint I give a feeling of backlighting. I use the paint very thickly and let the texture of the paint underneath influence each stroke. I then add a few notes of orange and red-orange to give a little pop and emphasis to this area. Yellow-green and middle-value green added the foreground help to break up the shapes. I paint blue-violet to red-violet clouds in a negative fashion to form the top edges of the pinyons. I repeat the banding of the foreground and trees with the movement of the clouds.

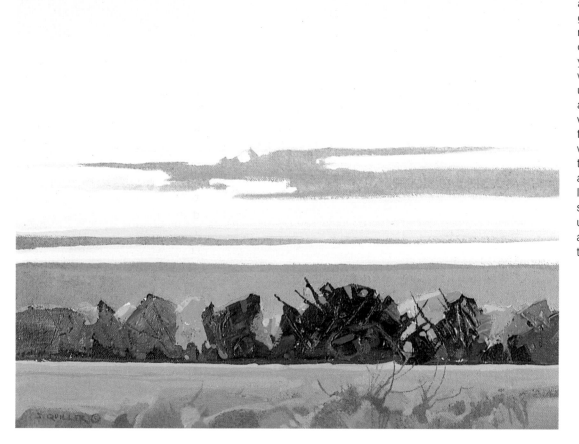

Now in the sky area I put in the golden light, next to the lower clouds, using a yellow-orange white. Moving upward, I go to a warm yellow-white and finally to a lemon yellow-white. I then paint the foreground and add some lighter and darker shapes to break up the space and add rhythm to the composition.

EXERCISES

EXERCISE 1: Sand and clean the surface of an untempered Masonite panel (6 × 9" or 8 × 10"). Coat it with a white acrylic gesso and finely sand the surface four times, leaving a smooth surface. Select a subject that has a lot of white, such as a floral still life, winter landscape, white buildings in rural setting, or an abstract. Use standard-body acrylics in an opaque application, but save the whites of the gessoed panel for the white shapes. Look for a nice pattern of these shapes in the composition. If any of the whites need to be toned or grayed, use a thin transparent wash. When finished, notice the contrast between the thickness of the opaque paint against the raw white or thinly stained white gesso.

EXERCISE 2: Prime a small cotton or linen canvas with a brightly colored gesso—orange, yellow, red, green, blue, or violet. Now select the dominant colors of the composition to contrast or complement the gessoed color. For instance, if the gesso is red, select colors like yellow-green, green, and blue-green plus white. These should comprise an analogous group of colors. Use the standard-body acrylic in thick opaques and build a composition leaving a show-through outline that

isolates the forms. Notice how the red gesso outline visually vibrates against the contrasting, dominant colors.

EXERCISE 3: Gesso a panel or canvas with a gray color. Pick a dominant color scheme from one color family—for example, yellow, yellow-orange, and orange with their semi-neutrals, raw sienna, yellow ochre, and raw umber. As you develop your composition, leave open a section of the raw gray gesso. When finished, stand back and note what happens to the gray. Your eye will see that it takes on the color that is the complement to the dominant scheme.

EXERCISE 4: Prime a raw cotton canvas with acrylic gloss medium. Start by staining the canvas with transparent standard-body acrylic mixed with the gloss medium. Build the transparency of the paint to show the beauty of the weave and color of the canvas. Now add some translucent color and a few opaques while leaving the most of the painting transparent. Work for nice relationships between these visual qualities. Focus on hard and soft edges and nice transitions between the shapes.

Mural Painting

Not long ago, I was commissioned to do an 8 × 40' mural on the north exterior wall of a building in the town of Creede, Colorado. It was sponsored in part by the Colorado Arts Council, the Creede Arts Council, and private donation. I was excited about doing this project in the hope that it would help tie the various industries of the community together and enhance the beauty of the main street. It was my challenge to put the elements of mining, outdoor recreation, wildlife, ranching, and the arts into a landscape composition that was indicative of our region and also representative of the four seasons.

I worked for two months in my spare time designing the mural. I did numerous sketches and color studies, gradually refining my idea. Eventually I worked not on a wall but on four plywood panels in my studio, each 8 × 10'. With volunteer help, I built a frame on the building, and attached the panels to the frame. It was important that each section work on its own and with the composition of the rest of the mural. I made sure that the main lines of each section connected with the main lines of the next section. Furthermore, I picked up key tones and color notes and repeated them from one panel to the next.

In the final study for the mural, the far-left panel represents mining history and winter, the second panel spring and wildlife, the third summer and outdoor recreation, and the far-right autumnal ranching and grazing.

I wanted this mural to endure, so I talked to conservators in museums and chemists at major acrylic manufacturers to find the best path to follow. Creede is in the San Juan Mountains of southern Colorado, at an elevation of 9,000 feet. The temperatures can get down to −25 degrees in winter and up to 85 degrees in summer. We see snow, rain, hail, sleet, and intense sunshine. The mural has now withstood two winters (as of 1994) but looks as fresh as when first painted.

The site chosen for the mural was in the downtown area, a place where one could stand back to look without poles or other buildings in the way. The owners of the building were receptive to and in fact helped with the project. But most important, the wall had nearly a true north facing. Thus, direct sunlight would not be touching the mural except for a short time each day during the summer months. Damaging ultraviolet rays would have little effect on the paint. A post and beam frame was erected flush to the wall at the site where the mural would eventually be attached.

Each panel consisted of two 4 × 8' sheets and one 2 × 8' sheet of an exterior-grade, 1"-thick treated signpainter's plywood board. Four 8 × 10' frames were constructed of 2 × 4" studs to hold the boards, which were attached together on the frame with wood glue and screws. Then wood filler was applied to fill in the cracks and cover the screw holes. When this was dry, a belt sander with a very fine sandpaper was used to give a uniformly smooth surface.

The back frame and panel were painted with three coats of oil-base primer to help protect against moisture and adverse weather. The front of each panel received three coats of white acrylic primer. The surface was then ready to paint.

PAINTING THE MURAL

I referred to my final study constantly as I worked. On the study I measured points where a line started on the edge of a section and marked it on the panel. For instance, one inch on the sketch would equal one foot on the panel. Borrowing an idea from Matisse, I used a 4' dowel rod and taped a charcoal stick to its end. I could then stand back and draw the essential lines of the composition of each panel. By measuring where each main line stopped on the edge of a panel, I could then measure and start with that line on the next one. I liked this approach to laying out the design much better than using a standard grid.

Because of its richness of color, versatility of handling, and permanency, I felt that acrylic was by far the best choice for an outdoor mural. I purchased quarts and half-gallons of Golden acrylic paint and also used some Liquitex colors.

This is the final study for the mural. Its dimensions are 8 × 40" and thus it measures in inches exactly what the mural does in feet. Notice the main linear elements that flow through the complete composition. I followed this study fairly closely as I worked on the large panels.

All the paint had a lightfastness rating of I or II, which means excellent to very good. The palette included titanium white, Hansa yellow light, Hansa yellow medium, vat orange, cadmium red medium, naphthol crimson, quinacridone violet, dioxazine purple, ultramarine blue, cobalt blue, brilliant blue (Liquitex), Jenkins green, and emerald green (Liquitex). I used some mural painting brushes (Richeson series 915090) that had long handles.

I applied the paint rather thickly. I was told by a leading chemist that the more pigment, the better for extending the life of the mural. When one panel was completed, I started the adjacent panel. When they were both finished, they would be placed together for additions or alterations.

Finally, I varnished with Golden matte varnish, an acrylic medium that would protect the pictures from damaging ultraviolet rays. Another feature I find very valuable is that it can be removed with mineral spirits. This means that any graffiti sprayed or drawn on the mural could be removed without disturbing the painting itself.

PUTTING UP THE MURAL

July 1, 1992 was the festive day! First, a large volunteer crew arrived to move the panels out of my second story studio. The weather seemed to cooperate. There could be no wind, for if it caught the broad mass of the panel, we would have a disaster. We obtained the forklift of the local lumberyard to reach to the second floor, where I worked. I removed the frame and glass window above my door, so there was room to slide the panels out, and even had a deck built so that the panels, once outside the door, could be maneuvered more easily to the forklift.

Each panel was removed gently from the studio and lowered and transported to the site by the forklift. The panels were raised and put in place by the forklift and crew.

Later, volunteers from the Creede Arts Council painted the wall frame and surrounding brick wall a light gray. They also had a protective roof added with a copper sheeting that is in keeping with the turn-of-the-century architecture of our area.

The panels as I worked on them in my studio. Fortunately, I have a lot of room and good north light with which to work.

Here we install the panels. Notice the frame built on the exterior wall.

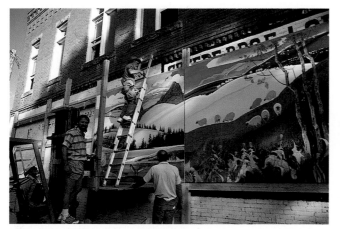

Each panel frame fits within the wall frame and essentially rests on it. The edges of the panels are then screwed to the wall frame. I made strip-wood molding frames and painted them in colors to go with each season. Eventually, these would cover the screw holes.

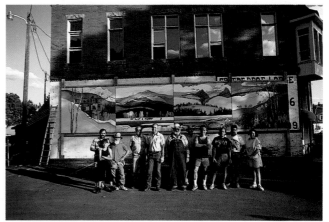

The key to the success of the mural raising was the fantastic volunteer crew. Although not everyone is pictured, you can see it was a wonderful and varied bunch. (Photos this page by John Gary Brown)

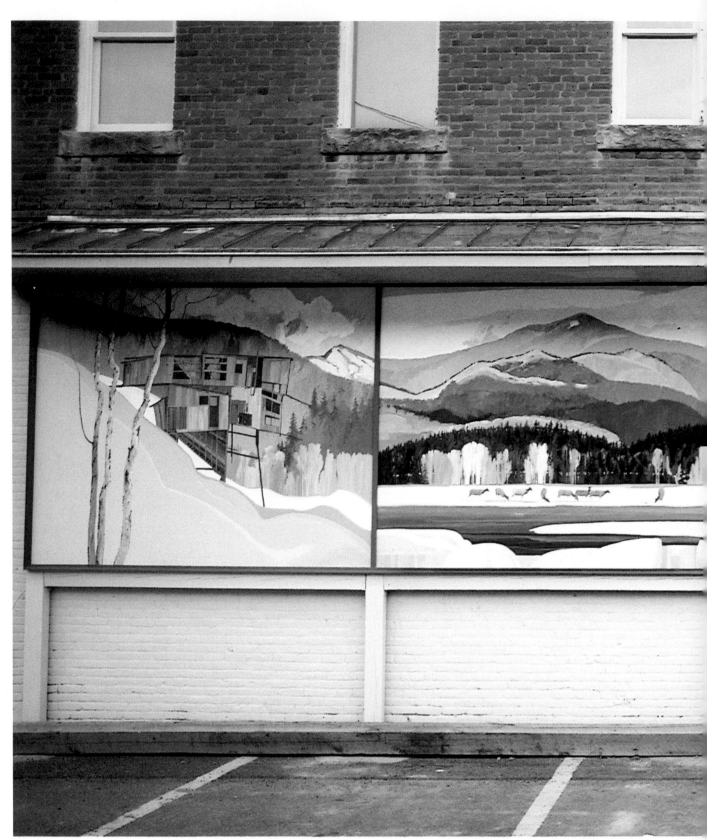

This is the finished mural as it looks today. With a north facing wall, treated and primed exterior-grade panels, primed and lightfast pigments, ultraviolet protective varnish, and a beautiful copper roof to protect it somewhat from the elements, the work will, I hope, be around for a long time. (Photo by John Gary Brown)

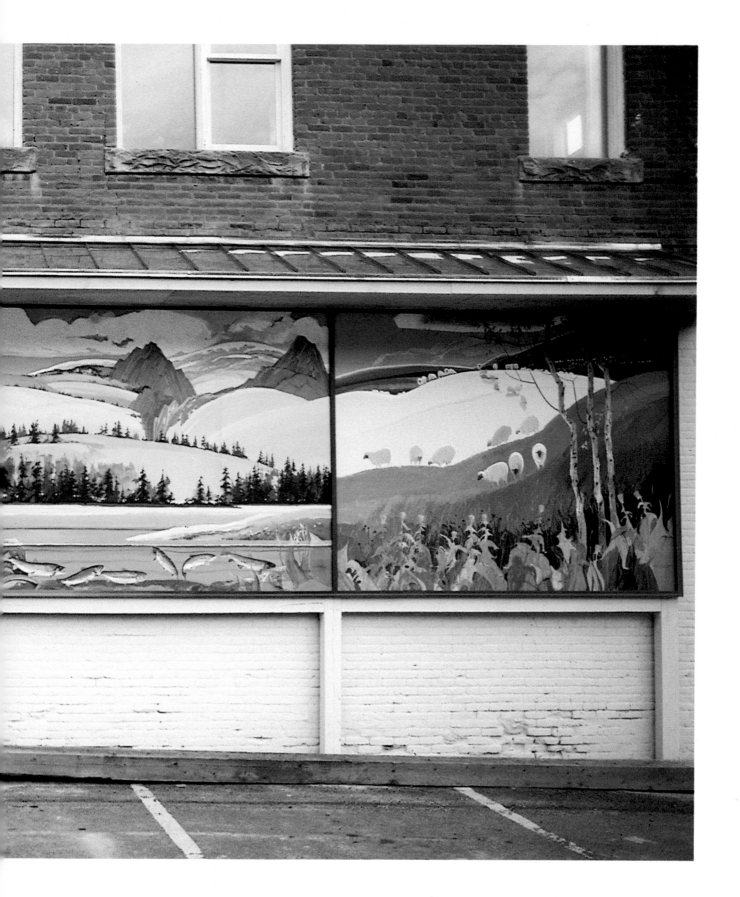

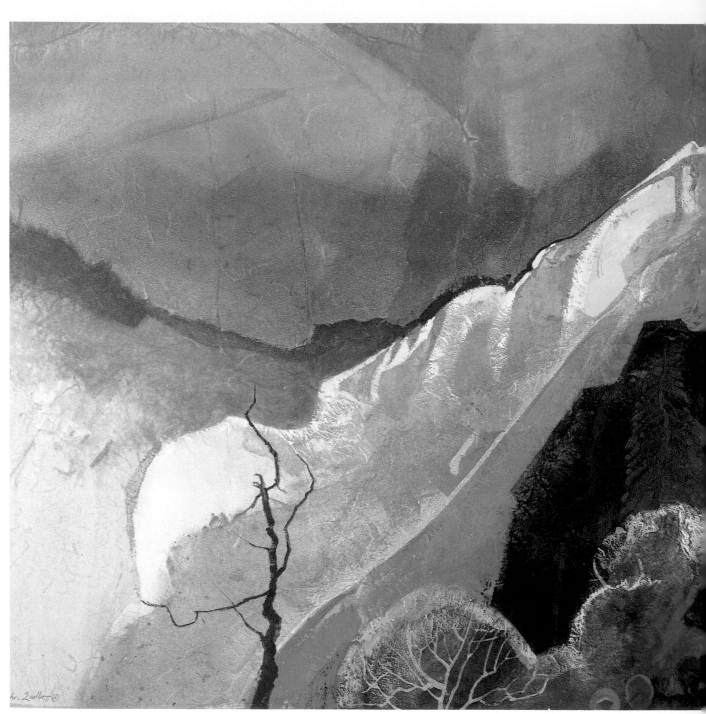

SAN JUAN STORM. Acrylic collage using standard-body, fluid, and metallic acrylics on rice paper, 22 × 34" (55.9 × 86.4 cm). Collection of Sherry Boeckh.

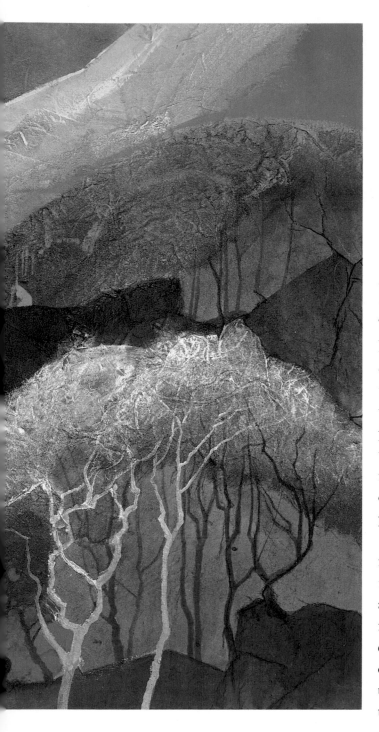

5

INNOVATIVE APPROACHES

In the last few years, there has been an explosion of different experimental acrylic-based paints and media, with new products coming out constantly. These media are simply tools that are made to help the artist express him- or herself. I encourage each painter to try these materials and explore their potential. They may help to increase your vocabulary and add to the painting experience, push you further, and give you ways of painting that were never before possible for you. They are meant to be used not as a crutch, not to dazzle or shock, but as an integral part of a successful painting process.

In discussing many of these media—including matte and gloss mediums; fluid acrylics; interference, pearlescent, and metallic colors; acrylic gouache; textural modeling paste; gel medium; and acrylic paste paints—I offer demonstrations, ideas, and finished paintings of my own showing some possibilities for their use. There are many other directions in which these media can be incorporated, so experiment, enjoy, and discover!

Glazing and Painting with Matte and Gloss Mediums

Acrylic matte and gloss mediums are simply composed of the polymer resin base for acrylic paint. The fluid appears milky white in the container, but it will dry clear and is totally insoluble once dry. These acrylics can be used in a number of interesting ways; they are, for instance, excellent as an adhesive for collage, as will be illustrated later in the chapter.

The choice of whether to use matte or gloss medium depends on the finished look desired for the painting. A semi-gloss finish can be achieved by mixing the matte and the gloss mediums together.

First, I will discuss glazing with this medium.

GLAZING

Here, I use "glazing" to refer not to the use of a watered-down, transparent paint, as in watermedia technique, but to painting with color that is mixed with the clear medium, retaining its full-bodied quality yet acquiring transparency or translucency.

Acrylic glazing can be used to give a painting depth and body. It also can lend a luminosity and an airiness that adds an exciting visual quality. It can be used as a matte to give an very natural look without a sheen, or used as a gloss to increase color intensity for a rich, shiny quality.

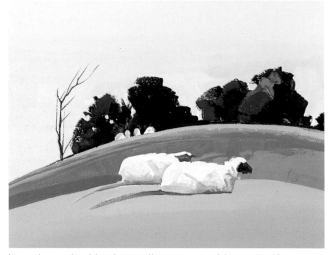

I used standard-body acrylic to create this pastoral composition with sheep. My palette is limited, and the motif has a curvilinear rhythm. I painted a soft, pale blue sky and strong lime green fields, with deep green and violet trees.

Next I simply created a yellow-orange translucent glaze by thoroughly blending a little cadmium yellow medium and cadmium orange light with a touch of titanium white. I mixed all this with a liberal amount of acrylic matte medium. I wanted to produce the hazy atmosphere of soft yellow-orange light that I see so often along our coasts. I painted the glaze in the sky, neutralizing the blue, and I added a touch more of the orange and glaze into the tree and the middle-ground hill. Having this common color tone for a glaze helps unify the composition.

Opposite page: The idea for this painting came from a dream I had at a time when I had made plans for the following autumn to be in Scotland teaching a painting workshop. I had been very excited about this and it had been on my mind. In the dream, I saw this seascape with the light and color that are in the finished painting. There were rolling hills and cliffs moving down to a sea of black. The far meadow had intense color and light, while the near one had a softer orange light; there was also light hitting the rain squall. Sheep moved on both hillsides. I woke in the middle of the night and did a quick line-drawing sketch and went back to bed. The next day I tacked the sketch on a wall of my studio and looked at it from time to time. A month later I set my palette with acrylic standard-body colors and started this composition.

To capture the change in light, I painted the entire painting in strong colors. I then mixed a soft orange glaze with matte medium and some acrylic and brushed it over the foreground hill to the bottom of the painting.

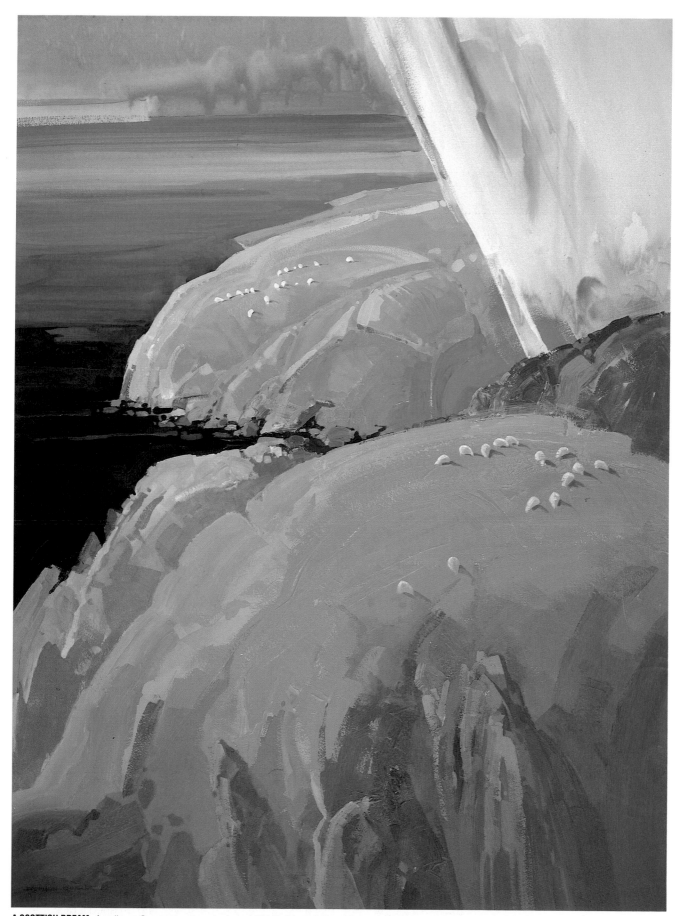

A SCOTTISH DREAM. Acrylic on Crescent watercolor board #5112, 24 × 34" (61 × 86.4 cm). Collection of George and Ruth Gilfillan.

PAINTING

Adding gloss medium to acrylic color can increase its brilliance and add depth of transparency as well as a juicy, painterly quality to the passage. I like working in a loose manner while using this approach. Using the gloss medium allows the mark of the brush to show. This example demonstrating this way of painting is followed by one of my finished works using the painterly gloss medium.

Here, I have mixed the color with a liberal amount of gloss medium to attain this loose, abstract, painterly effect. With a large round #12 brush, I push various tones of green, yellow-green, and violet-green paint around and complete the passage while the paint is still very wet. The visual quality of the paint is translucent and juicy.

Many times when I go in this direction I like to set things off with some opaque areas. I have put in some solid, opaque acrylic to produce the density and matte quality that sets off the translucent, painterly gloss medium.

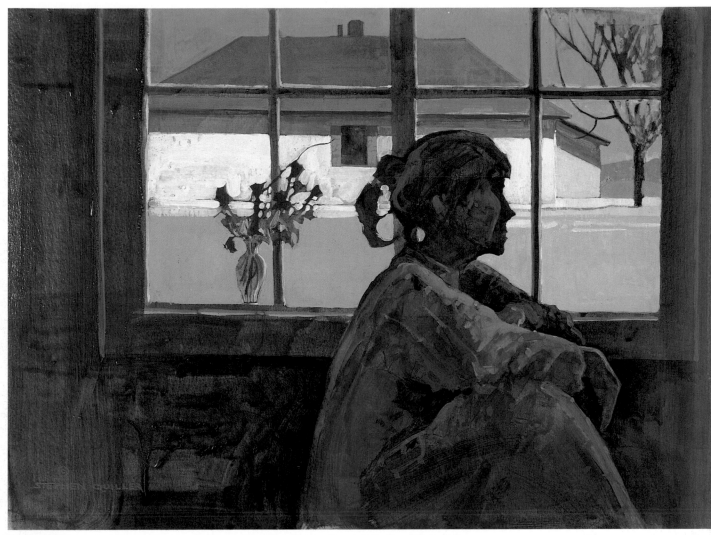

BLUE MORNING. Acrylic on Crescent watercolor board #5112, 9½ × 13" (24 × 33 cm). Collection of Marta Quiller.

Many early winter mornings I see Marta in her nightgown, sitting on the cedar chest by the window watching the morning news. I like the mix of blue light coming from the television and the winter daylight. I did a charcoal sketch and, after some rearranging, started this painting. I wanted the quality of thin, dark interior light contrasting with the more heavily painted exterior winter light. Thus, I decided to approach the painting using matte medium with transparent dark blues and violets for the interior. I left the brush marks and allowed some of the medium to drip in order to show this painterly quality. I then painted the sky, snow, and house very opaquely and much lighter in value to contrast the interior light. I washed a thin whitish blue glaze vertically on the right edge to give the sense of light generated by the television.

Acrylic Gouache

Another medium with the polymer resin base is acrylic gouache. It is a beautiful medium and differs from the standard-body paint in many ways. One important difference is that it is soluble once dry. Thus, the paint edges can be softened and passages can be changed at any time.

The visual quality of acrylic gouache is velvet matte It works well light over dark as well as dark over light. The paint is workable and painterly for large painting formats as well as for small. Extremely fine detail can be achieved, and the paint works well with mixed media drawing and painting applications. I have discovered that the Lascaux brand of acrylic gouache, made in Switzerland, has superior quality, and the color has a good lightfast rating.

Below are some studies demonstrating acrylic gouache applications. Following these studies are two finished paintings using this medium.

This is a detail of a finished painting done entirely with acrylic gouache. It demonstrates the solubility and lifting qualities of this medium. I lifted the reflection of the fallen dead tree on the right with a clean, damp brush. I gently massaged the brush on the paint, cleaned the brush with water, and blotted the area, continuing until enough paint was removed. The horizontal yellow-green band was first lifted from the blue-green paint down to the white of the paper. Then transparent lime green gouache was applied to the area.

This abstract study shows the beauty of acrylic gouache. The paint, with its rich color and velvet matte finish, has been applied both light over dark and dark over light to demonstrate its coverage power.

I first painted transparent violet, dioxazine purple, and ultramarine blue using standard-body acrylic. Once it was dry, I rewetted the surface and flowed on the acrylic gouache. First, there was a translucent layer of turquoise blue and white that veils the red-violet in the upper area. As I moved down, I put in yellow-green, greens, and blue-greens in a more opaque way. While the paint was wet, with a clean, damp brush I lifted color, allowing some color to show through. When the paint was dry, I lifted a few linear "fingers" with a crisper edge. Acrylic gouache highlights gave the picture a little snap.

This painting started very loose and painterly. As it progressed, I refined the shapes and developed more detail. I painted the fine leaves and flower buds last. Very fine detail can be achieved working light over dark with a small round brush.

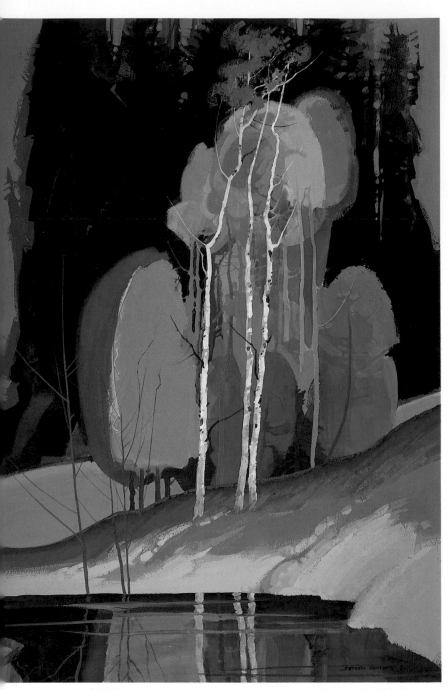

THE ASPEN STAND. Acrylic gouache on cold-press Crescent watercolor board #5112, 28¹/₂ × 20" (72.6 × 50.8 cm). Collection of Robert and Dixie Slater.

Left: Exploring a mountain trail, I found myself in a landscape that few people see. In addition to the dramatic peaks, there were stands of old-growth aspen. I climbed down a ravine and did some sketching. I focused on the curvilinear shapes, and noted the value and color. Back in the studio, I referred to the sketch as I did this painting.

I chose acrylic gouache for this painting because of the richness of color, the velvet matte finish, its strong coverage power, and the workable qualities of the paint. I first applied dark paint for the background spruce trees. Once dry, the light blue passages and areas of the sky were painted. Notice how the light opaque covers the dark color. I massaged some edges of the light green aspen foliage with a damp, clean brush. This softened the edges and provided an easy transition to the next passage in the painting. It also provided variation with the crisp, hard-edged shapes. Finally, I painted the thin, flowing branches of the aspen trees.

Opposite page: From my studio, I always notice this building at different times of day, and in late afternoon the sun rakes through some trees and forms these shadows for a few minutes before setting behind a mountain.

I used standard-body acrylic for the underpainting and acrylic gouache for the overpainting. I first washed in the sky with transparent acrylic, starting in the upper area with blue-violet and moving to the horizon with Naples yellow. Once it was dry, I rewet the same passage and used wet-on-wet acrylic gouache, pooling in the blues around the clouds, from an ultramarine blue to a cooler cobalt blue, down to the turquoise along the mountain edge. When the paint was dry, I lifted some of the soluble gouache to reveal wispy, light Naples yellow clouds. The acrylic undercolor does not lift.

Next I washed red-violet standard-body acrylic from the top mountain edge down. I wanted to unify the undercolor that would be the complement of the various yellow-greens of the mountain. Returning to the acrylic gouache, I developed the mountain and background areas, occasionally leaving bits and pieces of the red-violet showing through. The building is a good example of the opaque covering power of the gouache. First I painted the shadow color over the entire building shape. Gradually, I painted the light poking through the trees, and finally the windows and reflections.

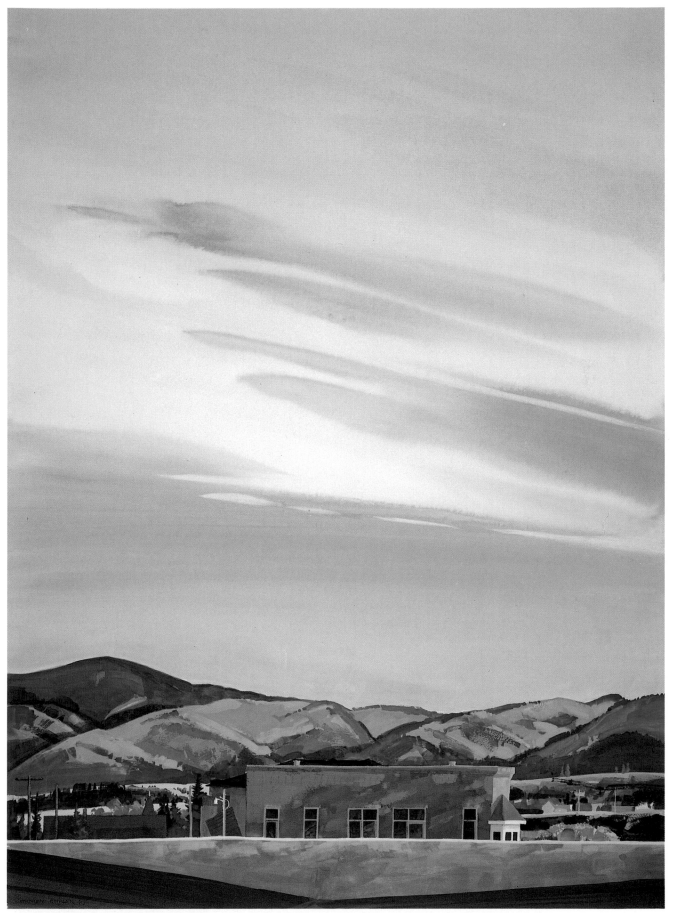

LATE AFTERNOON LIGHT, A VIEW FROM MY STUDIO. Acrylic gouache on Crescent watercolor board #5112, 20 × 29" (50.8 × 73.7 cm).

I was painting in my favorite canyon in the early morning. I noticed this scene and did a drawing focusing on the simple light and shadow patterns on the water and the foreground snags. The background trees were nearly the same value and intensity of almost neutral color. There was an interesting rhythm in the rock positions and crags. I tried to simplify to be rid of the excess detail and to capture the essence of the morning. The shaft of light was touching the water, creating the lime green strip, and it was hitting some rocks on the opposite bank. The light also hit two dead spruce trees and caught some of the rocks on the bank. There were deep blue-green pools and reflections on the water.

I used only Lascaux Aquacryl for this painting and chose it to try to capture the mood of early morning light. This acrylic watercolor has a velvet-matte quality that gives the feeling of stillness in the air. The paint is very workable, and I could soften some of the edges to lift the paint if I needed to. The solubility of the medium was very important to this painting. I lifted rock forms and a dead snag shape along the bank after the paint was dry. I also lifted the light strip on the water and added transparent lime green paint. Notice the transparency of the background shadows and trees, the translucent, cloudy veil on the central land form, the strong opaques of the red-orange spruce, and the sunlight on the dead snags and rocks. Of utmost importance was the strong contrast of dark water against sunlit lime green strip. I wanted the sunlight to dance from tree snags to rocks to water to rocks.

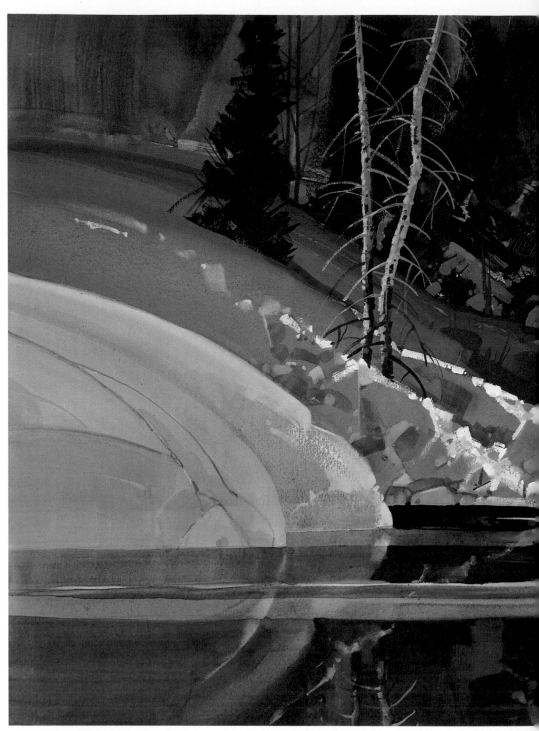

EARLY MORNING LIGHT. Acrylic gouache on Crescent watercolor board #5112, 18 × 29" (45.7 × 73.7 cm). Collection of Robert and Dixie Slater.

Interference and Iridescent Colors

Interference and iridescent colors are made with mica platelets coated with an extremely thin layer of titanium dioxide or—in many cases with the metallics—an iron oxide coating in addition to, or in the place of, the titanium dioxide. Refraction of light from the titanium dioxide layers produces various colors and effects.

The interference colors have the phenomenon of light interference at work. This is most familiar to us in the rainbow effect created by a thin layer of oil on the surface of water. Whenever light strikes a boundary between two materials of different densities, the light will be either reflected or refracted. Thus, the interference colors not only give off their own hue, but as light moves on the surface or the viewer changes position, a complementary sheen is transmitted.

Unfortunately, the printing inks for this book lack the special ingredients found in the paints and thus cannot convey their sheen in the reproductions. Nevertheless, the following studies demonstrate the use of interference colors. After these examples is a painting that uses them also. Throughout the rest of the chapter are additional paintings that also incorporate the interference and iridescent colors in other ways. See also the painting *Sea Caves* on page 122 for a use of these colors in collage.

In this study, I flowed transparent blue and orange fluid acrylic paint onto a wet surface. Once this was dry, I rewetted it and put in a wash of interference blue acrylic. The mica platelets transmit a blue sheen that enhances the blue wash, while contrasting the orange wash. As the light changes, this sheen will change to a buff orange.

This example demonstrates a different way to mix acrylic color to achieve thick, yet transparent, iridescent color. A small amount of fluid acrylic was mixed with a compatible interference color and combined with a generous amount of glossy acrylic gel. The thick body of the gel when mixed with these provides a transparent thickness that allows light to be reflected and refracted on many different levels. Here I have used this approach with blue, green, and orange fluid acrylics.

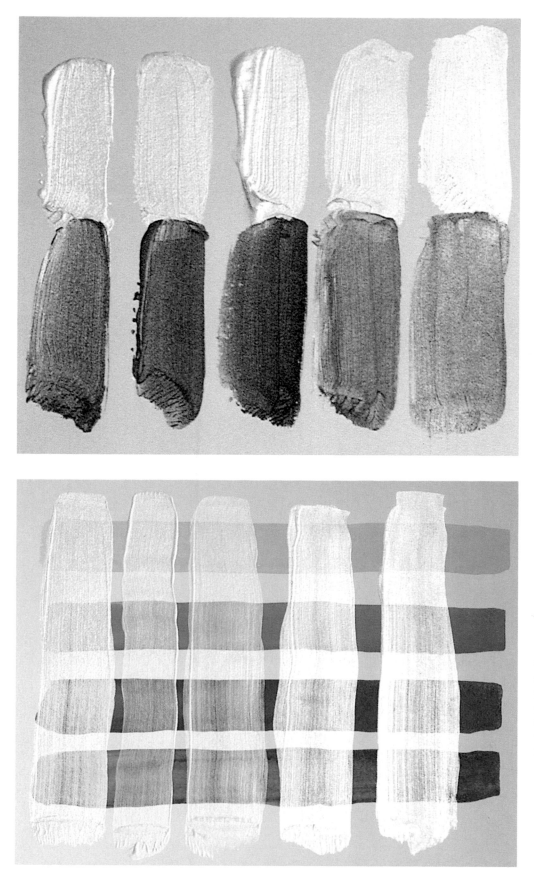

This diagram suggests how interference acrylic color looks by itself or combined with a very small amount of black acrylic. The upper paint strokes are interference colors placed on a white surface. These colors have no pigment themselves but have the color of their iridescent components. The lower strokes use the same paint, but this time are combined with a small amount of black acrylic. The carbon in the black paint sets off and enhances the interference medium and gives it some body. From left to right I used interference green, orange, red, violet, and blue.

In this diagram, I placed four horizontal strips of transparent yellow, orange, blue, and green. From left to right, I layered vertical strips of the interference colors green, blue, violet, red, and orange over the horizontal swatches. The interference blue strip gives the undercolor yellow a yellow-green sheen, neutralizes the orange with a bluish sheen, enriches the blue undertone, and makes the green appear a more lively blue-green sheen.

109

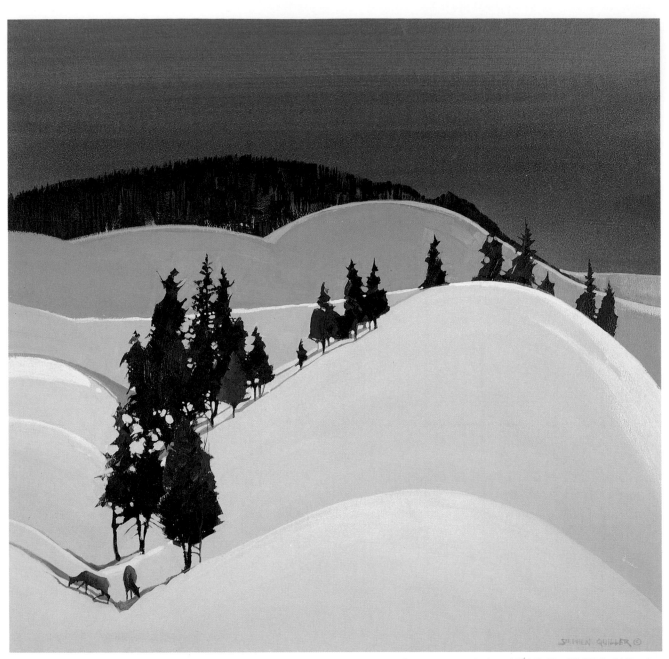

FEBRUARY FULL MOON, SAN JUAN. Standard-body acrylic, interference, and iridescent color on Crescent watercolor board #5112, 30 × 32" (76.2 × 81.3 cm). Collection of Sally and Forrest Hogland.

The inspiration for this painting came in February of 1993, during the full moon. At this particular time, the moon was at the closest it will be to earth in its orbit for many, many years. With the blanket of snow and the mountain forms, the moonlight created a beautiful monochromatic iridescence. As I walked around the scene in late evening, I could sense the ice crystals shimmering in the air. I wanted to try to capture that feeling and decided that the interference acrylic color should supplement my palette. The view is actually right out of my studio, looking up to some of the mountain forms above town.

I chose cobalt turquoise, brilliant blue (both blue-green colors), and cadmium red medium, which is the complement of the blue-green hues. Together, they mix a marvelous gray. Along with these colors, I chose ultramarine blue and

dioxazine purple to enrich and give depth to the darks and to enhance the wintry feeling. I also used titanium white and some iridescent white to lighten and tint.

I began by laying a transparent wash of the blue-green and red-orange mixed with interference blue over the entire surface. I worked on a nearly vertical easel and let the paint fuse downward. As the color settled and dried, the mica from the interference color transmitted the feeling of the particles shimmering. I intentionally kept the color limited to achieve the moonlight effect. From here on, I worked opaquely and focused on the rhythm of the painting. When mixing the snow tones, I added titanium white and some iridescent white. This contributes to the moonlight sheen on the snow.

Fluid Acrylics

Fluid acrylic paints are of a liquid consistency formulated from 100-percent acrylic polymer emulsion. The pigment levels of this paint are comparable to those of the standard-body acrylics. With this concentration of pigment, you can imagine the vibrant intensity these colors offer. The paint dries to a high gloss.

Before use, shake the container. The fluid acrylics can be thinned with water to obtain a paler transparent tone. These paints can be used on paper as well as canvas. I have used the fluid acrylics in other parts of this chapter, demonstrating additional ways they can be used. Here, I have chosen to show a poured-acrylic approach. From the late 1950s and early '60s, stained paintings, color-field paintings, and other abstract work have been done in this manner. Morris Louis and Helen Frankenthaler are two well-known contemporary painters who incorporate this method of applying paint into their work.

Oil on canvas was used for some early paintings done by pouring paint. Primer was not used on the canvas because the paint needed to stain the material. After thirty years, it has become evident that the oil attacks the cotton and linen fibers and that the paintings will not last. Acrylic paint, however, does not need a primer and will not harm the canvas. Paint can be poured directly onto either paper or canvas with permanent results. Below are two studies using fluid acrylics and a poured-paint approach.

For this study, I chose to use a cold-press sheet of Lanaquarelle 300-lb. watercolor paper. This paper is very white compared to some brands and will reveal the richness of color. The cold-press surface handles the wet approach well. I squeezed the fluid acrylic into baby food jars and added a little water to help the flow. I taped the paper to a thin plywood board and saturated the paper with water using a wide 2" synthetic brush. I then poured the fluid acrylics directly onto the vertical wet sheet and let the color fuse down. I used the colors diarylide yellow, vat orange, and ultramarine blue. Notice the brilliant color this medium has to offer.

In this study, I have used stretched raw-cotton canvas. I first wetted the fabric completely to allow the staining paint to be thoroughly absorbed into the fibers. I prepared the paint in baby food jars with a bit of water, and placed the canvas vertically on an easel. I poured vat orange, ultramarine blue, and phthalocyanine green onto the support. Notice how the paint interacts with the cotton fibers. When I completed the deep blue-green field to the right, I put some vat orange fluid acrylic, squeezing it straight from the tube, over this passage.

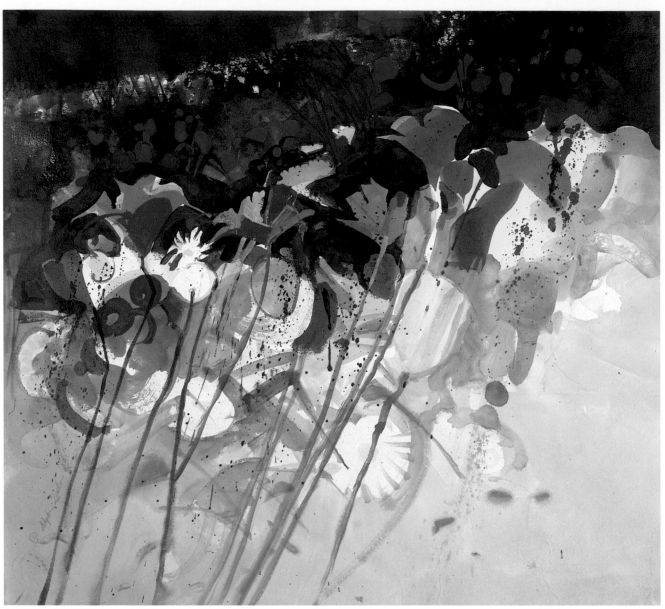

GARDEN IMPRESSIONS. Fluid acrylics on Hosho rice paper, 17 × 19" (43.2 × 48.3 cm). Courtesy of the Quiller Gallery.

Childe Hassam's beautiful Isle of Shoals paintings inspired me to do this painting. I referred to sketches done in my own garden and worked with fluid acrylics because of their high concentration of pigment. I chose rice paper because it has no sizing, so the paint bleeds into the fibers, totally coating them with intense color.

I emphasized complementaries here: the pure notes of red-orange against the deep field of blue-green. I worked the painting vertically on an easel and used round brushes ranging from a #6 to a #24. Starting with pure-hue reds,

red-oranges, oranges, and yellow-oranges, I developed a fairly abstract pattern. Then I painted around and through some of the warm colors with the deep blue-greens and blues. At points I actually laid the painting flat and squeezed some of the red-orange paint out of the tube onto the blue-green field—a more opaque application.

I was saving whites as I worked and covered most of the foreground with a diluted yellow-green. With a thin round brush I then added the strokes of middle-value green for the stems that break up the foreground with strong diagonals.

Metallic Acrylics

Metallic acrylic paints add still another option in the development of a painting. One must consider whether or not this medium will add to the expression of the statement. While not necessary for many images, it can be the perfect touch for some.

Metallic colors come in different compositions. The iridescent metallics are made with mica platelets, but an iron oxide coating is present either in place of, or in combination with, a titanium dioxide coating. Other metallic color is simply derived from highly reflective pigments. It is important to put a thin plastic spray coating or a thin layer of gloss medium to enhance

any iridescent or metallic colors and to protect them from future oxidation. Some of the metallic colors available include deep gold, pale gold, iridescent bright gold, iridescent bronze, iridescent copper (coarse and fine), iridescent copper light (coarse and fine), iridescent silver, iridescent stainless steel (coarse and fine), aluminum, and iridescent pearl (coarse and fine). A chart using many of these colors is shown on page 40. It locates them in relation to specific color hues. Look at the study of the finished painting here, and also see the finished paintings in the collage section (pages 120–121), where I also used some metallic colors.

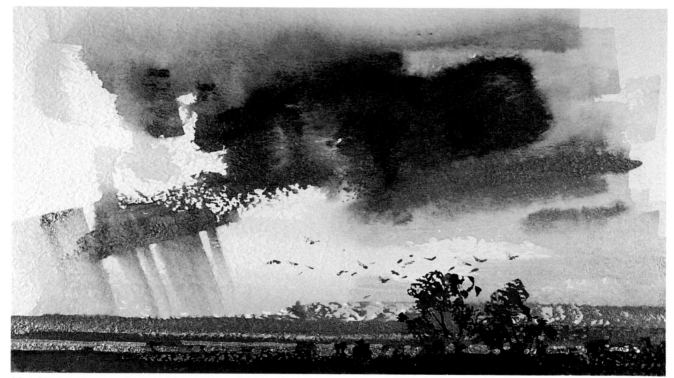

Metallic acrylics can be used in a range of ways. The sky is charged with transparent standard-body acrylic mixed with a generous amount of metallic color: deep gold, copper, and pale gold are in the washes applied to a very rough watercolor paper, whose texture collects the heavy pigments for a nice effect. Warm and cool strips are developed in the foreground, then dark blue and violet make the silhouetted trees and land. Opaque pale gold and aluminum acrylic provide pockets of light amid the dark shapes and repeat the banding rhythm.

THE YOUNG ARTIST. Standard-body and metallic acrylics, Conté pencil, and water-soluble graphite on Crescent watercolor board #5112, 19¼ × 17¼"
(49 × 44 cm). Collection of Allison Quiller.

I let this portrait of my five-year-old daughter Allison evolve
as it progressed. To give the work an ethereal quality, I first
applied a neutralized blue-violet wash to tone the entire
surface of my watercolor board. I then did a sketch using
brown and sanguine Conté pencils. To break up the
background space, I also lightly sketched two spirit birds,
representing guardian spirits or angels. Next I delicately
applied transparent acrylic for Allison's face.

I decided that the birds should be created with strong
marks and color. I wet the board's surface and put in deep

red-orange, violet, and blue. While it was still wet, I used
a soft water-soluble graphite pencil to make some harsh
lines to represent the birds' power. I now envisioned the
background negative space as having a Byzantine, gold-
leaf appearance. But it also needed an embossed texture
to lend it some play of light and shadow, so I thickly painted
the tree form using a gray gesso. When it was dry I filled
in all the space with Lascaux deep gold metallic acrylic.

I painted the duck pattern, which I found on a Greek vase,
in copper, green-gold, pale gold, and aluminum acrylics.

Textural Paste Acrylics

Modeling paste can be applied to any nongreasy surface, including heavy papers, boards, and panels. (Panels should normally be primed with acrylic gesso.) Paste is often used to model the surface for very textural areas. It can even be sculpted into a bas-relief, using a variety of tools to create texture. Sanding some of the passages where needed, when the paste is dry, is another possibility. I advise letting the medium dry naturally instead of using a hair dryer to shorten the drying time. Any tools can be used to apply the paste, including palette knives, fingers, sticks, coping-saw blades, and ceramic or sculpture tools. Once it is completely dry, thin transparent glazes of paint may be applied to allow the pigment to settle into the recessed areas; otherwise,

standard-body or paste acrylic colors may be applied to increase the tactile passages of the painting.

Paste acrylics are a heavy, thick version of the acrylic colors intended for textural, impasto painting. They are accordingly viscous and are normally applied with a palette knife. The palette knife is also used to mix the colors on a glass slab. Paste acrylics can be used in combination with modeling paste and transparently applied acrylics. They come in a selection of standard colors.

Shown here is an abstract study demonstrating both the modeling paste and some paste acrylic applications. Following this study is one of my finished paintings using a heavy textural approach with acrylic media.

I have applied modeling paste directly to a clean clayboard panel. I use a variety of sizes of palette knives, a coping-saw blade, and my fingers to apply paint and create texture. Here, I have raked the saw blade through the wet paste in a curvilinear fashion, leaving the narrow, parallel channels.

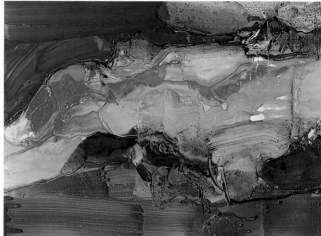

When the modeling paste is completely dry, I rewet the surface and wash on thin veils of color. Although I use fluid acrylics, any thin watermedia can be used at this point to create a variety of effects. I dilute and apply the yellow, orange, and blue thinly, letting the rich color seep into the recessed, textural passages.

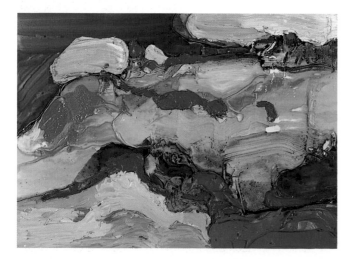

Now I add juicy applications of paste acrylics. These are of interest to artists wishing to paint in a very heavy and tactile mode. I lay on the turquoise, cobalt blue, and naphthol red colors with a variety of palette knives. To tint some of the color, I use a palette knife to mix white paste acrylic into the color on a glass slab.

SNOW SLIDE PATTERNS, WOLF CREEK PASS. Acrylic on Crescent watercolor board #5112, 28 × 18" (71.2 × 45.7 cm).

This detail of the central area of the composition demonstrates the contrast between the heavy modeling paste, the palette knife texture, and the paper support washed with transparent color. The paste is at least ¼" or more in thickness in some of the passages. Notice how the thin, fluid acrylic seeps into the recessed areas of the paste to enhance the texture. Furthermore, opaque standard-body acrylic is used in many of the tree forms, for contrast and variety.

Opposite page: I developed this painting from a series of drawings and an on-location watercolor done in late May at an elevation of 11,000 feet. The day was fairly warm, and the aspen leaves were beginning to emerge. I liked the contrast of textures between the rock slabs and tree patterns against the smooth snow and shadows. I thought it would be interesting to develop the contrast by building the modeling paste on a watercolor board in the rock and tree areas, while leaving the passages of snow and shadow untouched.

I began by using palette knives, coping-saw blades, and my fingers to develop the rock and tree forms. When the modeling paste was completely dry, I came in with fluid acrylics and applied thin veils of transparent paint to the rocks and trees. I applied the paint rather loosely, letting the color mingle and flow into the crevices of the paste. Once the paint was dry, I used standard-body acrylics in a very juicy manner. I was trying to work more abstractly, not desiring a lot of detail in the rock and tree areas. I finally added the shadow patterns using translucent to transparent washes of the standard-body acrylic. I began these shadows in the coolest areas with translucent turquoise, moved to transparent cobalt blue, and then to a bit of the blue combined with transparent permanent rose where the shadows approached the warm sunlight.

Acrylic Gel Mediums

Acrylic gel is formulated from 100-percent polymer emulsion. It has a translucent, milky appearance and dries a bit translucent. It can be purchased glossy or matte. Gel can be used to extend color and enrich its transparency, or to glaze with color. Any amount can be added to the acrylic color. The gel can be used to modify the body and viscosity of the color. A small amount will increase the body but not change the opacity. A large amount will make the color appear transparent while maintaining the thick, juicy body.

You can also use gel to alter the finished look of the paint, giving it a glossy, semi-gloss, or matte quality. Gel may also be used as an adhesive for collage, as I show later on.

Any nonabsorbent support face should be abraded with sandpaper to help with adhesion. Gel does require a minimum film formation temperature of 49 degrees Fahrenheit or 9 degrees Centigrade.

Shown here, along with a detail, is a painting using gloss acrylic gel in a variety of ways.

This detail reveals a variety of ways that the gels, interference, and iridescent colors were used in *Celebration of Spring* (opposite). In the upper foothill passage, I added plenty of gloss gel to the red-violet, green, blue-green, yellow-green, and orange strokes for additional body and translucency.

For the transparent veil of the deva wing, I used a thin application of gel with a bit of color and some interference color. This allowed the sketchy quality of the black Conté crayon to show through. In the land form, I applied thick strokes of gel with a little terre verte.

CELEBRATION OF SPRING. Standard-body acrylics, gel, interference and iridescent colors on Lanaquarelle 550-lb. rough, 25¹/₂ × 41" (64.8 × 104.1 cm). Artist's collection.

Being a landscape artist for many years, I cannot help but feel very close to nature. Watching the seasons come and go I notice the symbols that reoccur every year. This painting is part of my *deva* (angels of nature) series, and it's about how I feel every time spring arrives. I notice the leaves budding, flowers blossoming, ice thawing, and water clearing, and all kinds of colors radiating from the earth. This painting is not at all meant to be representational but is an inner-vision painting.

To fully understand my conception, I first did a well-developed study in drawing media and gouache on a toned, gray paper. I then put the study up and referred to it as I worked on the painting.

Using a large sheet of watermedia paper, I first applied a transparent wash of iridescent gray. This was mixed with

vat orange, cobalt blue, and a generous amount of interference blue. This toned the paper with an even, low, light-value gray. I then sketched extensively with a black Conté crayon with the purpose of leaving a lot of the line showing in the finished composition. I painted the devas with both thin opaque and translucent veils of interference color, white, and a small amount of either warm or cool acrylic. I used a generous amount of gloss gel in the tree and mountain forms, along with some interference color and a touch of pigment, to get a thick, juicy, transparent look. I used iridescent white in many passages, such as the sheep and blossoming fruit trees, for an opalescent radiance. For this painting, acrylic was the ideal medium because of its transparent, translucent, and opaque uses and its unique interference and iridescent paints.

Acrylic Collage

Collage is a natural for the acrylic medium. It can be developed in many different ways; for an in-depth look at collage I encourage the interested artist to read *Collage Techniques* by Gerald Brommer, published by Watson-Guptill (1994). Here, I show you my own approach to collage, which I normally use when painting from an inner vision.

I let the painting and paper tell me what is needed rather than an existing sketch or study. I may use gels or matte medium as an adhesive, standard-body acrylics, fluid acrylics, acrylic gouache or watercolor, and metallics and interference colors—anything can happen and usually does. Here is a step-by-step demonstration of this approach.

I begin by taping my support to a plywood board. In most cases I use Crescent watercolor board #5112, a totally acid-free support, including the backing. I place it vertically on an easel and wet it thoroughly. I cover the surface with a 60% gloss medium and 40% water mixture. I then start tearing and adhering rice papers to the surface using a 1¹/₂" flat brush and the medium. My favorite rice papers are the *unryu, hosho,* and *chiri.* I cover the support completely, using the less textured papers in the larger, outer areas, and the heavily textured ones in the areas of emphasis. If the papers crease or fold, it contributes to the texture. However, I do brush out the unwanted air bubbles that are sometimes trapped.

While the paper is wet, I flow transparent standard-body acrylics over the surface The paint creeps into the paper's fibers. I have no conscious image in mind but let the shapes and texture of the paper indicate the composition. I choose turquoise deep, brilliant blue, phthalocyanine blue, cobalt blue, dioxazine purple, and the contrasting color, cadmium orange deep. I leave the paint to dry before going further.

I look at the shapes and see some forms developing. Working with darker values and stronger intensity, I lay the color on and build the composition. I am aware of the texture of the rice paper and try to use it to its advantage. I use the flat side of the brush and lightly drag it across the fibers, leaving paint just on top.

I use metallic silver and paint the negative space around the bird shape. I scumble it into the rice paper in the upper-left area to give an impression of frosted tree forms, and I also touch some of it into the foreground. I add a few accents of red-orange and I'm done.

Recently, I have been experimenting with acrylic collage. I have found that my collage approach draws from my more free-form, intuitive nature. Starting with the fluid acrylics and the wet, textured rice paper (as developed in the previous sequential study), I flowed on the color and let it indicate the shapes that I should follow. In this case, I began to see coastal cliffs and sea forms, and developed the work in that direction. I used the standard-body paint in some places in an opaque manner to give contrast to the transparents. I painted interference orange on some of the edges of the cliff forms, and then added the deep and pale gold metallics. Sometimes this image also seems like tree roots that move upward to tree branches. The ambiguity of the forms is interesting to me. The sheep were added to represent the spiritual side of nature.

SEA CAVES. Standard-body and fluid acrylic, interference and metallic acrylic on Crescent watercolor board #5112, 34 × 26" (86.4 × 66 cm). Collection of Duane Block and Susan Cook.

122

I did this painting by laminating rice papers on watercolor board and flowing acrylic watercolor over the surface while it was wet. When I work in this direction, I explore my intuitive side. I let the paint move freely and react to the shapes that are being created on the various torn, textured rice papers. Shapes of spruce trees and water emerged in the predominantly blue-green painting. I then used fluid acrylics to add depth and richness to the sky and some of the tree passages. I applied standard-body acrylic opaquely to give substance and contrast to the transparents. Finally, I added the metallics to give richness and life to this fantasylike painting.

The note that pulls the composition together is the electric red-orange ribbon that runs horizontally across the lower part of the painting. It is set off by the surrounding complement, blue-green. I place sheep in the image, moving across the channel at the bottom of the composition.

THE CHANNEL. Fluid, standard-body, and metallic acrylics and acrylic watercolor on Crescent watercolor board #5112, 35 × 27" (89 × 68.6 cm). Collection of Dr. Randy and Teresa Snook.

EXERCISES

EXERCISE 1: Paint a composition, using any support with transparent, translucent, and opaque acrylic. Keep in mind while doing the painting that you will be covering the work with a transparent colored glaze. Select colors that will be in the same color family or in contrast. When the subject is completed and the paint is dry, tint the matte or gloss medium and glaze the painting to create the desired mood.

EXERCISE 2: From your sketchbook or photograph file, select a simple composition. Do not try to duplicate a photo's color, but instead work with color relationships that are selected from Chapter 2. Use a watercolor board for the support and use the color transparently, mixing each brushstroke with a generous amount of acrylic gloss medium to give the paint body. Treat this subject in a very painterly way. When the application is dry, work with some opaque acrylic and paint in and around some of the shapes to set off the first procedure.

EXERCISE 3: Use two complementary acrylic gouache colors: ultramarine blue and orange plus white. Do a series of studies working transparently, translucently, and opaquely, with both underpainting and overpainting. Lift the color to get back the white of the paper and glaze over the passage. Work in a painterly fashion and paint light over dark with a very small brush, adding detail. Explore the medium.

EXERCISE 4: Try a collage using the methods described in this chapter. Laminate various textures of rice paper to a cold-press watercolor board. While it is wet, flow either fluid acrylics, acrylic watercolor, or transparent standard-body acrylics over the surface. Use just four or five related colors. When it is dry, develop some of the shapes with opaque color. Glaze over some areas of the composition with interference colors. Finally, set off some shapes and highlight areas of the study with opaque metallic acrylics.

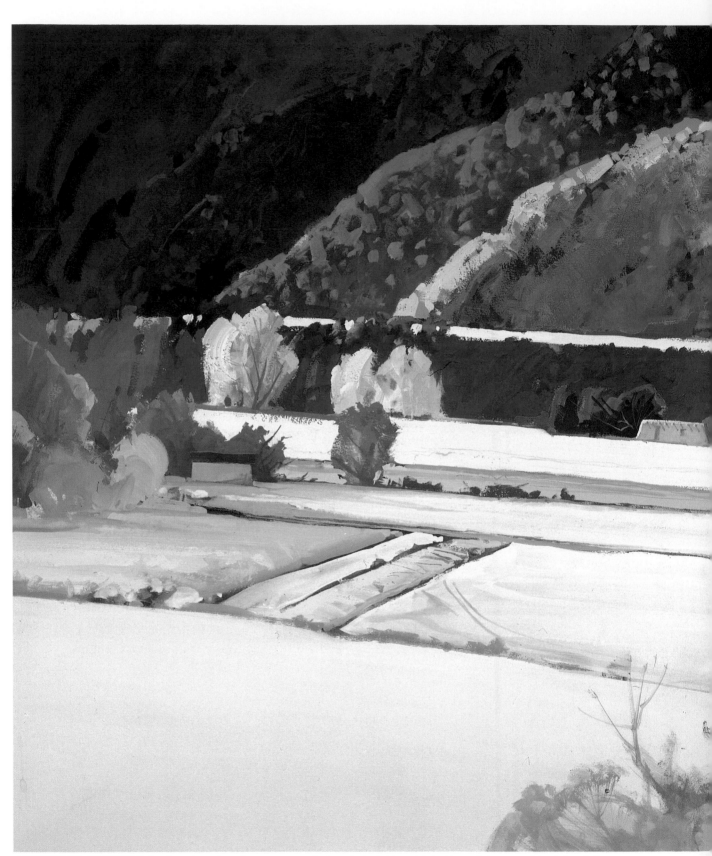

LATE NOVEMBER, VALDEZ LIGHT. Acrylic and casein on Crescent watercolor board #5112, 26 × 34" (66 × 86.4 cm). Courtesy of the Quiller Gallery.

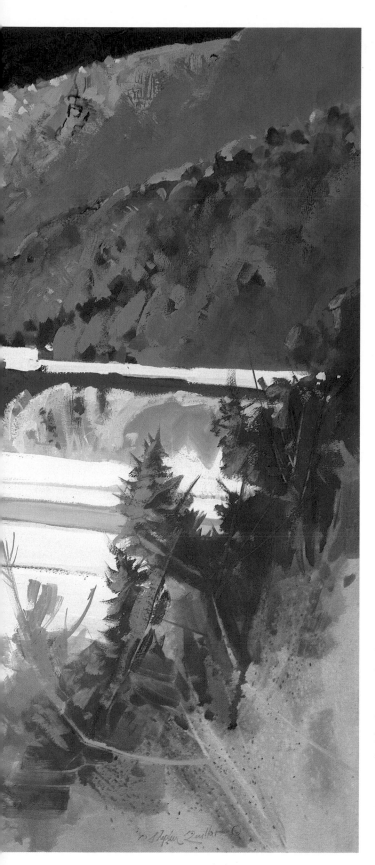

6

INTEGRATING OTHER MEDIA

As has been demonstrated, acrylic is by far the most versatile of the media currently available. In most watercolor exhibitions today, you will see opaque and transparent watermedia combined with drawing media and collage paintings taking top awards. Acrylic is central to many of these paintings, yet also this medium combined with other media gives painters a wonderful range of ways to apply paint to paper. I have been combining acrylic with other media since 1970 It is important whenever combining media to make sure that they integrate and that one of them is not just an afterthought. Just as I strongly feel that the artist should know the craft of painting, I advocate that he or she have available a full vocabulary for artistic expression.

In this chapter I cover a variety of ways to combine acrylic with other media. I will illustrate possibilities through studies and some of my finished work, but keep in mind that there are many other directions and possibilities for the uses of the combinations than are shown here. After reading the chapter, give some a try. Exploring these combinations can be quite exciting.

Acrylic and Watercolor

There are many ways to combine acrylic and watercolor. The advantage of using them together is that acrylic is insoluble once dry, while watercolor is soluble. Playing with the lifting of watercolor used over various transparent or opaque acrylic bases can produce some beautiful effects. Below are two possibilities for combining these media.

In the first study, I demonstrate a method developed by noted watercolor painter Jane Burnham, in which gel medium is used to seal a rough watercolor paper and heavily pigmented watercolor is put over the gel. The second study employs acrylic gesso as the seal for the support, a method universally used by artists for quite some time.

I choose a very rough-textured watercolor paper, Schut (made in Holland), and coat it with slightly diluted acrylic gel so that the surface is sealed completely. When the gel is completely dry, I charge the surface with heavily pigmented watercolors. I use ultramarine blue, manganese blue, cobalt violet, burnt sienna, raw sienna, and viridian. I vary the value and intensity and let the pigment settle in the recesses of the paper.

I use a damp, soft ³/₄" flat watercolor brush to gently massage the paint, blotting it with a paper towel. This is called a *subtractive* method—removing rather than adding paint. I regulate the lifting by lightly dragging the brush to remove a little paint from the surface, either leaving behind the recessed paint or working the area heavily and blotting to remove all the paint. Modulating the lifting will reveal the abstract value pattern of the composition.

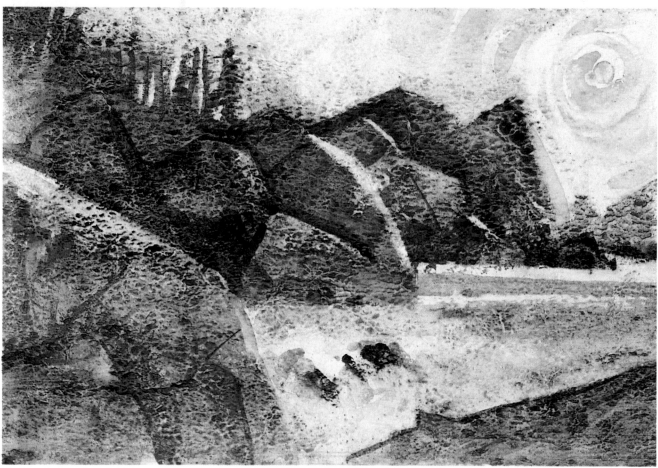

I now apply paint in an *additive* method. I glaze on warm tones of transparent watercolor for a feeling of warm light and water. I add dark, crisp shapes and edges using ultramarine blue, burnt sienna, and viridian watercolor to define the rocks.

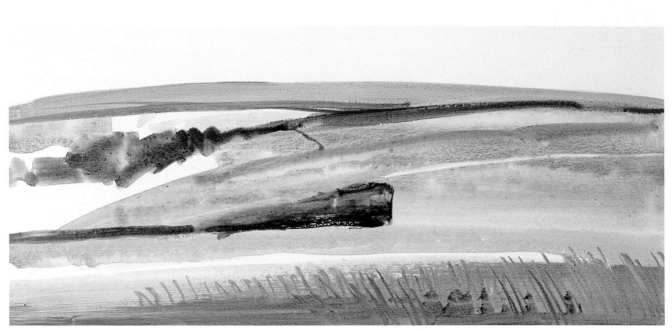

Here, a smooth surface is best—Masonite, watercolor board, hot-press or cold-press paper. In this example, I coat Crescent watercolor board #5112 completely with white acrylic gesso. This seals the surface and gives a slick, sliding feel to the application of paint. When it is dry, I apply transparent watercolor loosely to let the paint move and slide. I work with abstract shapes, referring to a drawing from my sketchbook.

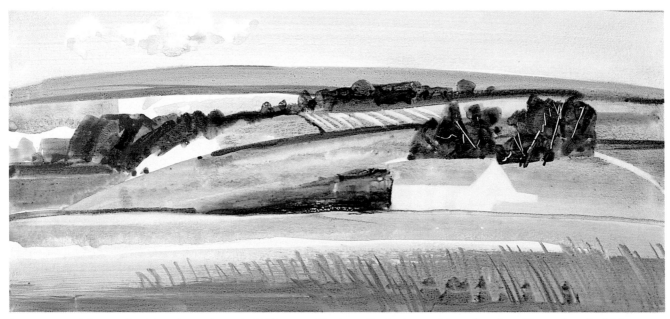

I now start adding and subtracting color to build form and texture. For instance, I tone the sky with a pale cobalt blue and, while it is wet, lift with a damp brush to reveal the white, forming the cloud shape. Then I add dry, pale tones of cool and warm to define the cloud. Notice in the foreground trees how easy it is to scrape back to white while the watercolor is still wet. At this time, I also lift to the white shape of the house.

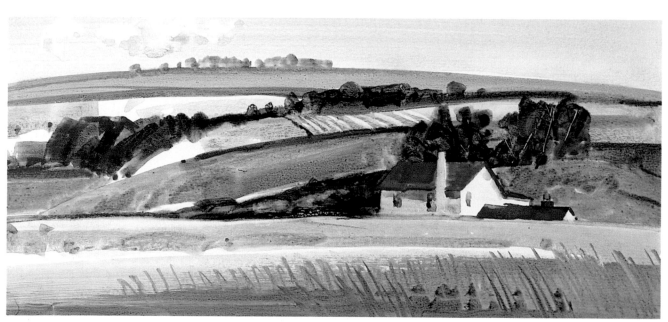

Now I define other forms. The shadow and the light of the cottage are added, as is the red-orange roof. I glaze in some areas and add the distant tree forms. I add complementary reds to some greens.

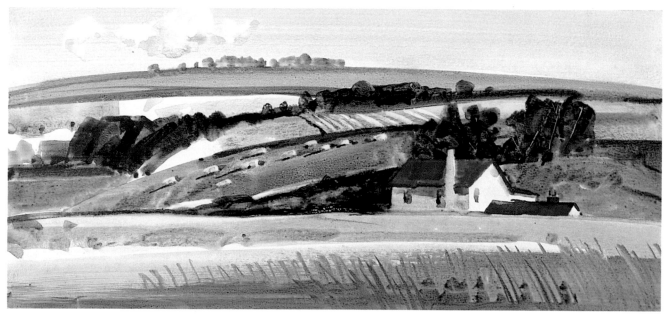

Finally, I add the sheep to the meadow by lifting color to get whites. A few dark touches define them with shadows, and the study is completed. Especially note that paint settles differently on this surface from the way it does on uncoated paper. Paint can be pushed around and lifted very easily.

Acrylic, Watercolor, and Gouache

Now I want to move one step further and introduce gouache to the acrylic and watercolor combination. Gouache, an opaque watercolor with a soft, chalky, matte quality, can be used transparently, translucently, and opaquely. The binder for both watercolor and gouache is gum arabic. Thus they handle much the same way on the brush. They are both very compatible with acrylic.

The main reason for using these media together is to play the vibrant transparency and insolubility of acrylic as an underpainting against the transparent to opaque visual range of soluble watercolor and gouache. The following is a progressive study demonstrating my method. After the study are two finished paintings displaying various possibilities with this mixed-media approach.

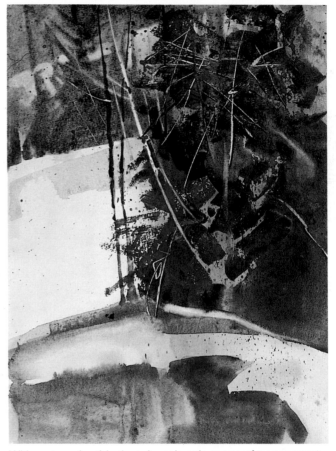

I first apply a transparent acrylic wash with warm yellows and oranges and let it dry completely. The stronger oranges are positioned where I will eventually want more emphasis in the painting. When dry, this wash is completely insoluble.

With watercolor this time, I wash pale tones of transparent blue, violet, and green into the upper region, over the acrylic, to suggest background forest, and then I develop darker foreground trees. While the surface is wet, I use a clean, damp flat brush to lift out the watercolor and show the warm undertone of the acrylic. Notice the scraped texture in the darker tree forms: I use a pocket knife to scrape back to the yellow layer while the paint is damp.

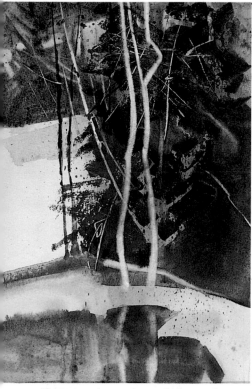

Taking a clean, damp #10 round
brush, I lift the shape of the main
aspen trees. The brush removes the
soluble transparent watercolor to
reveal the warm, transparent acrylic
undertone. I focus on the relationship
of the abstract patterns between the
two main aspen trees.

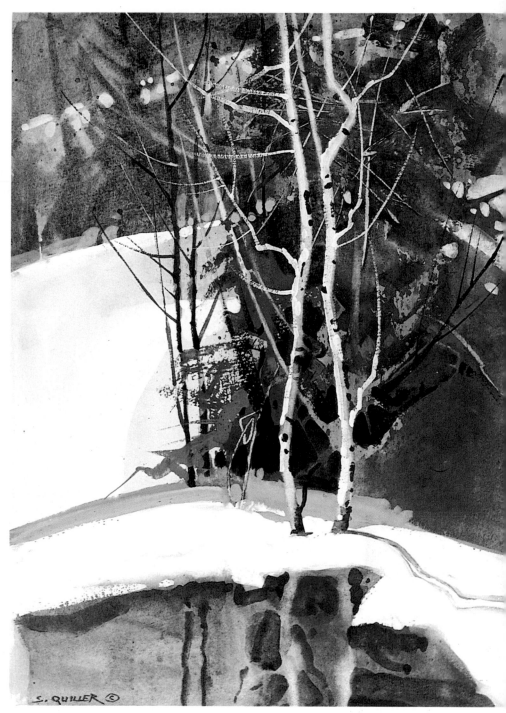

Now I charge in the gouache, building translucent pockets of light in the upper
background spruce and a soft, cool blue veil on the yellow left field. I apply
stronger, cool opaque gouache in the foreground snowbank and use opaque
and translucent gouache to develop the aspen forms. I then go back to the
watercolor to put a bit more emphasis on the reflections.

Among my favorite subjects are the winter landscapes in the San Juan Mountains where I live. I never tire of painting their rhythms and light. While cross-country skiing, I made sketches and took notes for this painting, which I executed in my studio.

There was a warm yellow light that I wanted to emphasize in the painting. I first washed on a transparent acrylic tone of this color, in order to allow it to radiate through the overpainting. I used watercolor and white gouache for the rest of the painting. I rewetted the paper and charged transparent watercolor onto the surface, developing the large mass and shadow areas, then the background tree patterns and texture. When it was dry, I added some of the foreground spruce. I lifted color for the foreground aspen trunks with a damp clean brush, exposing the warm acrylic undertone. I then applied gouache and watercolor to create the bark and branches. Finally, I painted an opaque to translucent gouache to form the frontal sunlit snowbank and shadows. Notice how the warm yellow underneath unifies the final composition.

FEBRUARY LIGHT. Acrylic, watercolor, and gouache on 300-lb. Lanaquarelle rough, 29 × 20" (73.6 × 50.8 cm). Collection of Richard and Cathy Ormsby.

BEAVER POND, DEER HORN PARK. Acrylic, watercolor, and gouache on Crescent watercolor board #5112, 26 × 34" (66 × 86.4 cm). Collection of Grant Heilman.

I have painted many compositions from this site during different times of the year. However, this composition proved quite different, for the reflections became the focus. At this beaver dam, the animals work diligently every night, and new aspen logs float on the pond every morning. I actually did the entire work on-location on a large easel.

I approached this painting differently. I used watercolor totally in the upper horizontal strip of sunlit willows, aspen, and spruce. I painted the majority of the composition, creating the dam, water, reflections, and floating logs with acrylic and gouache. I chose watercolor for the upper horizontal passage because it would best give the feeling of transparent sunlight, and I could still lift and move the

paint around, as I did in the shadow area. I then washed on transparent acrylic, covering the entire beaver pond. I tried to capture the atmosphere of murky yellow-greens, in the upper area, to murky greenish red-violets in the lower. While it was wet, I used dark, transparent acrylic to develop the reflections. When the surface had completely dried, I rewetted it and put opaque and translucent blue-white gouache in and around the forms to establish the feeling of cloud reflections. I let it dry again and used a clean, damp brush to lift some of the gouache, revealing the acrylic underpainting and developing the water patterns, as seen in the upper-left central area. Finally, I applied opaque gouache to the logs along the dam and the closest floating forms.

Acrylic and Casein

I especially like to use the combination of acrylic and casein in my painting. The transparent color of acrylic is vibrant as an underpainting with the translucent and opaque velvet-matte of casein as the overpainting. A translucent veil of casein allows the acrylic to radiate through in some areas; it can be scraped away in other passages. Then casein will sometimes be used opaquely, covering the acrylic underpainting with some solid shapes. Many times I will work with complementary relationships as well as the interaction of the different media in the underpainting and overpainting.

Casein is a milk-based paint that uses the curds of milk for the binder. It is a fairly fragile medium, in the sense that the paint is rigid and somewhat brittle when dry. Thus, when working in a juicy, opaque way, it is important to use a heavy support. I recommend a 300-lb. watercolor paper or board. Masonite panels can also be used. Casein has good opaque covering power; light over dark areas can be worked easily. Moreover, both broad areas of color and fine detail can be achieved. With proper care in the choice of materials, the medium is very permanent. It has a blonde, velvet-matte finish that looks and feels unlike any other medium's. Over time, the paint becomes completely impervious to water. Another advantage to casein is that it is very reasonably priced.

Casein is gaining in popularity with today's emphasis on watermedia. I use the same synthetic brushes for casein that I use for all my watermedia painting, being careful to clean the tips and heel of the fibers with soap and lukewarm water after use.

The following is a study using the combination of acrylic and casein. It is fairly typical of my methods when working with these two paints. Following this are three finished paintings demonstrating the interaction of these media.

Using a heavy cold-press watercolor board, I wet the surface and charge transparent, warm acrylic over the entire format. I will be coming into the upper area with green and blue-green casein, so I choose the complements red and red-orange. The lower snowfields will be yellow-white and violet-white, so I have selected the warm yellow acrylic underlayer.

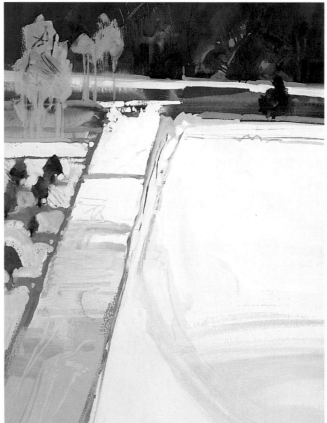

In the upper background area, I paint in greens, blue-greens, and a touch of violet in translucent and opaque casein. Some of the underpainting radiates through. In casein, I develop the lower field patterns with warm yellow-whites and cool blue-violet whites. In some areas, I scrape back through to give texture and to reveal the underpainting. I also apply a neutralized violet for the general tree shapes.

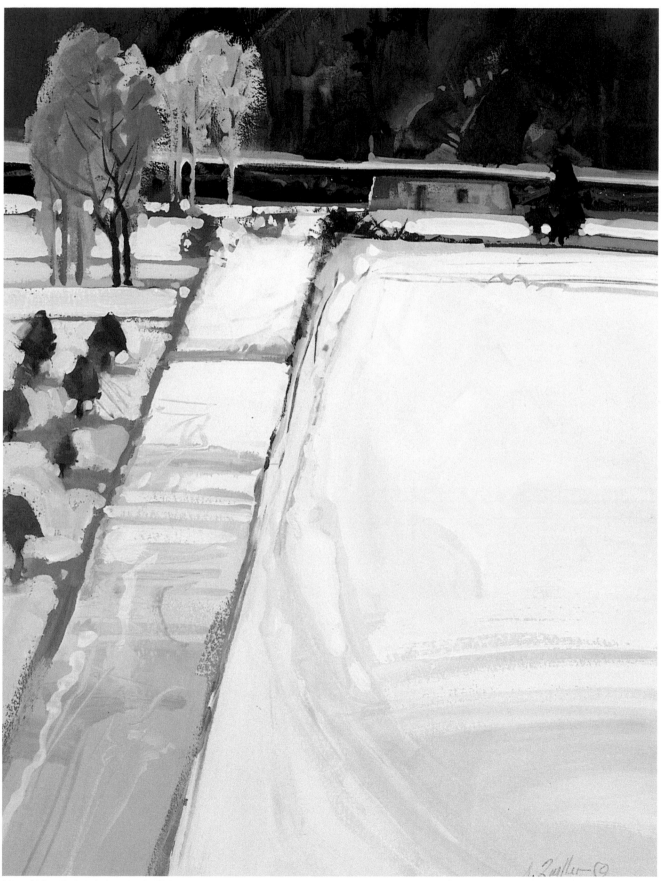

Now I simply use opaque casein to pull the composition together. I build the dark value in back of the adobe and let it weave through the back of the cottonwoods. I finish the trees, their highlights, and some of the background field patterns. I add some cool violet-white patterns to the foreground snow.

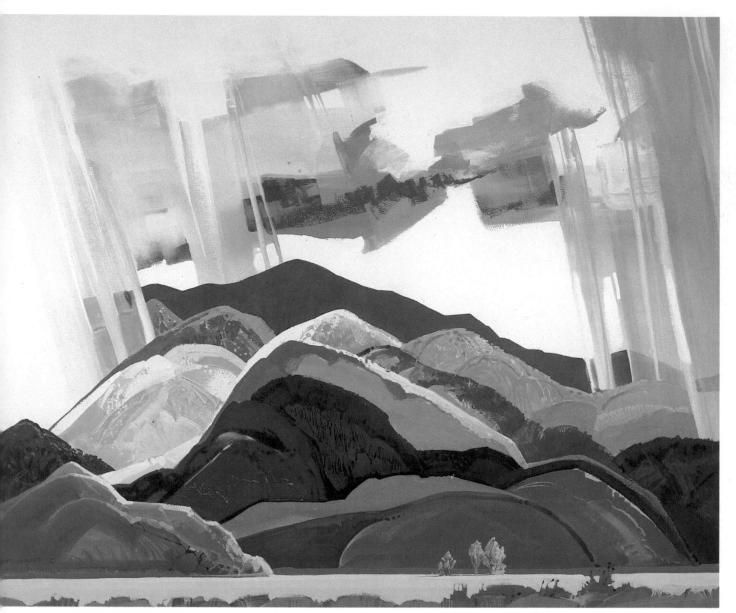

SUNLIGHT AND WINTER SQUALL. Acrylic and casein on Crescent watercolor board #5112, 28 × 34" (71.1 × 86.4 cm). Courtesy of Mission Gallery, Taos, New Mexico.

On Snowshoe Mountain, in Colorado, the shapes are quite beautiful in late afternoon or early evening when strong light is hitting it. I did the original color study for this painting in the summer. However, when I started the final painting, I sensed that it needed to be done with a winter theme to simplify the forms. The color needed to be variations of yellow and yellow-orange, violet and blue-violet. The concept I desired was of the color, light, and form that speaks of a winter squall moving through this landscape. I felt that acrylic and casein would best express this image.

First I laid an underwash of intense, transparent yellow, yellow-orange, and orange acrylic over the entire watercolor board. When the acrylic dried, I used it as the base, and casein was used for the overpainting. I first painted the wet-on-wet sky with the buttery casein. I then added the mountain layers. The casein completely blocked out the acrylic in some of the mountain forms. In others, translucent veils of casein allowed the warm underlayer to be seen. In still others, I left the acrylic exposed. Some of the fun of this painting was scraping back through the cool, darker colors of the casein to the warm yellow acrylic. I did the scraping with curvilinear strokes, repeating the rhythms of the mountain forms. The finished work is a good example of the interaction of these two media.

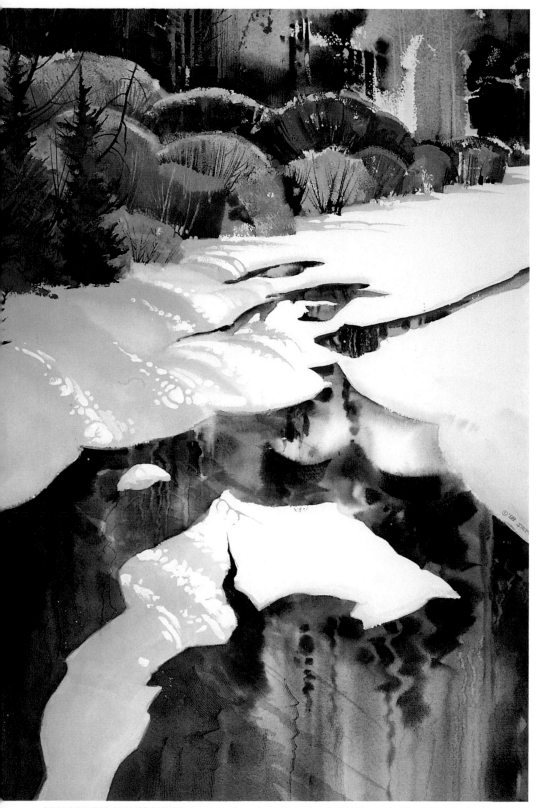

SPRING RUNOFF, CANEJOS CANYON. Acrylic and casein on Lanaquarelle 300-lb. rough, 29 × 21" (73.7 × 53.3 cm). Collection of Jack and Ruth Richeson.

Light, reflections, and mountain patterns seem to be ongoing themes for me. The early spring in the high country is a perfect time to work with this subject. On a calm day, the light casts shadows on brilliant white snow. The river ice is melting, revealing the reflections of the mountains. For this scene, I made a sketch and took some notes and returned to my studio to work on the finished painting.

I used acrylic to catch the feeling of light and strong transparent color in the tree patterns and reflections. I used casein to give solidity and weight to the snow and shadows. First, I created the upper tree and willow passage with acrylic. I applied transparent paint expressionistically, scarring, scraping, and spattering the acrylic. I repeated this procedure in the open water.

I cleaned my glass palette and laid out my casein colors. Starting with the willows, I dashed in analogous colors of opaque casein, letting much of the acrylic show. I then added the shadows and snow. I painted the cerulean blue mass and then added the opaque pockets of white sunlight and snowbanks. I added the dark spruce at the left opaquely with casein. The final composition demonstrates the interaction of the two media. Starting at the top, I used transparent color to create the tree forms, moving to opaque and transparent color for the willows. The central snowfields and shadows are opaque, while the water and reflections repeat the transparency of the upper area.

I have lived in Creede, Colorado, off and on for over twenty years and I'm still inspired by its wealth of subject matter. Recently I noticed this particular view. The rich August sunlight gave the color of the buildings a jewel-like appearance. I went back to the spot for the next few days to gather informational sketches and to do this painting.

The subject called for warm, transparent undertones of acrylic with translucent and opaque overpainting in the rich, velvet matte medium of casein. It is particularly evident in the backdrop cliff form. I did the red-violet transparent underwash in acrylic. I added the complementary, translucent terre verte and the opaque tree patterns using casein. The red-violet acrylic wash in the background changes to a warmer orange as it moves to the foreground. Throughout the composition, warms are played against cools, transparents against opaques, and acrylic against casein.

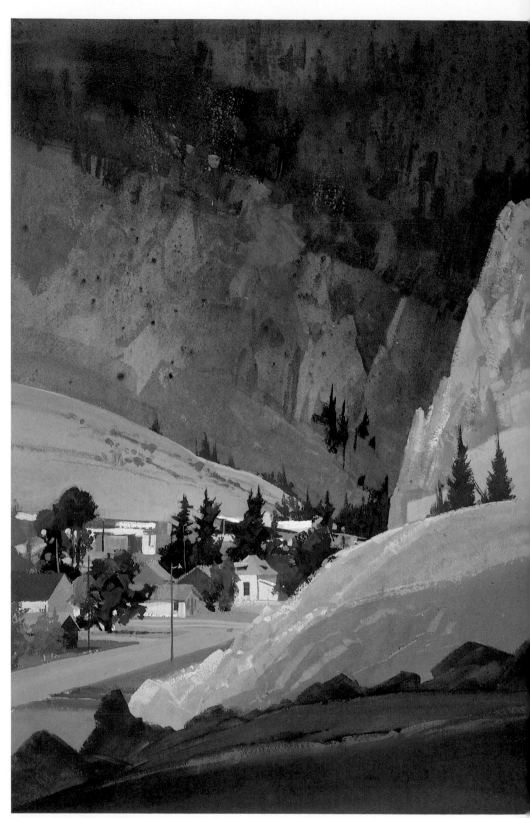

AUGUST LIGHT, VIEW OF CREEDE. Acrylic and casein on Lanaquarelle 300-lb. watercolor paper, 29 × 20" (73.7 × 50.8 cm). Collection of Patricia DeStefan.

Drawing Media with Acrylic

Drawing is another form of expression that I find particularly intriguing to combine with acrylic in a watermedia approach. The expressive line is a mark you cannot get with a brush. Drawing is the foundation for all two-dimensional art, so why not experiment and combine it with some fluid, painterly acrylic? There have been some very exciting works done combining drawing and watermedia, but there is much more potential in this direction.

There are many different kinds of drawing media and they will do different things when used with acrylic. Some are black or graphite-colored, others are multicolored. Some are soluble, others are not.

The ten illustrations below demonstrate what most of the drawing media will do in different situations when combined with acrylic. The first box displays the appearance of the line on a rough paper; in the second it is drawn on a smooth-grain surface. In the third box, the line is drawn *into* wet acrylic, in the fourth wet acrylic is washed *over* the line. In the fifth box, the line is drawn over dry acrylic paint. Under each of the media is a brief analysis of the advantages of and considerations for their use with acrylic.

As these illustrations suggest, there are quite a few things to consider before working with these combinations.

As with any combined element, the line needs to be an integral part of the composition, not an afterthought. Which way should the line be used? Should it be drawn first and painted over, charged into wet transparent paint, or drawn after the paint is dry? What drawing medium will best express the mood you want in this composition? Should it be a black or colored medium, should it be a fine or strong line? What kind of paper will work best for the line and the paint separately and together? Should it have a smooth, even tooth, or a rough textured surface?

Next, permanency is an important factor. Charcoal, India ink, Conté crayon, and graphite are indeed permanent, and when using colored pencils, pastel, oil pastel, or crayon, you should choose quality materials. Get information on the lightfastness of the medium that you are using. And if you are using a soft medium such as charcoal or pastel, it will be wise to spray the finished work with an clear acrylic spray. The spray tends to darken a colored line a bit. Sometimes, if you are careful in its application, a thin coat of matte or gloss acrylic medium will serve as a binder and a sealer.

Shown on pages 142–143 are two final paintings combining various drawing media with acrylic.

| **LINE ON ROUGH PAPER** | **LINE ON A SMOOTH SURFACE** | **LINE CHARGED INTO WET ACRYLIC** | **ACRYLIC WASH OVER LINE** | **LINE ON DRY ACRYLIC TONE** |

Charcoal has a rich, powerful black line that shows boldly on top of acrylic and melts to a dense, velvety black when charged into wet transparent paint. It lifts very easily when washing acrylic over it.

India ink can be drawn with a brush, stick, or pen and has a black, piercing quality. It bleeds out nicely into wet transparent paint and is insoluble when painted over with wash. The bold line reads very well on top of dry acrylic.

LINE ON ROUGH PAPER	LINE ON A SMOOTH SURFACE	LINE CHARGED INTO WET ACRYLIC	ACRYLIC WASH OVER LINE	LINE ON DRY ACRYLIC TONE

Graphite is basically what you find in a soft 6B pencil. The strong silver-gray line deadens when drawn into a wet wash, but it holds well when washed over. It also reads nicely when placed over a dry tone.

I use water-soluble graphite frequently when sketching on-location. The graphite melts to a dark, soft line when drawn into a wet passage of acrylic. It dissolves and lifts easily when painted over—desirable, in some instances. The line is very rich on top of an acrylic wash.

The Conté crayon has a bold, soft quality when drawn directly on paper. It melts nicely on wet acrylic and bleeds softly when painted over. It also reads very well on a dry acrylic tone.

Colored pencil is a bit timid and the color less intense when compared to some other media. It deadens a bit when drawn into wet paint but is insoluble and holds nicely when painted over. The line is subtle over an acrylic wash.

LINE ON ROUGH PAPER	LINE ON A SMOOTH SURFACE	LINE CHARGED INTO WET ACRYLIC	ACRYLIC WASH OVER LINE	LINE ON DRY ACRYLIC TONE

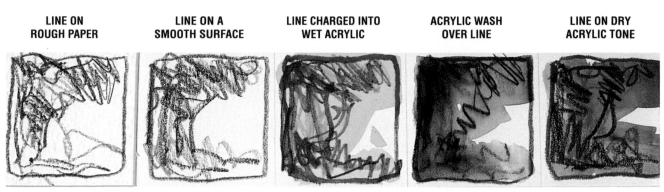

Water-soluble colored pencil has a rich, graphic quality that melts and charges well into wet acrylic. It is soluble and lifts very easily when painted over. It reads nicely on top of dry acrylic.

A crayon line has a waxy look that works well in combination with the vibrant intensity of acrylic. It deadens when drawn into a damp passage but resists well and gives a nice shimmer when painted over. The crayon line has a crisp but integrated look on top of dry paint.

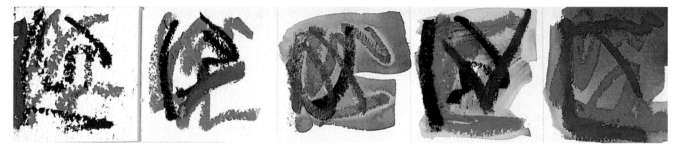

Oil pastel is a soft drawing tool that leaves a strong, greasy mark. The color stick, charged into a wet area, repels the water and leaves an interesting line. It smears very easily when painted over, lifting some of the oily pigment. It makes a beautiful, opaque mark when placed over dry acrylic.

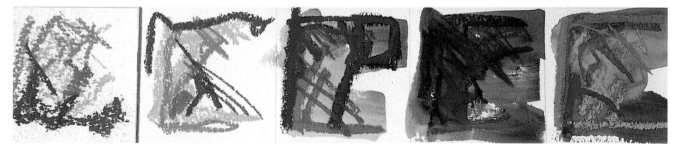

Pastel leaves a soft, matte opaque line and melts into a bold, dense pigment when charged into wet transparent paint. It lifts very easily when painted over, and can result in mud. It has a beautiful opaque look when drawn over dry paint.

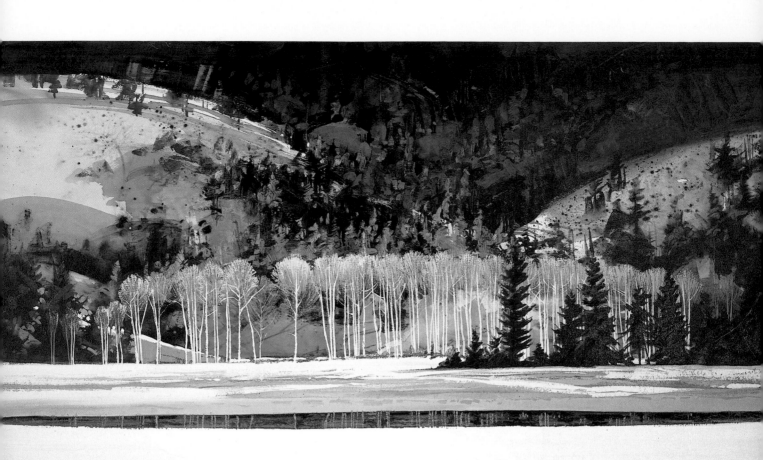

WINTER RHYTHM, ASPEN PATTERN. Acrylic, casein, and pastel on Crescent watercolor board #5112, 19 × 34" (48.3 × 86.4 cm). Collection of Randy and Laura Brown.

I did this painting on-location in the early spring. Working inside my camper, which has a wide, horizontal picture window, I can turn on the heat and paint even on the coldest days. Many of these paintings end up having a wide, horizontal format.

I began this painting with transparent acrylic, washing a blue and blue-green undertone but saving some white of the paper to represent sunlight on snow on the upper hills.

I then developed the main tree forms and snow patterns with translucent and opaque casein. The foreground snowbanks, the aspen trunks, and some branches are all opaque casein. I then used pastel and, with my thumb, smudged in some olive greens in the upper forest areas. I added some light red-orange marks to the distant trees. I then used thin, linear pastel to create the lacy aspen. I repeated some strokes in the thin band of open water.

This painting grew out of my feeling of a flow of energy between nature and humanity. A deva is an angel or, in this case, a guardian spirit of nature. At times, as a landscape painter, my hand, eyes, mind, and spirit all connect to the brush, paint, and paper and to nature's stream of sounds and smells—birds, animals, and wind. It is a beautiful, timeless experience.

On a tan pastel paper, I started by drawing the main composition, trying to capture the essential texture of the spruce. In some instances, I would wet the paper with a soft, flat brush and draw with charcoal pencil or Conté crayons (both sepia- and sanguine-toned). The line would melt into the damp paper to give a rich, velvety quality. In other instances, when the paper was dry, I drew with charcoal, Conté crayon, graphite, and Prismacolor pencil to produce a sharper line. I developed the spirit form with the same media and used a few notes of orange pastel to draw a little attention to its shape. I then sprayed the drawing with a plastic fixative and coated the drawing with matte medium. I glazed over the lower shapes of the rocks with silver and gold metallic acrylics combined with matte medium. While the paint was wet, I used the tip of the brush handle to scrape some curvilinear forms into the rocks. Finally, I mixed a large, opaque light yellow with standard-body acrylic and painted the whole negative area around the rocks and trees.

SPRUCE DEVA. Acrylic, charcoal, Conté crayon, graphite, colored pencil, and pastel on tan pastel paper, 18 × 24" (45.7 × 61 cm). Collection of Dorothy Steele.

EXERCISES

EXERCISE 1: Tape an 11 × 15" sheet of rough, 300-lb. white watercolor paper to a painting board. Coat and seal the paper with clear acrylic gel diluted slightly with water and let it dry. Rewet the paper and flow on some heavily pigmented watercolor in an abstract design. Examples of heavily pigmented colors are manganese blue, cerulean blue, cobalt blue, ultramarine blue, cobalt violet, viridian, the cadmium reds and oranges, and the earth hues—raw sienna, burnt sienna, and burnt umber. Make the dominant colors both warm and cool. Let the watercolor dry. Now, using a clean, damp brush, massage and lift some of the color. In some areas, leave tints, and in others lift paint to expose the white of the paper. When finished, come back to an additive painting process and glaze other color on or add some dark notes to give the work some punch.

EXERCISE 2: Tape a small sheet of cold-press watercolor board or illustration board to a sheet of plywood. Wet the surface and charge the paper with rich, vibrant acrylic color. Let the sheet dry. Now rewet the paper and flow translucent and opaque gouache over the entire surface. Keep the layer thin and maintain a watermedia approach. When there is a dull sheen on the paint surface, scrape and scar with a knife to reveal the underpainting. When the paint has completely dried, use a clean, damp brush and massage and lift the gouache in various amounts, developing interesting abstract shapes. When completed, come back with more gouache to pull the composition together.

EXERCISE 3: Tape a small sheet of watercolor paper to a board. Wet and tone the entire sheet with one acrylic color. When it is dry, lay out casein on a glass palette. Choose the complement to the underpainted color and two colors analogous to that—plus titanium white. (Example: if the undertone is yellow, use ultramarine, purple, and violet.) Develop an image, exposing some of the underpainting. Work translucently and opaquely in areas, and scrape through damp passages to create texture and reveal the undercolor.

EXERCISE 4: Tape a 15 × 20" sheet of cold-press watercolor board to a plywood panel. Get a variety of drawing tools, such as charcoal, Conté crayon, graphite, and water-soluble graphite. Wet the surface and draw with these tools. Allow them to melt into the damp paper for soft, dark lines. When the paper is dry, continue drawing with sharp, crisp lines. Develop layers of abstract lines that have an interesting texture and rhythm. Spray the drawing with a clear acrylic spray. Now use standard-body acrylics to paint a solid mass around some of the drawn shapes. In some areas, glaze over some of the drawing with color and some gloss medium.

INDEX